IMAGES
of America

WHEELING

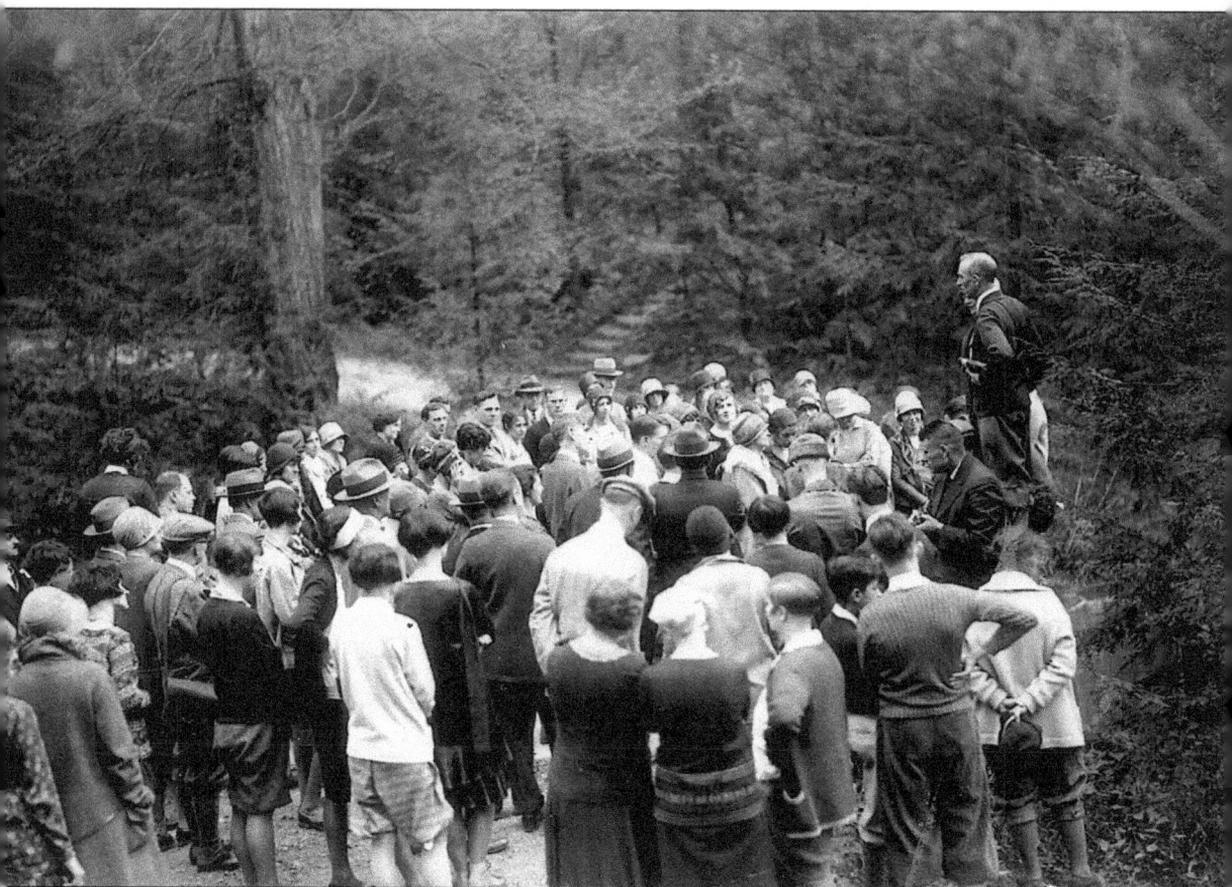

A.B. Brooks' Sunday Morning Nature Hike. The famed naturalist Alonzo Beecher Brooks led daily walks through the scenic trails of Oglebay Park. A.B., as he was known, established the Nature Leaders' Training School. Here he taught an entire generation of environmentalists his deeply religious and hands-on approach to nature. The Brooks Bird Club, named after him, has over 1,000 members in more than 10 countries. A.B. is a member of the Wheeling Hall of Fame and the West Virginia Agriculture and Forestry Hall of Fame. (Courtesy of Oglebay Institute Mansion Museum.)

IMAGES
of *America*

WHEELING

William A. Carney Jr. and Brent Carney

ARCADIA
PUBLISHING

Published by Arcadia Publishing
Charleston, South Carolina

Library of Congress Catalog Card Number: 2003111115

For all general information contact Arcadia Publishing at:
Telephone 843-853-2070
Fax 843-853-0044
E-mail sales@arcadiapublishing.com
For customer service and orders:
Toll-Free 1-888-313-2665

Visit us on the Internet at www.arcadiapublishing.com

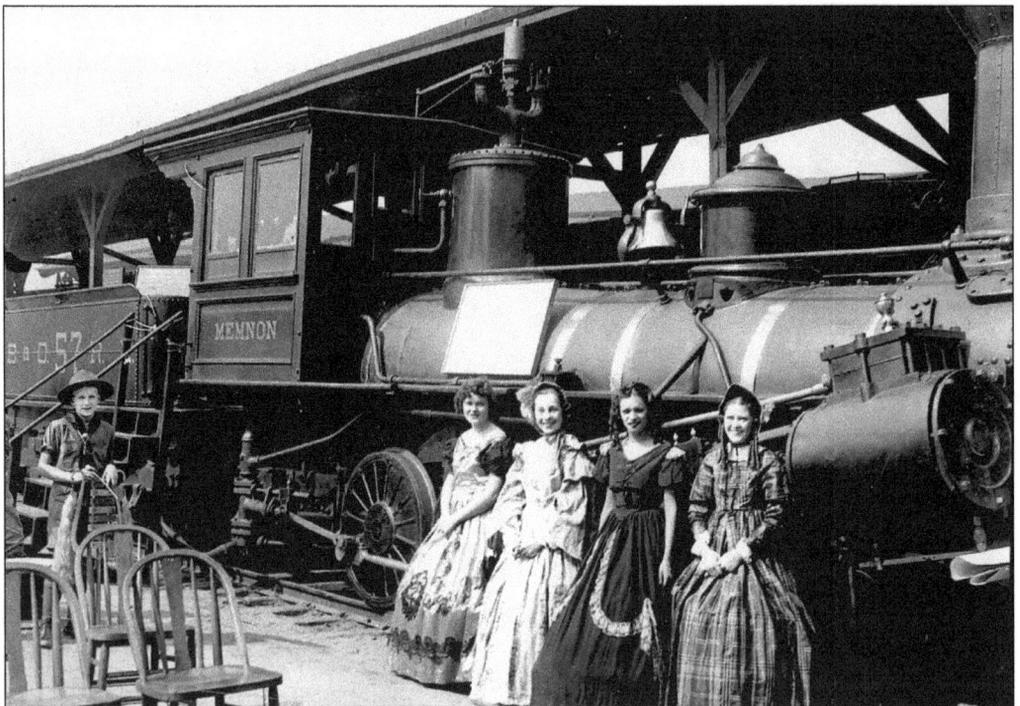

WHEELING CENTENNIAL, 1936. These beautiful ladies are posing beside the B&O Railroad engine number 57, called the Memnon. Built by the New Castle Manufacturing Company in 1848, the engine has blind, also known as flangeless, center drivers. It burned coal, whereas most engines of that day burned wood. The engine came to Wheeling for a local exhibition. (Courtesy of Harry Parshall.)

CONTENTS

ACKNOWLEDGMENTS

We would like to thank numerous people and organizations, including the following: Margaret Brennan, president, Wheeling Area Historical Society; Mary Staley, vice president, Wheeling Genealogical Society; Travis Zeik, curator, Oglebay Institute Mansion Museum; Gary Zearott, Zee photo; Jim Thornton, Creative Impressions; Robin Rhodes, Kirk's Photo-Art Store; Darryl Clausell, West Virginia Northern Community College; Dr. David Javersak, West Liberty State College; Sister Joanne Gonter, historian and archivist, Mount de Chantal Visitation Academy; Jeanne Cobb, archivist, T.W. Phillips Memorial Library, Bethany College; Debra Basham, archivist, West Virginia Division of Culture and History; Professor Robert W. Schramm, West Liberty State College; Tracey Rasmer, archivist, Catholic Diocese of Wheeling-Charleston; Jung Weil, Director of Communications and Creative Services, Glass Packaging Institute; Tom and John Weishar, vice presidents, Island Mould and Machine; Hydie Friend, executive director , Wheeling National Heritage Area Corporation; Tom Tominack, manager, Wheeling Ohio County Airport; Tom Featherstone, archivist, Walter P. Reuther Library, Wayne State University; Wheeling News Register; David B. McKinley, McKinley and Associates, Inc.; Arthur J. Rooney Jr., vice president, Pittsburgh Steelers; Merv Corning, president, Murray Card Co.; Randy Worls, president and CEO, Oglebay Foundation; Steve Johnston, Chief of Wheeling Fire Department; St. John the Divine Greek Orthodox Church; Corbis International; the Library of Congress; Wheeling Medical Park; Wheeling Police Department; Temple Shalom; Fort Henry Club; Ohio County Public Library; Ohio Valley General Hospital; Wheeling Symphony Orchestra; Warwood Armature Repair; Wakim's Sportsmen's Club; WWVA; the Galloway family; the Turner family; the Cooper family; Susan Hogan; Gene Kuhn; Katherine Snead; Lucy Busby; Joseph A. Krehlik Jr.; Milt Gutman; Ellis Boury; Frank O'Brien; Mickey Kryah; Chris Hess; Lee Wigal; Gene Kuhn; Earl Summers Jr.; Linda Cunningham Fluharty; Eva Marie; Ray Huff; Anne Thomas; Gordie Longshaw; Albert Doughty; Hal O'Leary; Betty June Weimer; Paul E. Rieger; Virginia Monolakis; Skip Olsen; Tom Gompers; Brad Johnson; Dorothy Parshall; Jerry Vitous; Robert E. Imhoff; Thomas Ream, M.D.; Herb Bierkortte; Cindy Hubbard; Nancy Paull; Nancy Pryor; Reverend Cummings; and Minister Roger A. Murfin.

We would also like to extend a special thanks to Newbrough Photo, Ed Parshall, and Rudy Agras for their technical support.

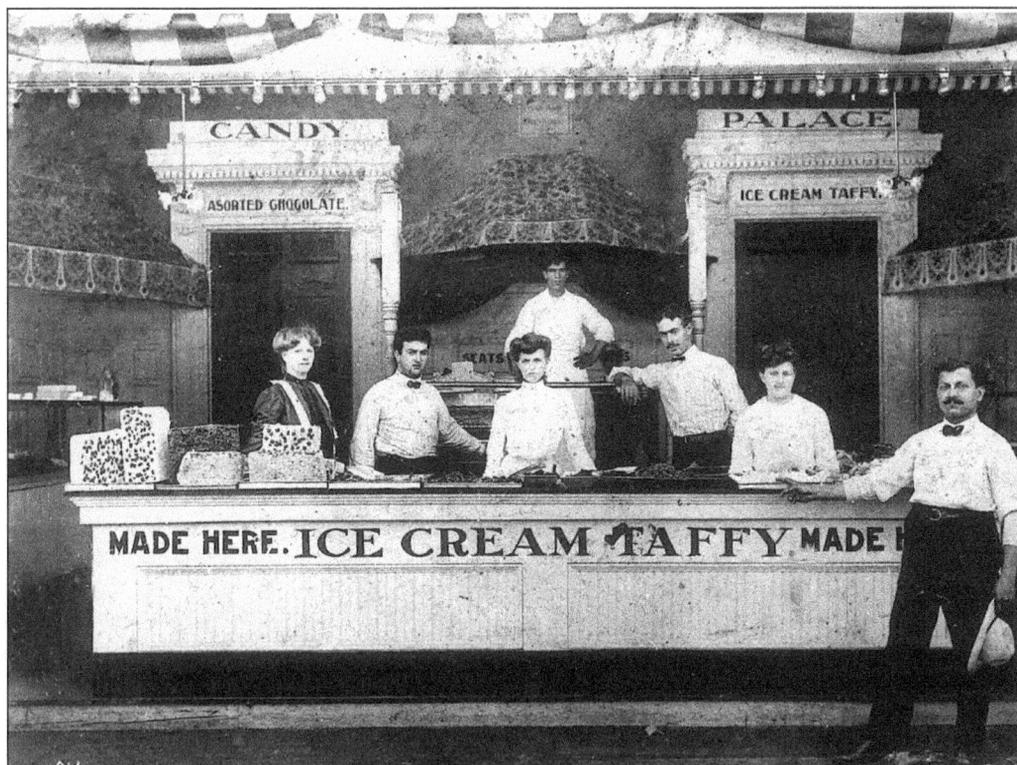

MICHAEL G. BOURY SR., C. 1916–1923. This former lion tamer and circus performer is the man standing on the far right. He had just leased this concession stand at the West Virginia State Fair. Mr. Boury also opened a confectionary stand near the B&O Railroad station. He later opened an appliance store on Market Street. At the height of this company's success, it had 6,000 employees and owned 70 restaurants. (Photograph courtesy of Ellis Boury.)

This book is dedicated to my father, William A. Carney Jr., who passed away before this book came to print. He cared more deeply about Wheeling's history than anybody I ever met. He also had a broader knowledge about the subject than anyone I have spoken with.

INTRODUCTION

The former Speaker of the House, Tip O'Neill once famously quipped that "All politics is local." His statement touches on the fact that broad national legislation is judged through the prism of how it affects one's immediate, local situation. After working on this book, we have come to believe that "All history is local." While collecting the hundreds of photographs for this book, we have come to realize that people from Fulton view Wheeling's history differently than someone from Elm Grove or Bethlehem. Each town has singular experiences, industries, and stories to tell. Everyone had a piece of Wheeling's puzzle and most knew of a friend of a friend who had a great photograph. Some of the most unusual photos came not from the major studios, but from the friend of a friend. Most of these people understandably cherish these visual treasures. A college study asked people if they could only take one thing from a burning house, other than a living being, what would that be? The number one answer was "my photos." After writing this book, we now understand why. Local photographs say more than "this is me at Myrtle Beach." They tell about family and friends, businesses and buildings that are no longer. They tell of the way we once lived, dressed, and worked. More importantly, they capture the journey of Wheeling to present day. Many of the photographs in this book will be familiar to our historians but many have only been seen by a small group of people. We tried to strike a balance between showing some of the best images for those unfamiliar with the Brown and Kossuth collections, and surprising those who think they have seen it all. No one has seen all of Wheeling's photographs. That is a testament not to a lack of diligence in our pursuit, as the Acknowledgements will testify. But rather, it shows that Wheeling's photographic history is so rich and so deep that it is practically unfathomable. We have only scratched the surface with this book and its sister book: *Wheeling in Vintage Postcards*. In the first book, we focused on buildings, streets, and parks. Those were the central themes in early 20th-century postcards. In this second work, we are looking at Wheeling's greatest resources—the people. The purpose of these two books is only to add a few more chapters to the voluminous history of our beloved city. The mission of this work is to show that America is not a simple meal of 50 different states, but rather, is a complex bouillabaisse consisting of thousands of different neighborhood ingredients. It is this uniquely American quality which gives our city, our state, and our country its rich flavor.

One

WHEELING'S AFRICAN-AMERICAN EXPERIENCE

MARKET HOUSE. The Market House was built for $690 on the corner of 10th and Market Streets. The Town Hall, on the second floor, rented rooms and slaves were sold at the west end of the market. People were called to the grotesque human auction by a large bell. At the west end of the market (pictured right) stood "a wooden movable platform about two and a half feet high and six feet square, approached by some three or four steps." From this site, the auctioneer sold slaves, which would probably be taken west along the National Road or north along the Ohio River. A whipping post was also reportedly near the site. (Courtesy of Margaret Brennan.)

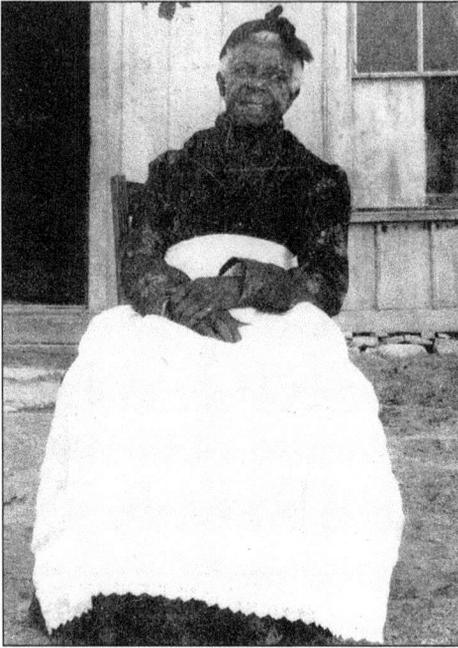

AUNT MARY, FORMER SLAVE, 1898. This 102-year-old woman was a slave and nurse to the Chapline family of Wheeling. When her master became afraid that his family heirlooms would be stolen, Aunt Mary buried them in a secret location. Years later she revealed the location of her master's sword, medals, and Wedgewood vases. (Courtesy of Margaret Brennan.)

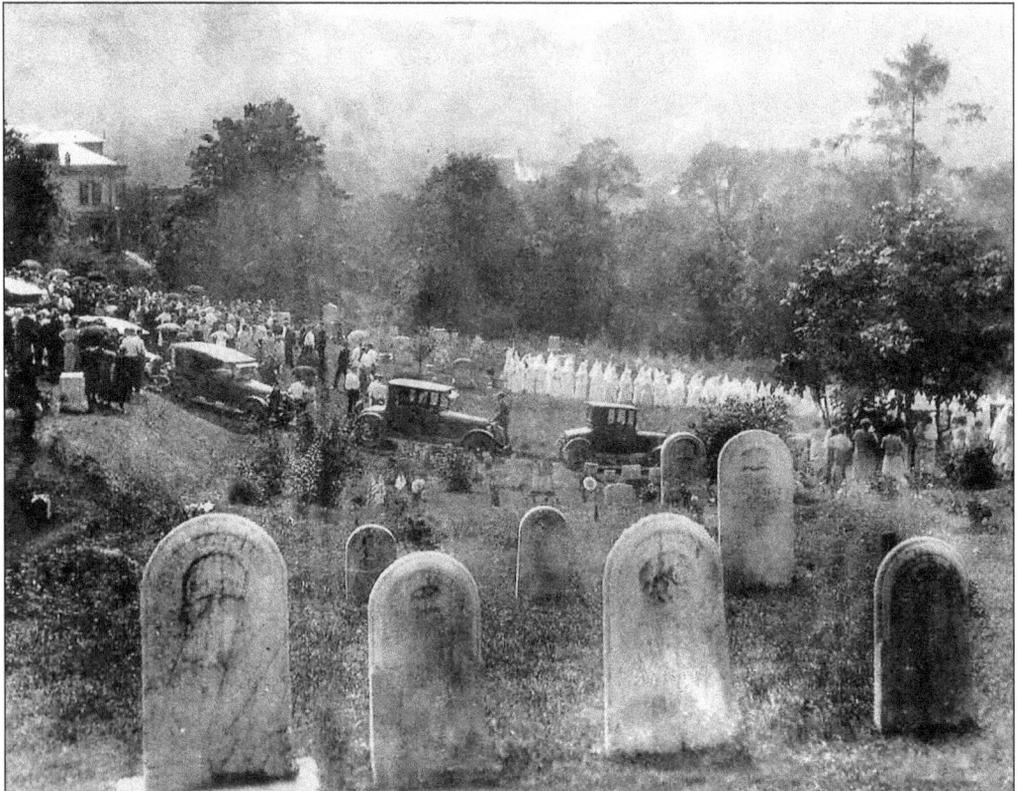

KU KLUX KLAN FUNERAL, 1920. This Klan funeral took place at the Stone Church Cemetery. The KKK harassed the black community in Wheeling as it did in the rest of the country. (Courtesy of John Weitzel.)

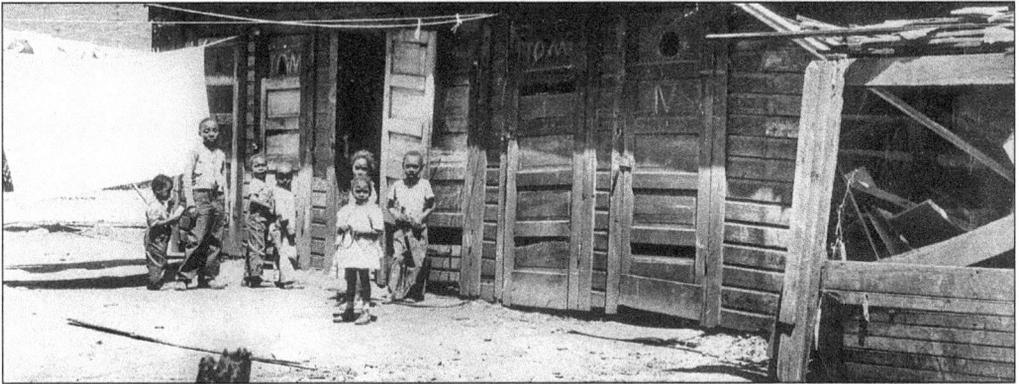

PARSONS BLOCK, 26TH AND MAIN STREETS, JULY 1949. Wheeling's Black History Census Statistics are listed below. In 1787, the statistics for Virginia, Ohio County (includes Marshall and some of Tyler Counties), were the following: 67 slaves over the age of 16, 70 slaves under the age of 16, 1 freeman, and 48 owners of slaves. In 1810, statistics for the Virginia, Ohio County (includes Marshall and some of Tyler Counties), were the following: 56 free black persons, 440 slaves, and it is noted that many free black people were residing in the household of whites. (Courtesy of Gary Zearott, Zee Photo.)

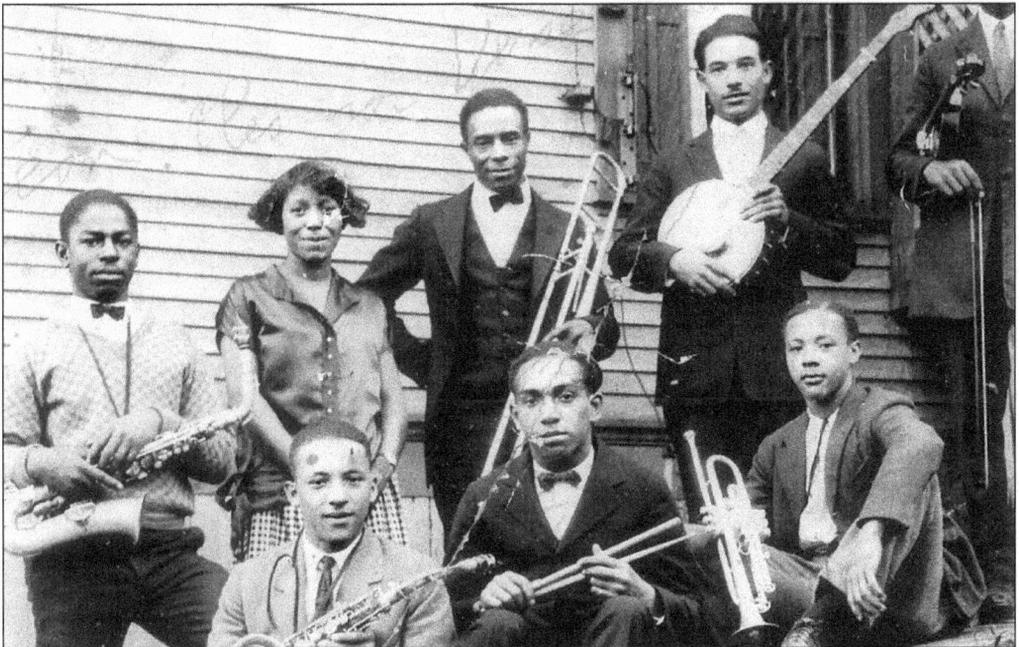

LEON "CHU" BERRY AND HIS NEIGHBORHOOD BAND, C. 1923. Chu Berry (1908–1941) was one of the world's greatest tenor saxophone players, though not as well known due to his early death at the age of 33 in an auto accident near Conneaut Lake, Ohio. He played with Cab Calloway, Count Basie, Fletcher Henderson, Bessie Smith, and others. In 1984, he was inducted into the Big Band and Jazz Hall of Fame and in 1998 honored at the Wheeling Hall of Fame. Coleman Hawkins said, "Chu was about the best." When asked who his favorite sax player was, Charlie Parker (known as the "Bird") said, "Yes—without doubt. Chu Berry. There's never been a player like him." The Bird named his first son Frances Leon Parker, after Chu. Pictured from left to right are (front row) Norman Campbell, Theodore Cooper, and Lawrence Campbell; (back row) Leon, Eleanor, Verse, Ralph, and Kent. (Courtesy of Katherine Snead.)

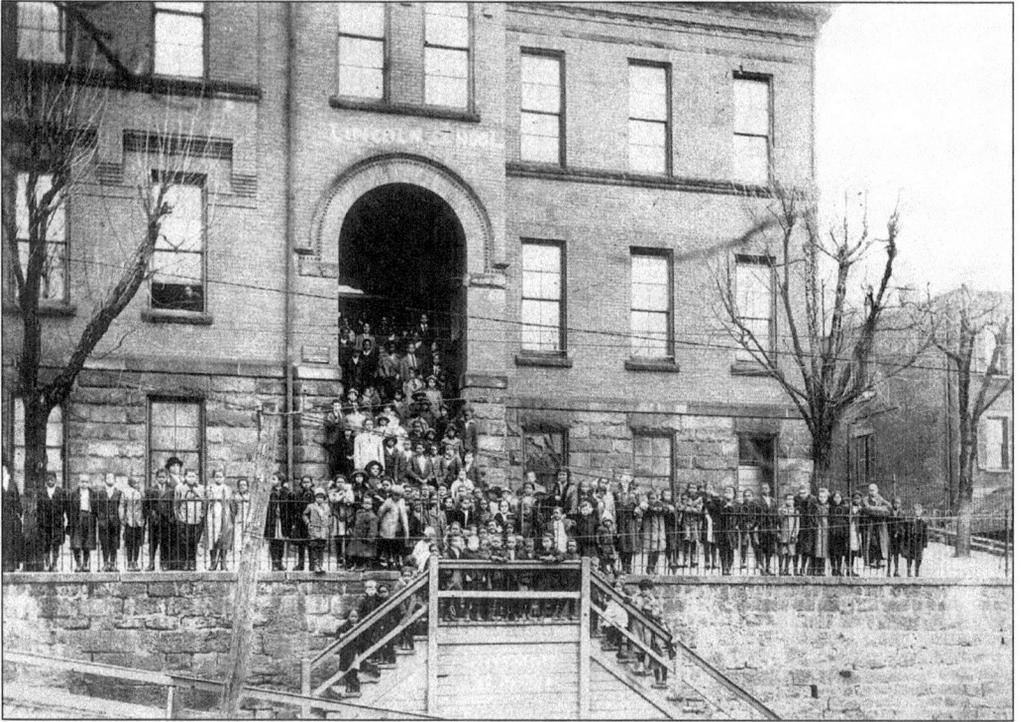

LINCOLN SCHOOL, C. 1914. Lincoln School was organized on August 22, 1865 and founded in 1866. It was located on the north side of 12th and High Streets. The school originally had only two rooms and burned down in 1893. A new school was completed in 1943 and contained both a high school and an elementary school. (Courtesy of Darryl Clausell.)

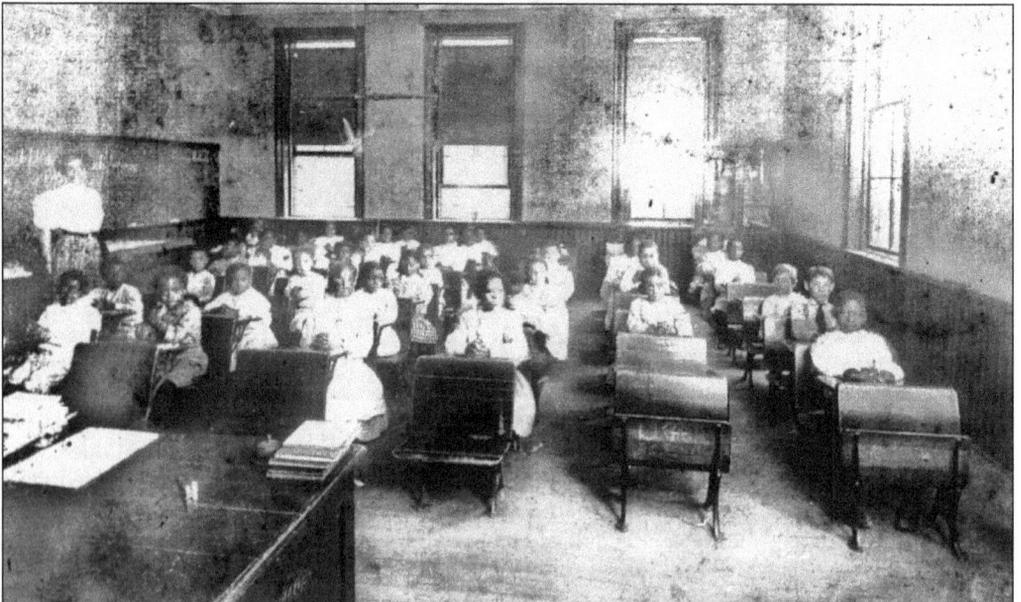

LINCOLN SCHOOL CLASSROOM. These modest classrooms were Spartan by design and lack of funds. Although bare, they were filled with a desire to learn and improve the community. (Courtesy of Darryl Clausell.)

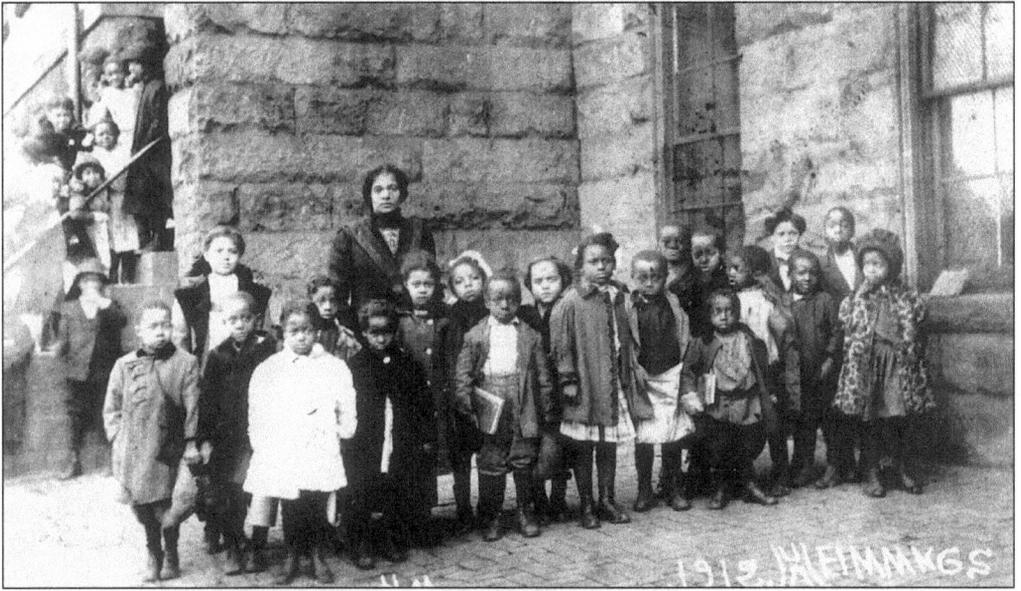

TEACHER AND STUDENTS. This photo was taken in 1912 in front of the old Lincoln School. Dorothy Cooper is the fourth student to the right of the teacher. (Courtesy of Darryl Clausell.)

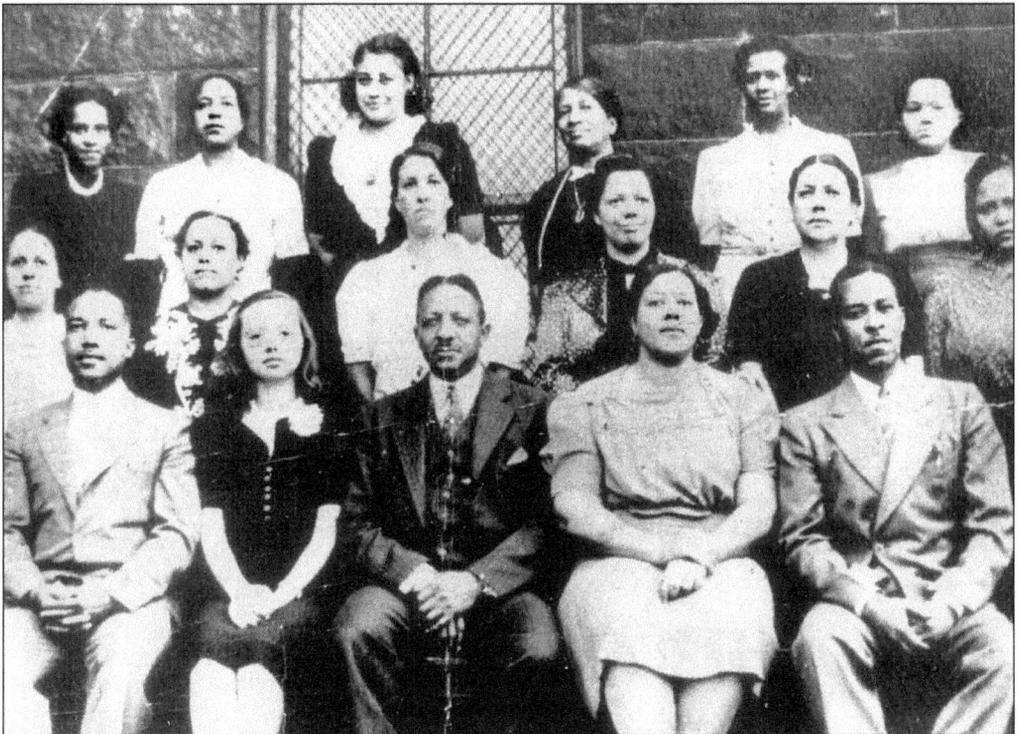

LINCOLN FACULTY. The Lincoln faculty pictured here are, from left to right, (front row) Teddy Chambers, Cornelia Williams Cheppel, Principal Rainbow, Gerldine Newman, and Chuckie Shannon; Gertrude Dixon, Ruth Banks, Winnie Paige Thomas, Mrs. Rawlings, Ms. Miller, and Helen Green; (back row) Betty Ross, Lilla Powell, Mable Cambille, Bessie Grant, Mildred Buckner Blackwell, and Thelma Warrick. (Courtesy of Darryl Clausell.)

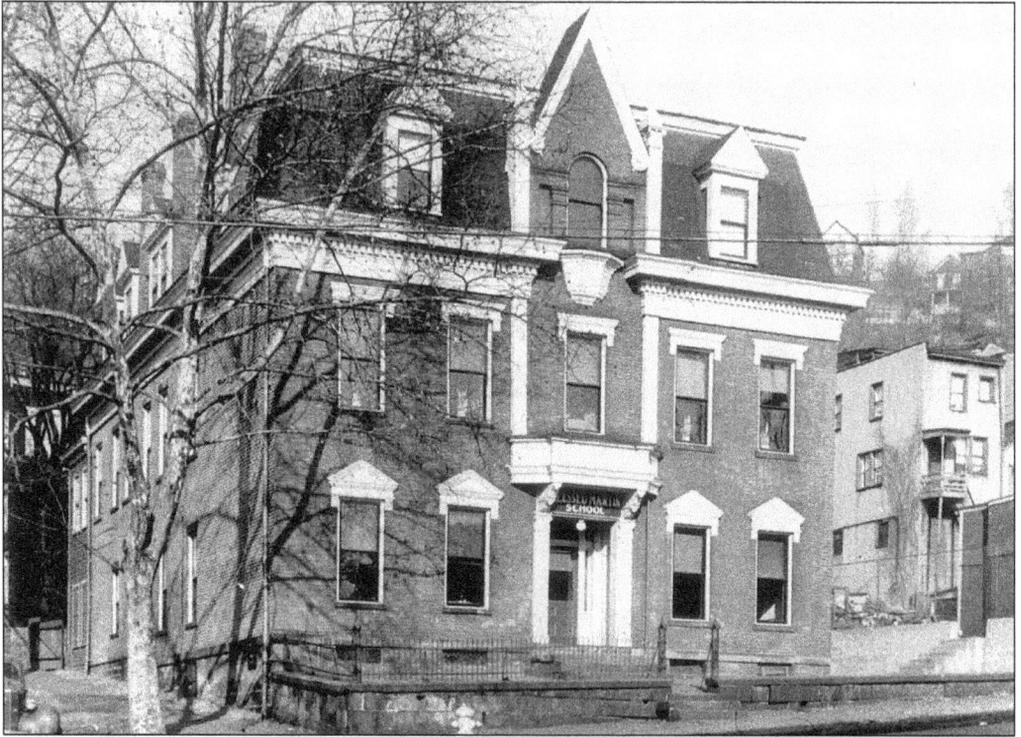

BLESSED MARTIN SCHOOL, 1942–1955. The school was located on 13th and Jacob Streets, where Wheeling Central Catholic School gym sits today. The school's dual *raison d'etre* was to care for the religious welfare of Wheeling's black Catholics and the propagation of the Catholic faith to non-Catholics. (Courtesy of Darryl Clausell.)

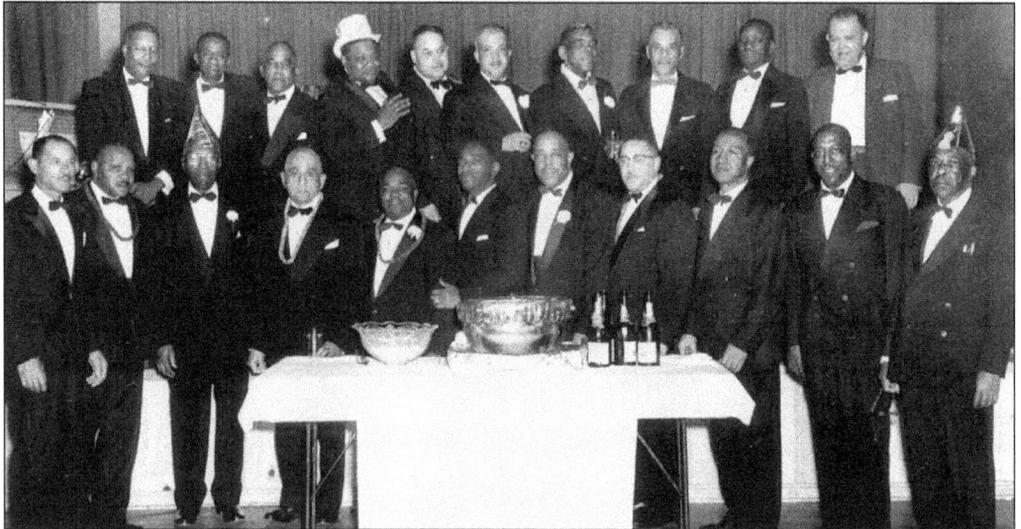

BEAU BRUMMEL, JANUARY 1, 1958. In 1930, 26 black men from Wheeling started the Beau Brummel organization as an upscale social club. The men would dress formally to the annual winter formal dance and spring formal. Only the summer picnic was without black tie. The organization offered yearly scholarships, rang the March of Dimes bells, and delivered care packages to the needy at Christmas. (Courtesy of Darryl Clausell.)

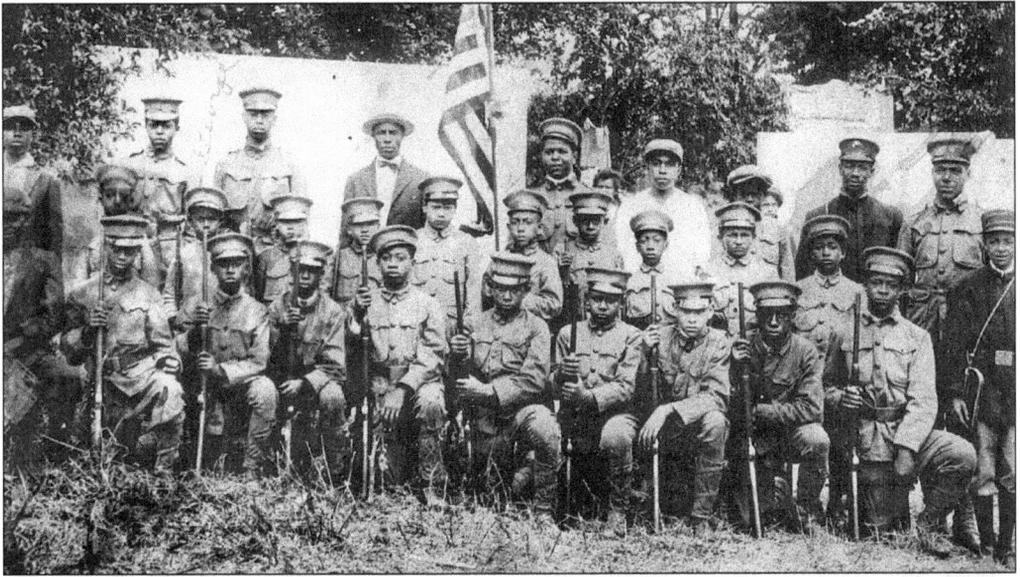

THE BOY'S BRIGADE, C. 1913–1914. In segregated Wheeling, many organizations did not permit blacks to become members. In turn, they formed their own groups. This group, the YMUA, was an offshoot of the YMCA. Pictured from left to right are (front row) Fred, George, Bowser, Thomas, Boots, Bob, Richard, Kelsey, Ed, and Saunders; (middle row) Herbert, Augee, Bruce, Lawrence, Norman Jim, Dungy, Charles, Lewis, Laun, and Sherlie; (back row) Blair, Verse, Jack, Ellis, Charlie, Cap, Hull Joe, and Benson. (Courtesy of Dorothy Cooper.)

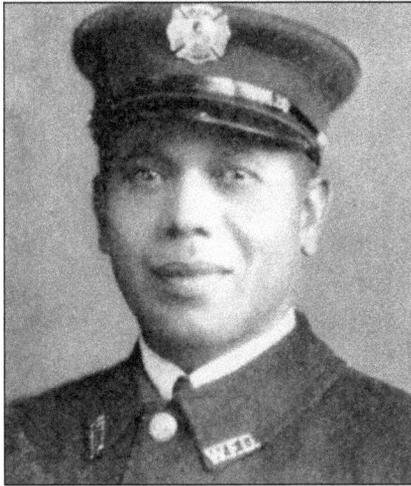

(above left) FIREMAN J. DOFFMEYER, 1896. Believed to be the first African-American firefighter for the city of Wheeling, Mr. Doffmeyer, who worked for Engine Company number 8, entered the Fire Department on September 16, 1919. This brave man died on April 1, 1945 and is buried in Stone Church Cemetery. (Courtesy of the Wheeling Fire Department.)

(above right) "DOC" WHITE'S PHARMACY. This pharmacy at 1033 Chapline Street was far more than just a place to buy medication. It served as a safe haven for young African Americans, during the time that Wheeling was segregated. Doc White would often dole free food and teach the kids valuable lessons about life. "Doc" started the Teen Club during WWII in order to help wayward kids. The motto was "No profanity, No allowed contact, No blocking the doorway." (Courtesy of Darryl Clausell.)

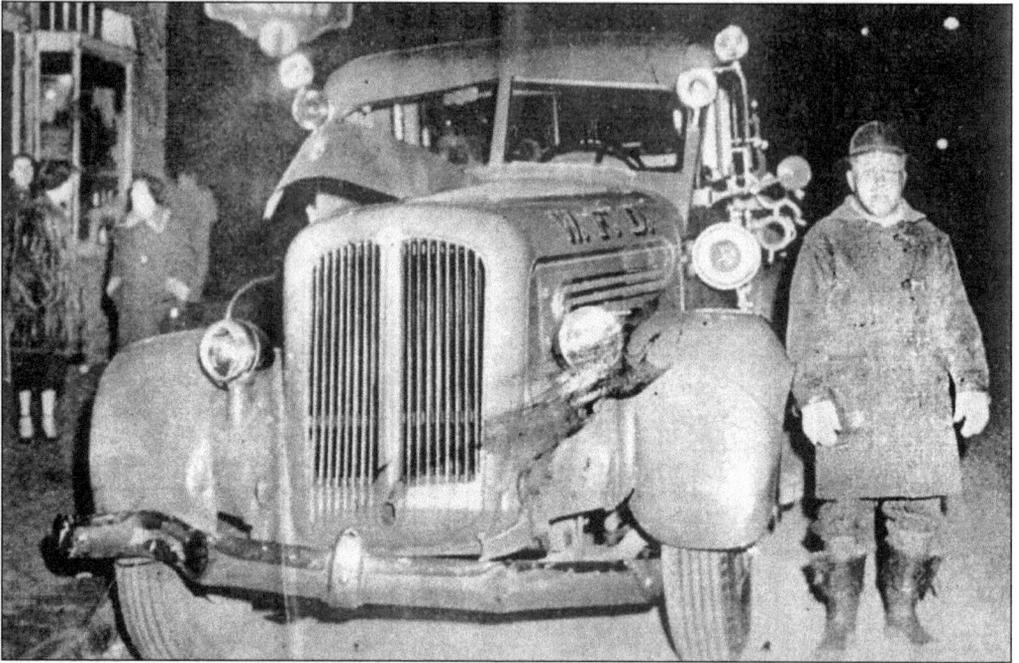

ALFRED "HAPPY" COOPER. Mr. Cooper was the first black fire captain in the Wheeling City Fire Department. He served at the 11th Street fire station. (Courtesy of Dorothy Cooper.)

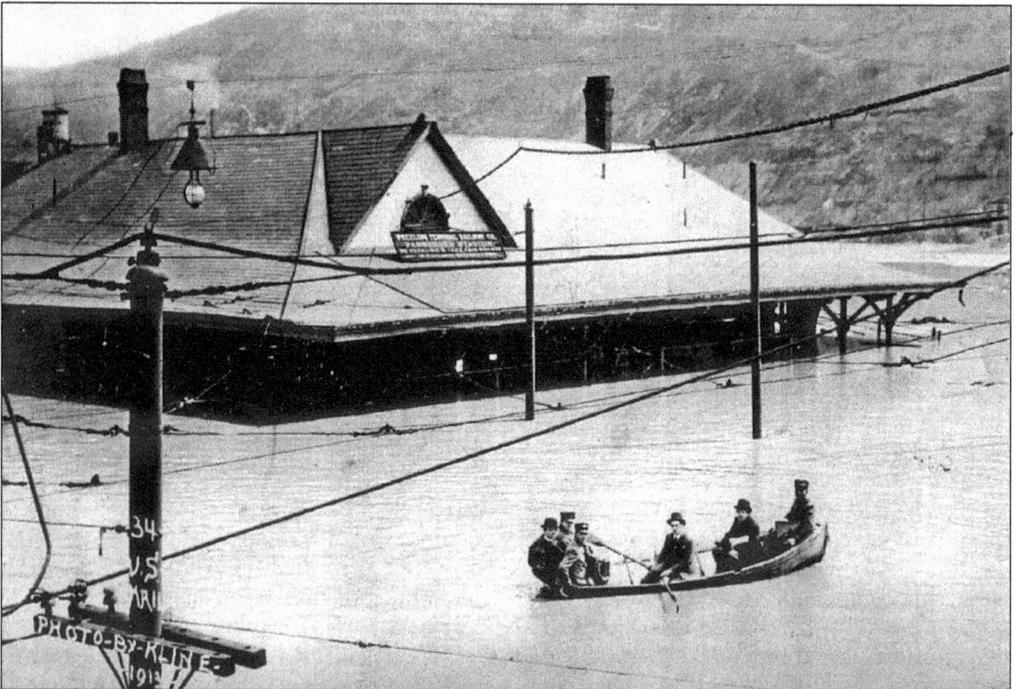

NOT RAIN NOR HAIL . . . Nothing would keep postman William Turner (seen here in the front of the boat) from his appointed rounds. This 1913 photograph was taken in front of the Wheeling Terminal Railway Co. by Kline. (Courtesy of Darryl Clausell.)

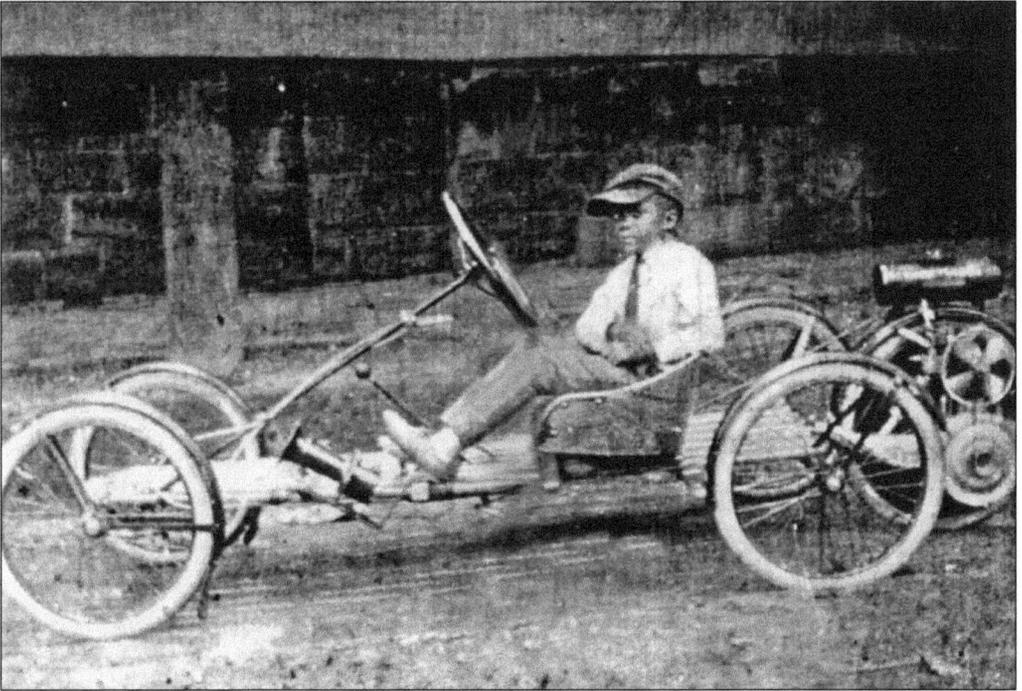

IVAN LEE TURNER IN HIS VEHICLE, C. 1912. Turner grew up to be an inventor; this unusual five-wheeled go-cart may have been one of his first creations. (Courtesy of Darryl Clausell.)

WILLIAM ALEXANDER TURNER. Mr. Turner (1865–1928) served the Wheeling Police department for 35 years. He solved many difficult crimes, including the capture of the slippery Miss Mabel Felway (also known as Miss Lizzie Ford) in December 1926. He is believed to be Wheeling's first black policeman. (Courtesy of Darryl Clausell.)

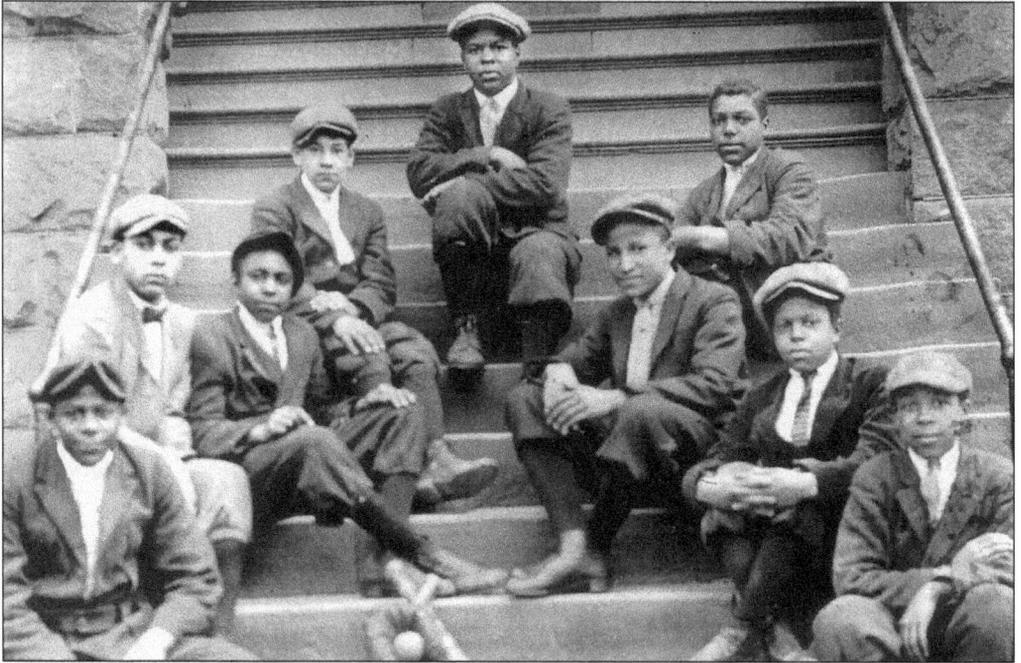

LINCOLN SCHOOL BASEBALL TEAM, 1914. Baseball was played principally between inter-school teams. The year 1914 saw Lincoln School's first sports programs. (Courtesy of Darryl Clausell.)

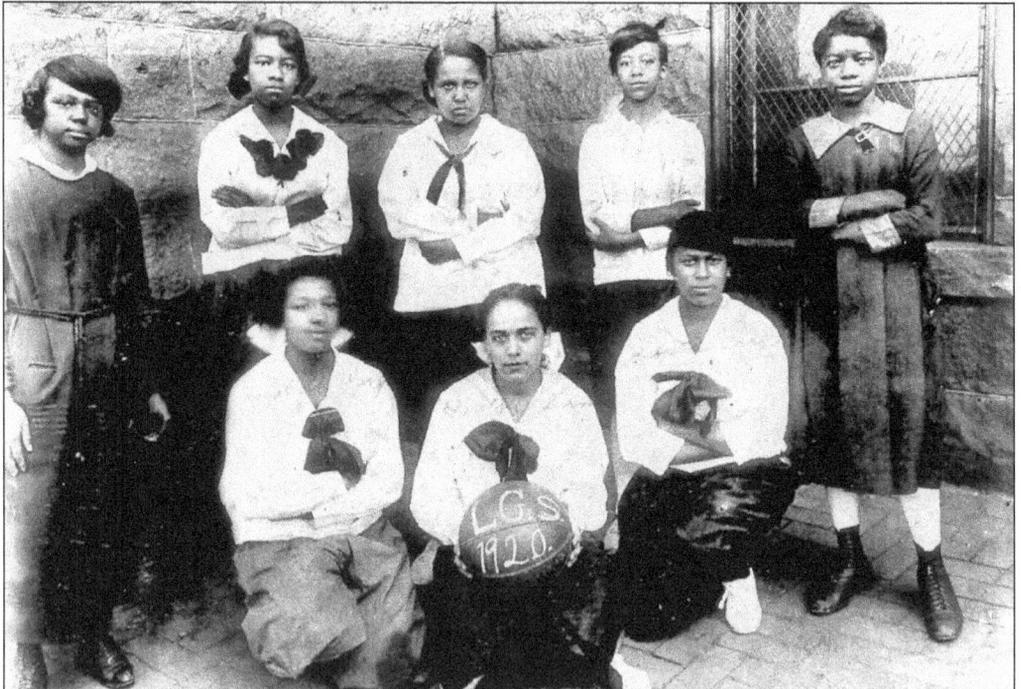

LINCOLN SCHOOL GIRL'S BASKETBALL TEAM, 1920. The Hilltop Courier newsletter stated that the first girl's basketball team at Lincoln was organized by Coach Cecil Miller, a former coach and teacher from Charleston, West Virginia. (Courtesy of Darryl Clausell.)

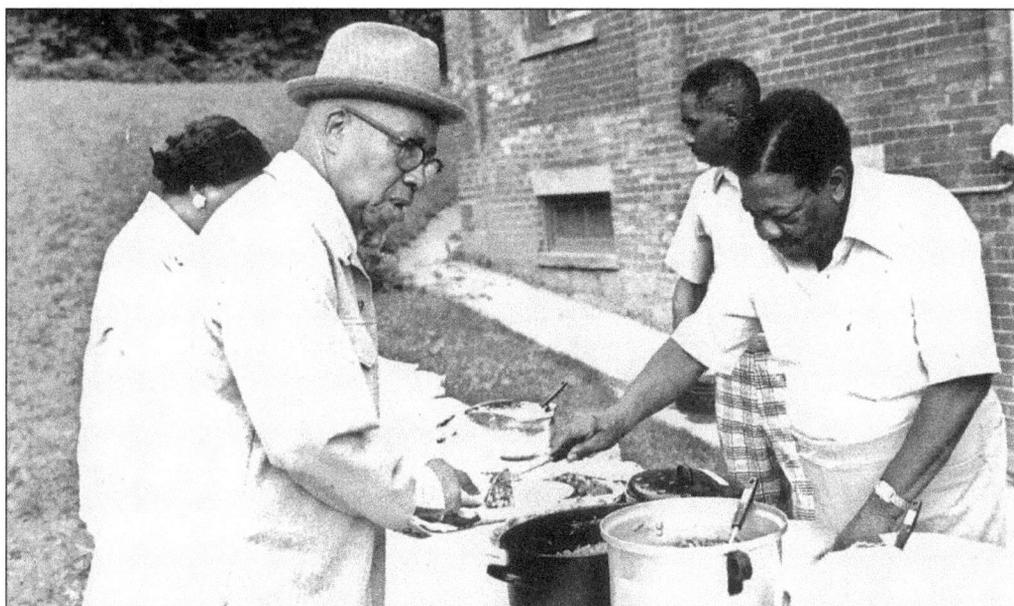

JAMES "DOC" WHITE, (1901–1988). "Doc" White, as he was known, was a mentor, benefactor, and friend to the black community in Wheeling. He was the oldest practicing pharmacist in West Virginia and worked tirelessly for the Wheeling Housing Authority. He constantly gave his time and money to help those less fortunate than himself, regardless of race, creed, or color. For his public service, he was inducted to the Wheeling Hall of Fame in 1986. (Courtesy of Darryl Clausell.)

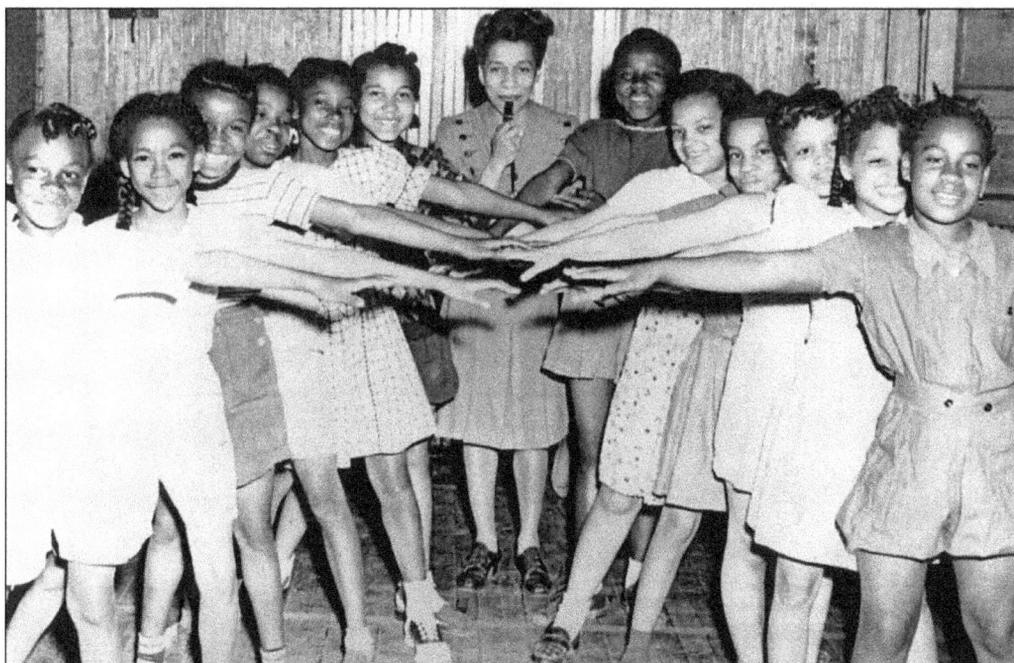

BLUE TRIANGLE BRANCH, YWCA, 1948. The YWCA formerly had segregated branches. The Blue Triangle branch offered black youngsters the chance to congregate, dance, and organize. This group had its own house on 12th Street. (Courtesy of Darryl Clausell.)

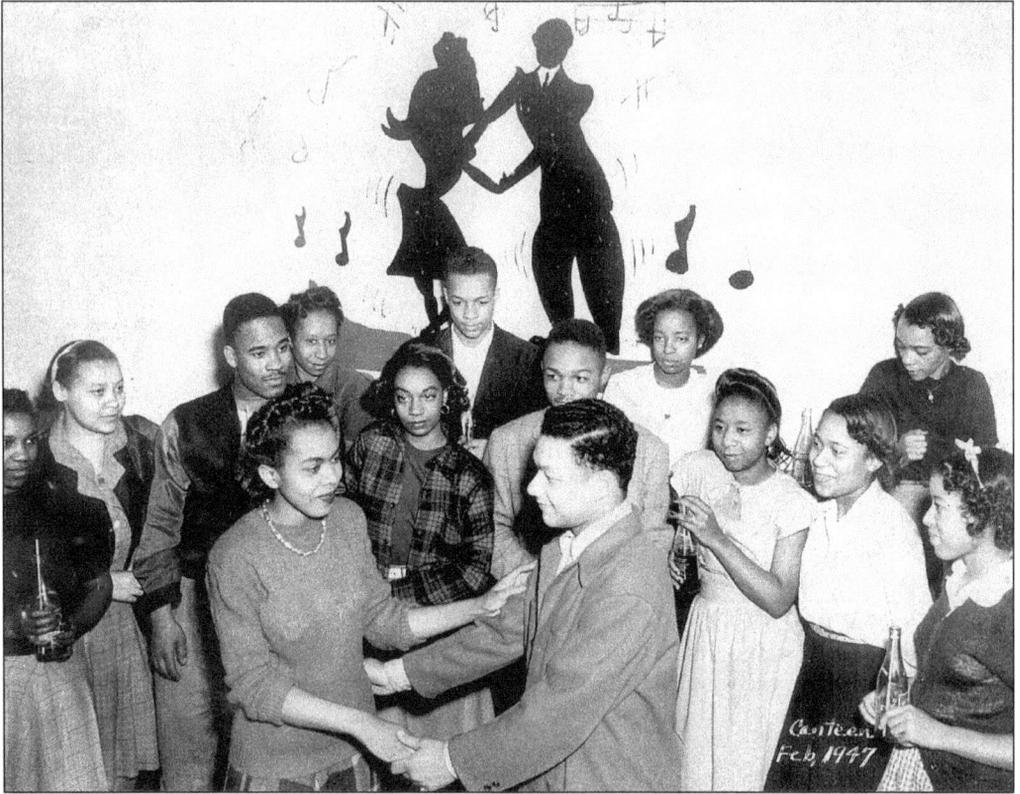

BLUE TRIANGLE DANCE AT THE CANTEEN, FEBRUARY 1947. The Blue Triangle branch also sponsored a vacation Bible school for black children. (Courtesy of Darryl Clausell.)

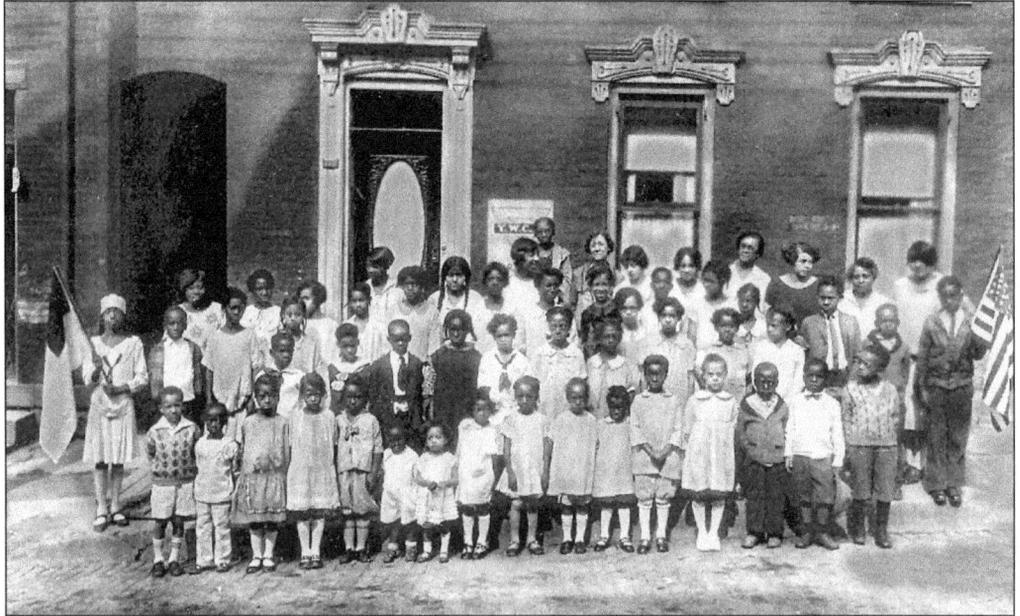

BLUE TRIANGLE, YWCA, C. 1947. Many sharply dressed children are posing in front of the YWCA building. Note the streets paved with brick. (Courtesy of Kirk's Photo.)

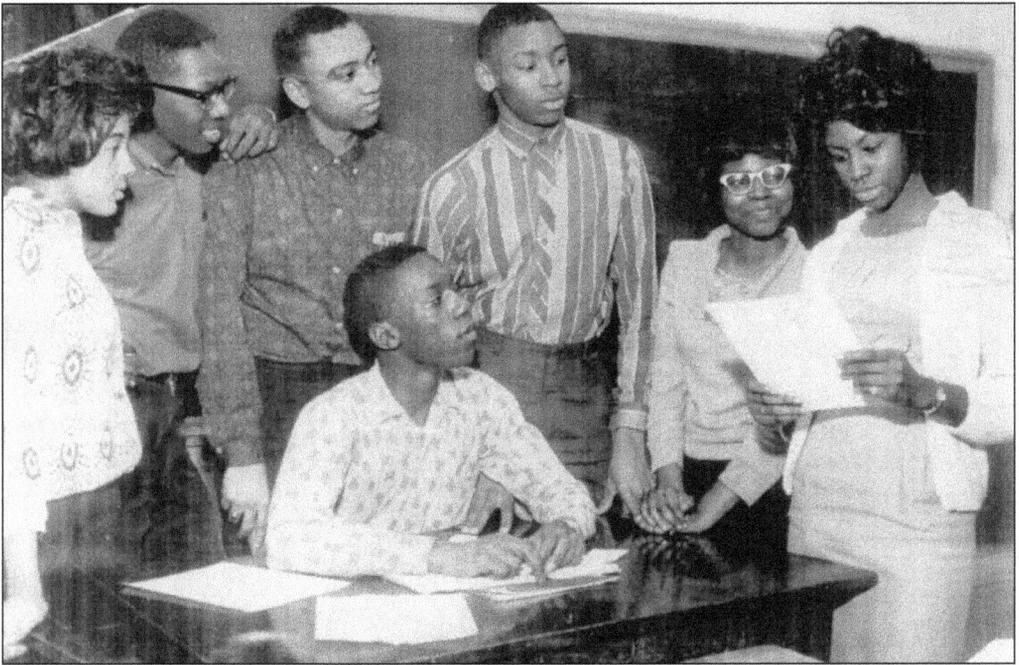

WHEELING YOUTH COUNCIL, 1963. Newly elected officers of the Wheeling Youth Council of the National Association for the Advancement of Colored People are centered around their president, Marvillis Webb. Standing left to right are Margaret Miller, Theodore Smith, James Cyrus, Stewart Catting, Doretha Brown, and Lavanda Burress. (Courtesy of Darryl Clausell.)

(left) **OLIVER T. SHANNON.** This Lincoln School coach sent the photo back to his family in Wheeling while serving in the army during WWII. Many former Lincoln students served in France during the war. (Courtesy of Darryl Clausell.)

(right) **BOB BROWN, WHEELING IRONMEN, C. 1963.** Bob Brown played for the Wheeling Ironmen and for the Green Bay Packers in Super Bowl I. He played in that historic game against Andy Rice, another member of the Ironmen, who played for the Kansas City Chiefs. This photo was taken outside the Ironmen headquarters on 14th Street between Main and Market.

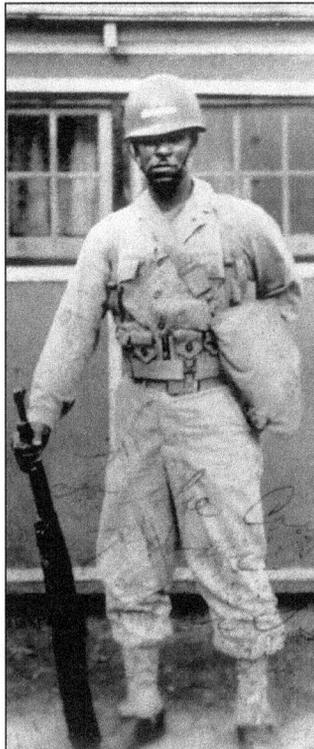

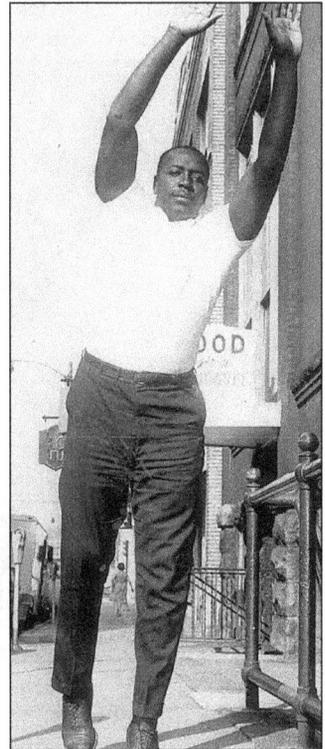

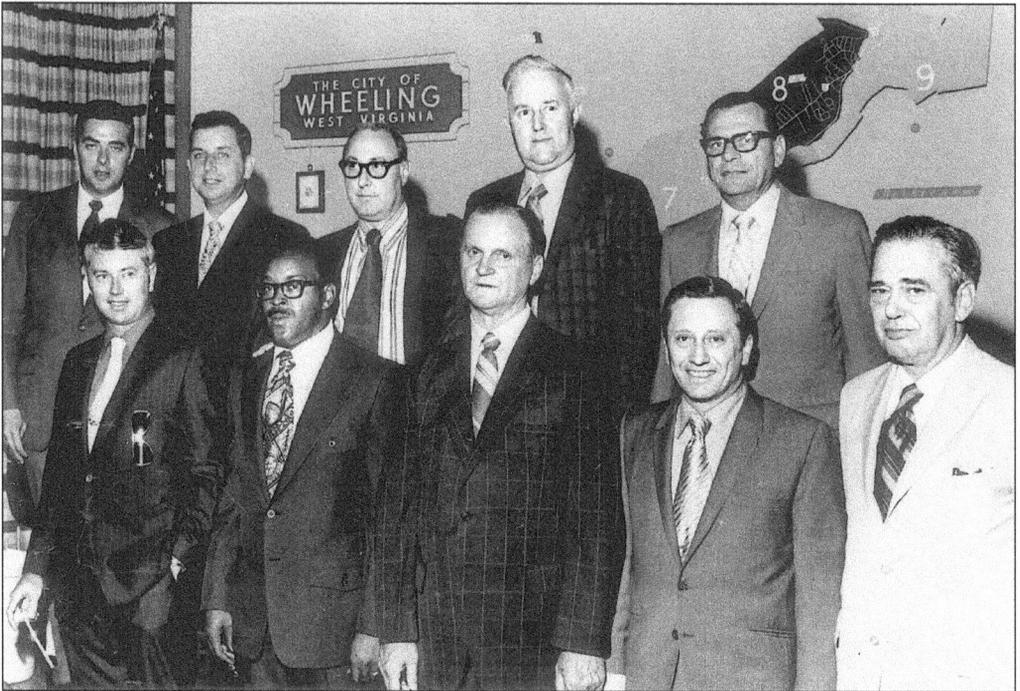

CLYDE THOMAS, CITY COUNCILMAN, JUNE 1971. Clyde Thomas served as Wheeling's first African-American city councilman. Pictured here, from left to right, are (front row) Bill McNeil, Clyde Thomas, Stanley Wojick, James Haranzo, and Judge McClure, who swore in new council members; (back row) Jerry Bender, Jack Fahey, Edward Berardinelli, Bill Muegge, and Bill Hastings. (Courtesy of Anne Thomas.)

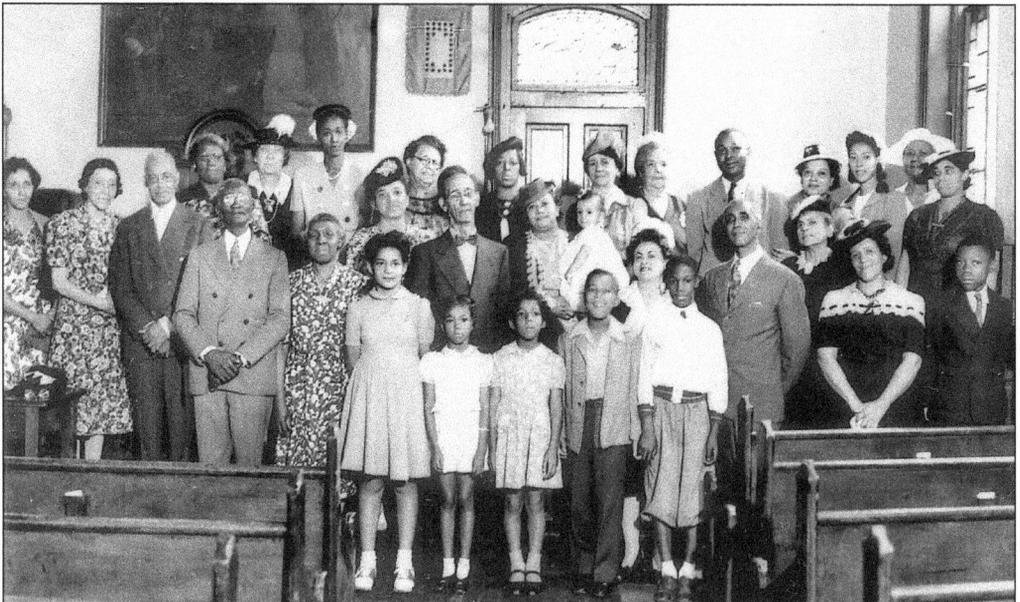

WAYMAN A.M.E. CHURCH, C. 1946. This church was destroyed in 1960 to make way for the Wheeling I-70 Tunnel. Reverend Harris is the man in the back row on the right side. (Courtesy of Anne Thomas.)

Two

ON THE TOWN

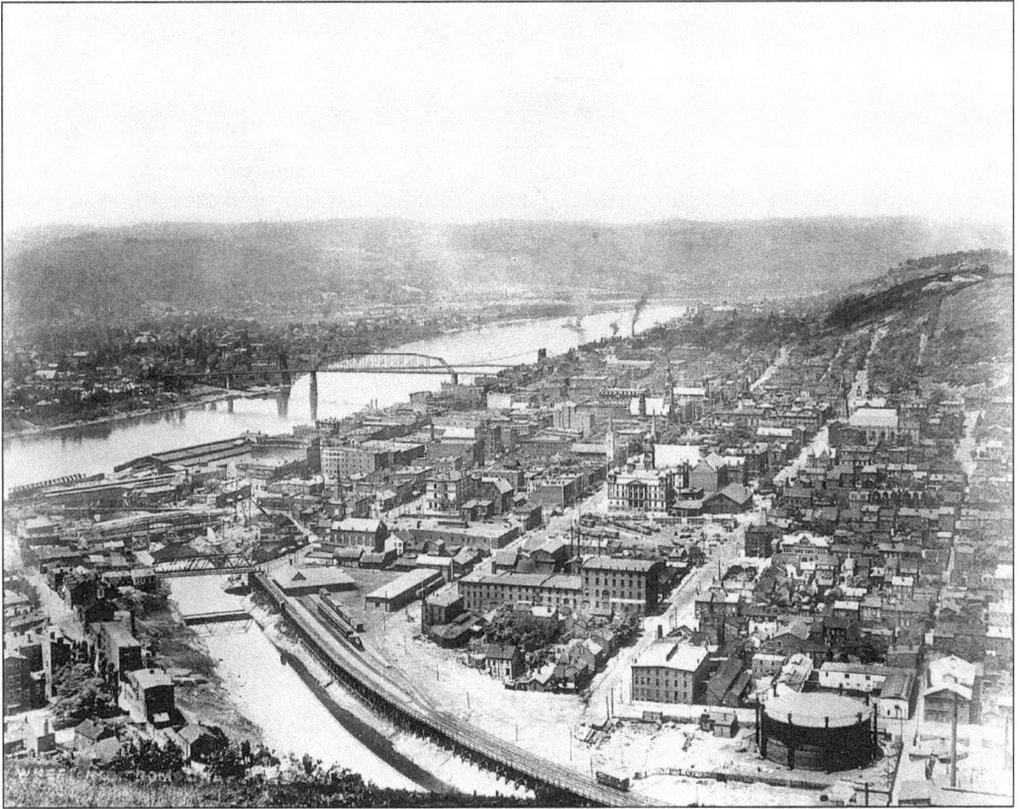

DOWNTOWN WHEELING FROM CHAPLINE HILL, 1890. During this time period, Wheeling was the transportation and industrial center for the state of West Virginia. The area had a powerful influence in several diverse industries including tobacco, cut nails, glass, iron, coal, and calico fabric. Wheeling's citizens will notice that the photo was taken before the construction of such landmarks as the Hawley Building, the Fort Henry Bridge, the Ohio Valley General Hospital, and the B&O Railroad terminal.

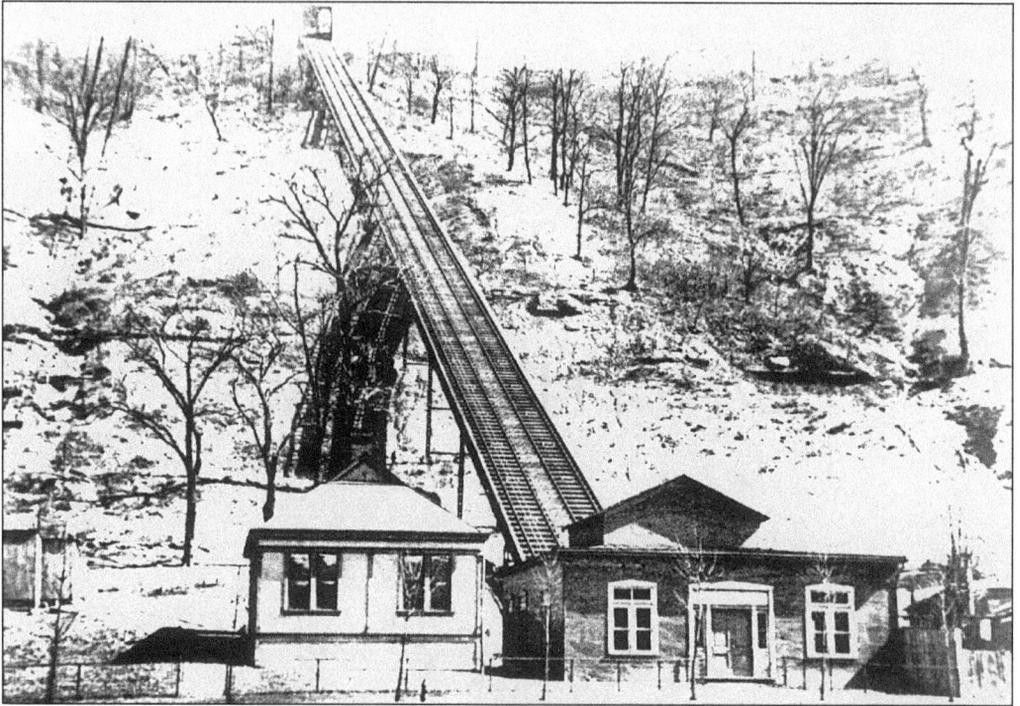

MOZART PARK INCLINE. The incline was built by local brewer Henry Schmulbach to bring patrons up the hill to his park. It opened in August 1893. By November of the same year, it was so popular that it ran every two minutes and handled 1,200 passengers an hour. The incline closed in 1907.

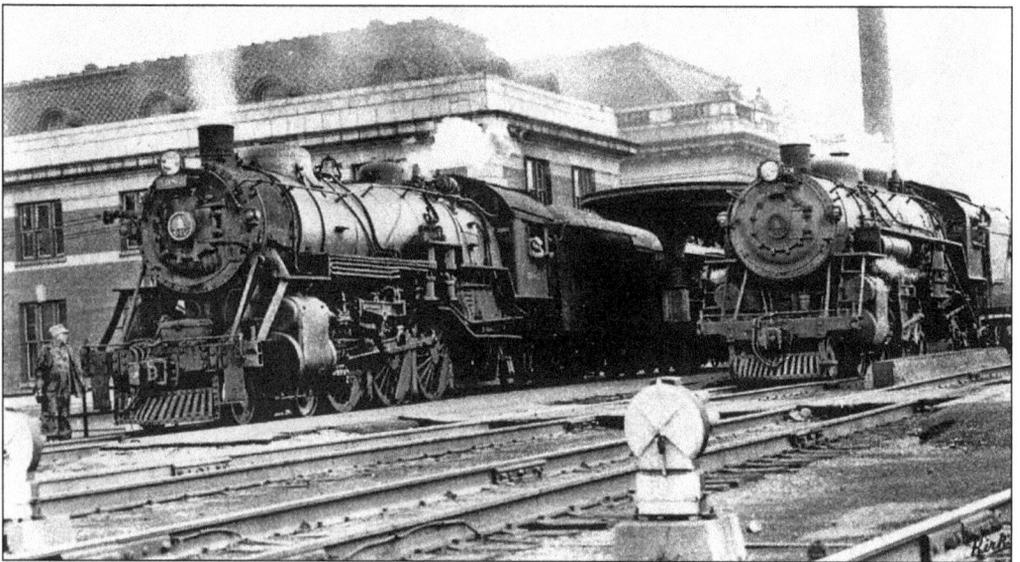

BALTIMORE AND OHIO RAILROAD. The B&O Railroad ran from Cumberland, Maryland to Wheeling. It was completed on December 24, 1852. Exactly 113 bridges had to be built and 11 tunnels were dug to connect the two cities. The Irish Potato Famine of 1845 to 1847 resulted in readily available immigrant labor. From Cork, Connaughton, and Killarney came capable, tough, spirited workers. (Courtesy of Kirk's Photo.)

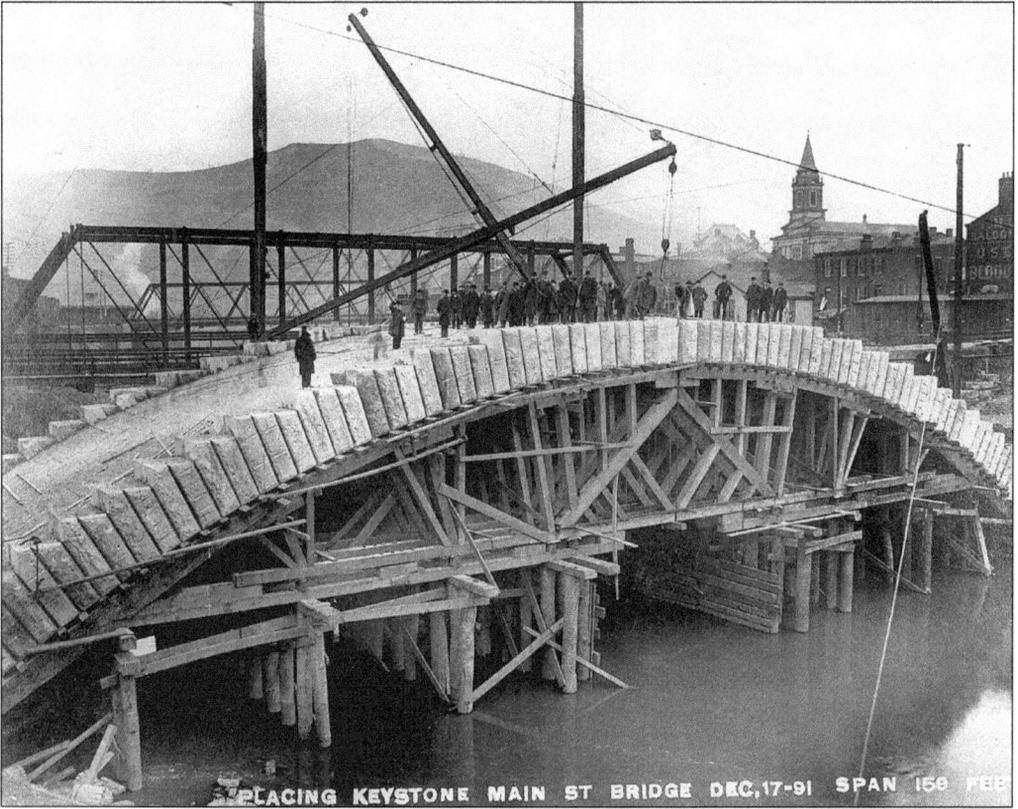

MAIN STREET BRIDGE. The men are placing the keystone on the Main Street Bridge on December 17, 1891. This 159-foot bridge carried goods and traffic over Wheeling Creek. Notice the West Virginia hill in the distance, which has almost all of the trees removed. At that time, lumber was used to fuel the trains, steamboats, and mills. Most of the hills around Wheeling had been deforested. (Courtesy of Kirk's Photo.)

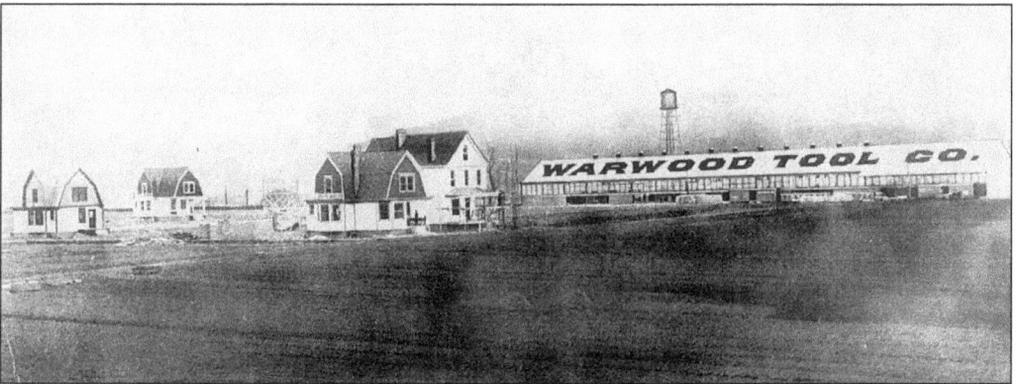

WARWOOD TOOL COMPANY. In 1854, a young Englishman, Henry Warwood, came to Martins Ferry, Ohio to begin making tools. In 1892, the business was sold to Daniel L. Heiskell and moved four miles outside of Wheeling to a newly constructed plant. The suburb of Warwood took its name from the neighboring plant. The houses in the picture were built for the managers of the plant.

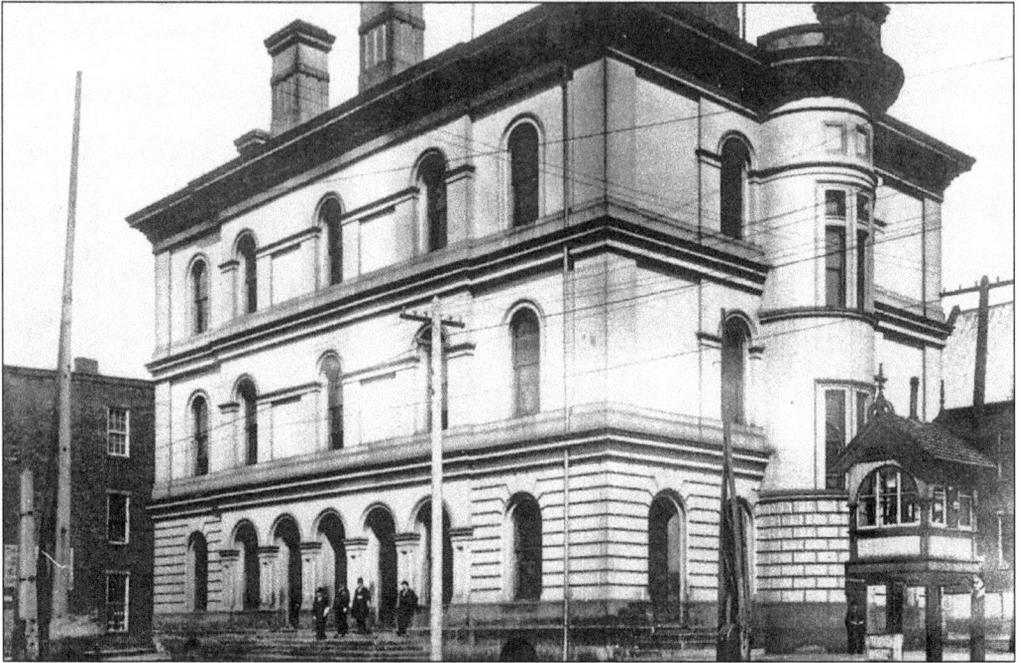

WEST VIRGINIA INDEPENDENCE HALL. Independence Hall, completed in 1859, served as a custom house, post office, and federal court. It is considered the birthplace of West Virginia because during the Civil War it was the site of a series of events leading up to the state's creation. Restored with period rooms and exhibitions, it is registered as a National Historic Landmark. (Courtesy of Kirk's Photo.)

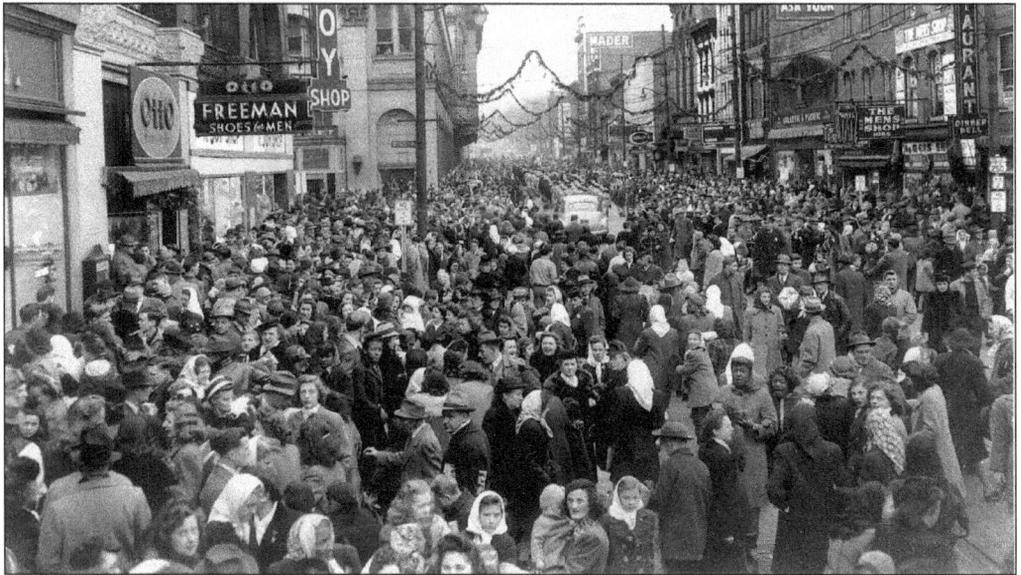

BUSY WHEELING STREET, DECEMBER 1948. This photo was taken following a Christmas parade from 10th and Market Street. Notice how every man wears a hat and most women are wearing scarves. After looking at this picture for quite some time, I found my grandmother, Dorothy Parshall in the lower left-hand corner. Can you see anyone that you know? (Courtesy of Gary Zearott, Zee Photo.)

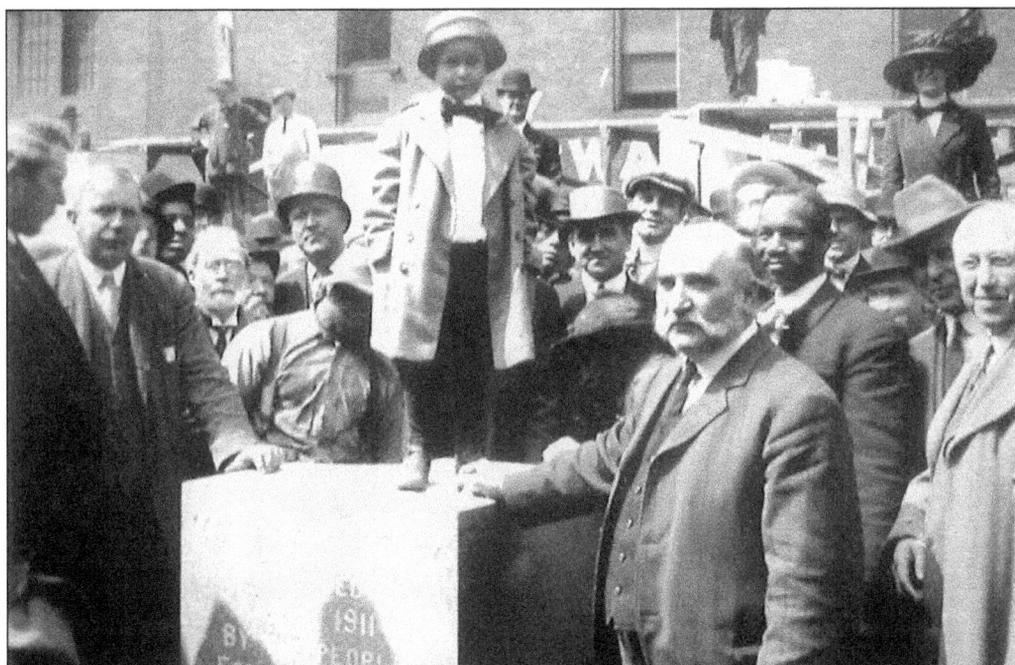

CORNERSTONE, MARKET AUDITORIUM, 1911. This photo postcard shows the arrival of the cornerstone for the Market Auditorium. The man with his hand on the stone is George W. Lutz and to his left is Ray B. Naylor. The stone reads "Market Auditorium, Erected AD 1911, By The People, For The People." (Courtesy of the Archives and Special Collections of the T.W. Philips Library Archives, Bethany College.)

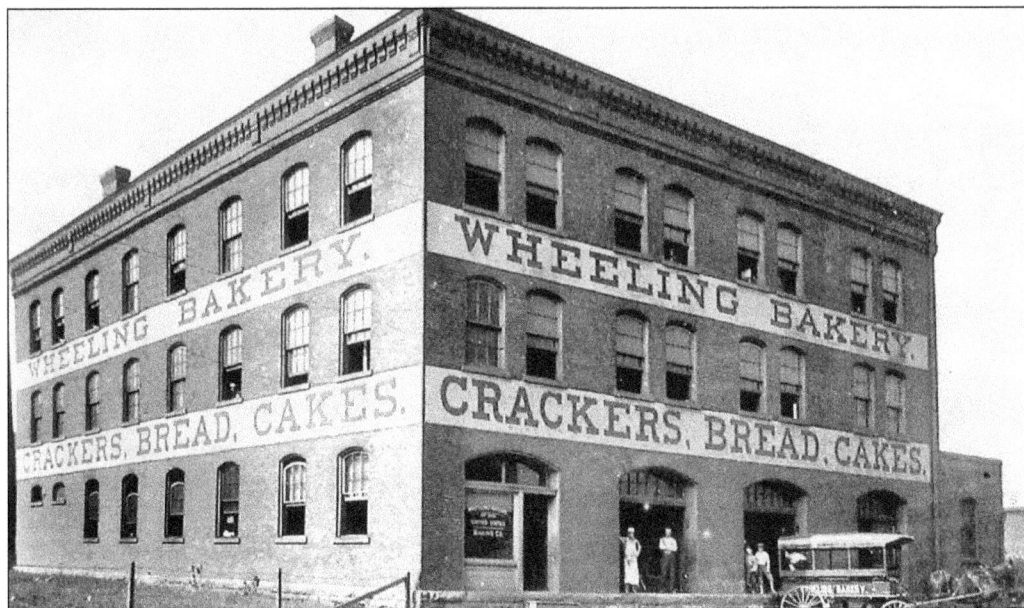

WHEELING BAKERY, C. 1900. The Wheeling Bakery was founded in 1881 and was a part of S.S. Marvin & Company until it merged with the United States Baking Company in 1890. The bakery was located at No. 1230 Market Street. Notice the horse-drawn wagon that delivers the daily fresh baked bread. (Courtesy of Betty June Weimer.)

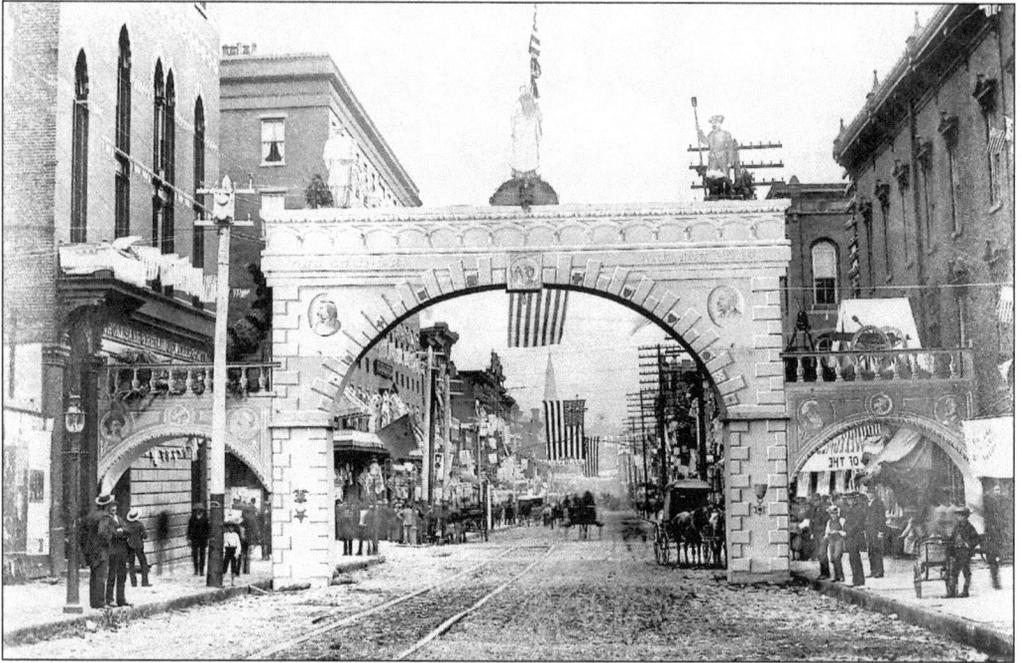

GRAND ARMY OF THE REPUBLIC ARCH, 1888. This arch was erected at the corner of Market and 12th Streets for the reunion of the Grand Army of the Republic. The ceremony included a parade and many patriotic speeches. (Courtesy of Gary Zearott, Zee Photo.)

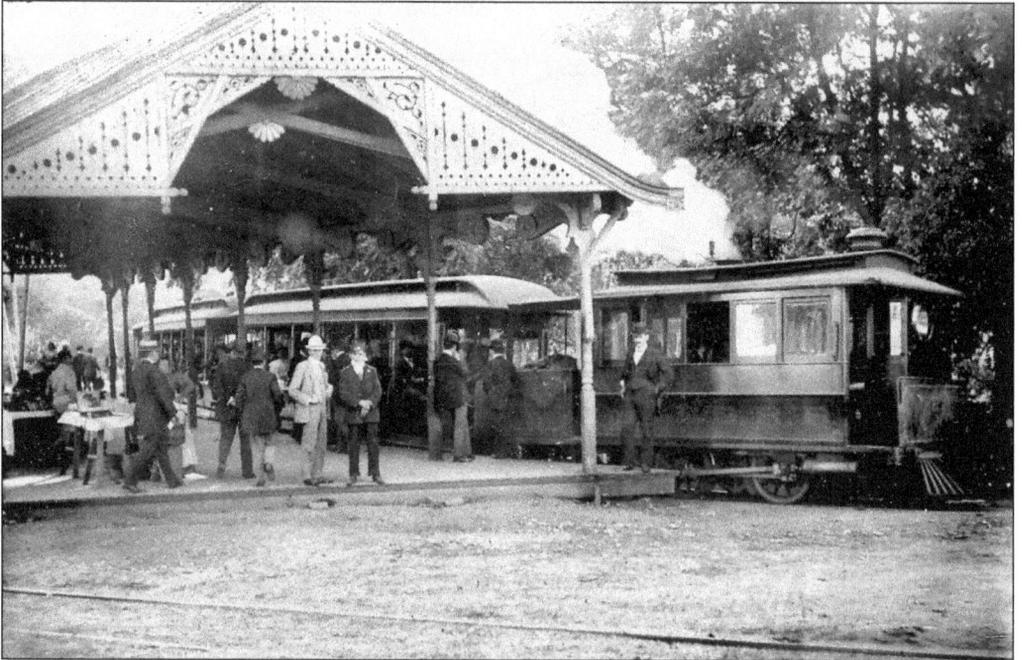

HORNBROOK PARK TRAIN STATION, WHEELING PARK, 1897. Hornbrook Park would later be named Wheeling Park. Trains such as the one pictured above operated from 1883 to 1898. This train carried people to and from Wheeling Park in style. Notice the conductor and the well-dressed gentleman peering at the photographer. (Courtesy of Creative Impressions.)

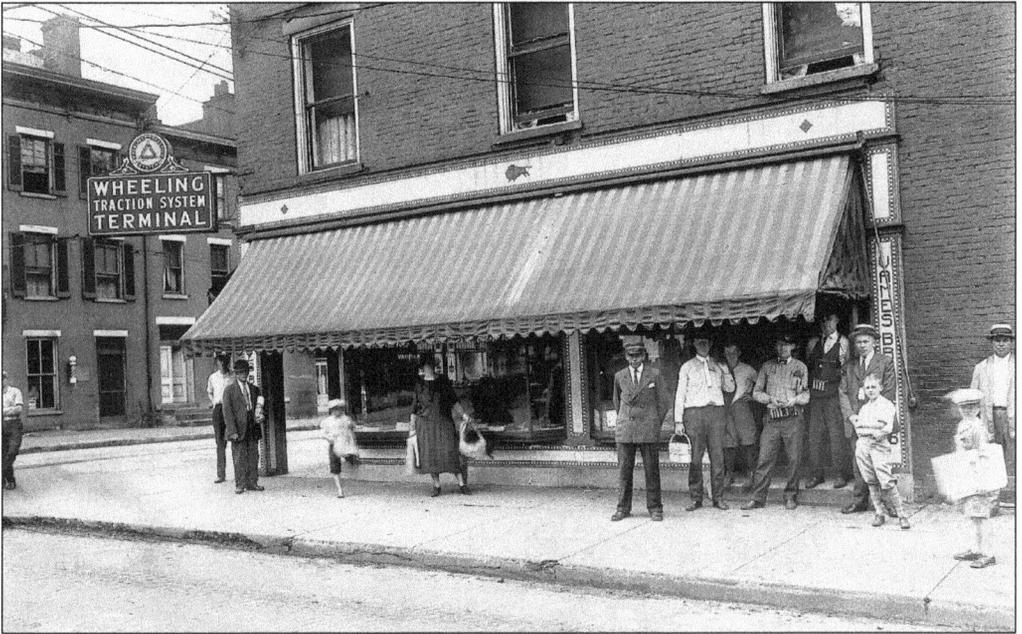

WHEELING TRACTION TERMINAL, C. 1915. In 1863, the Citizens Railway Company brought street railway service to Wheeling. In 1887, it consolidated with the Wheeling Railway Company. Wheeling's first electric cars were the Vanderpool style, which contained the motor in the front of the cab. In 1899, the Wheeling Railway Company became the Wheeling Traction Company. This terminal was at 10th and Main Streets. Did you notice the one-legged girl, the man with the salami, the metal lunchbox, or the newsboy? (Courtesy of Kirk's Photo.)

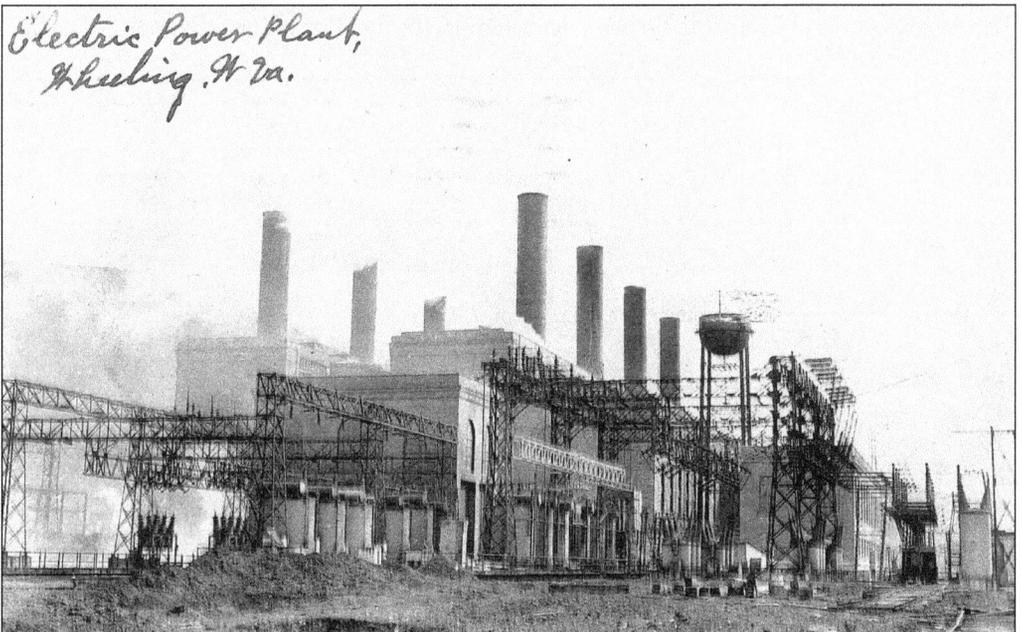

ELECTRIC POWER PLANT. The second electric power plant in the nation was located in Wheeling. It would have been the first, but Thomas A. Edison brought a lawsuit in Federal Court claiming it infringed on his patents. This plant was located in South Wheeling.

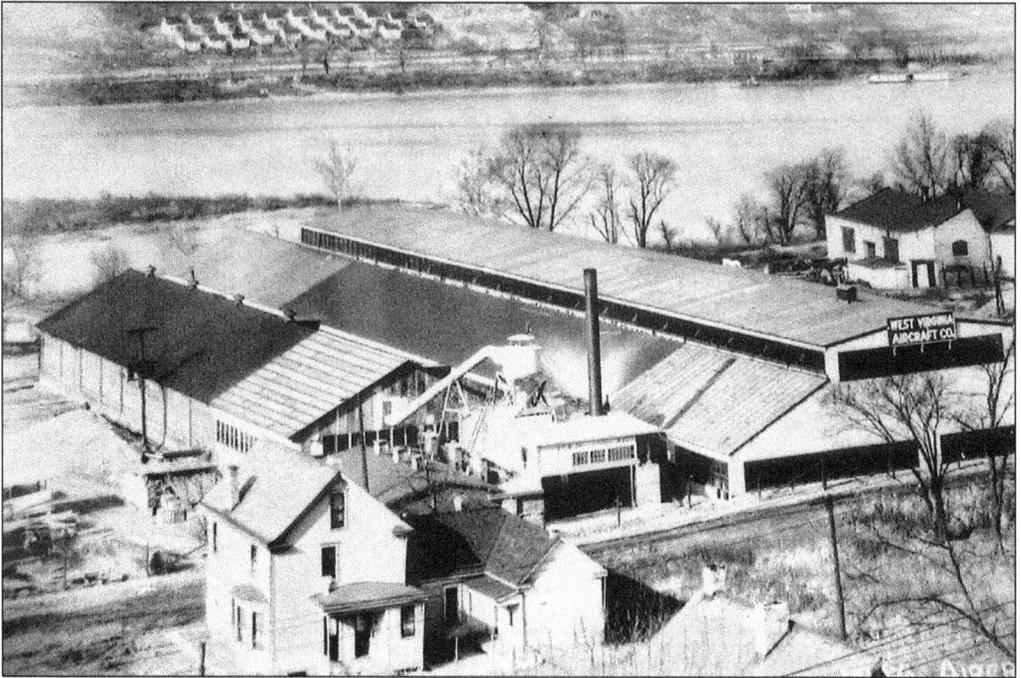

WEST VIRGINIA AIRCRAFT COMPANY, NOVEMBER 1918. This company was formed by Louis Bennett and his brother-in-law, Johnson McKinley around 1917. It was located on Hess Avenue in Warwood. This company made aircraft parts for British airplanes, including the SE5 and the Sopwith Dolphin during WWI. Louis Bennett was himself a fighter ace with three planes and nine balloons to his credit. He was shot down in aerial combat over France in August 1918. The Aviator statue at Linsly Military Academy honors the memory of Louis Bennett. (Courtesy of David McKinley.)

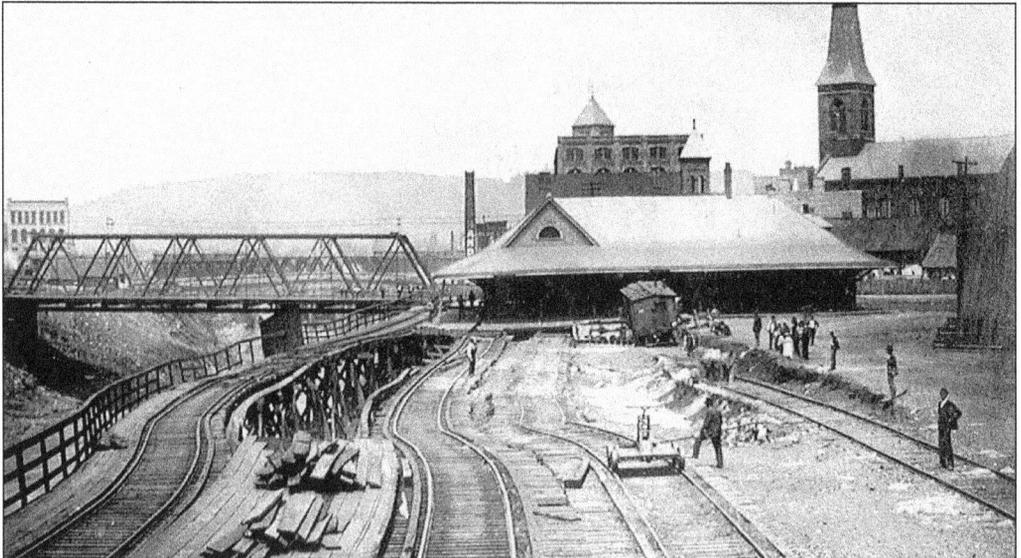

WHEELING TRAIN STATION. The Wheeling Train Station was still under repair at this time and workers can be seen on the right. Notice the dramatic bend in the end of the tracks. It was located at 1902 1/2 Market Street. (Courtesy of Betty June Weimer.)

BAER GROCER CO. The Baer
Grocer Company sat at 1600 Main
Street and contained a wholesale
grocer's office and a warehouse.
B.S. Baer was the president and
Jos. H. Baer was the secretary.
Sadly, today this unique building
has a sign that says offices for rent.
(Courtesy of Betty June Weimer.)

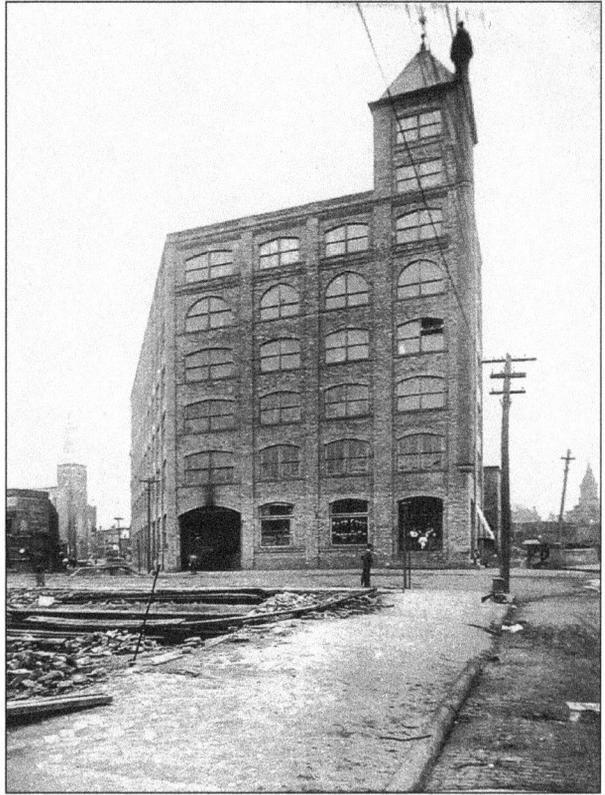

ZANE COVERED BRIDGE. This bridge stretched from Wheeling Island to Bridgeport.
Construction was started by Noah Zane in 1833 and completed in 1837. (Courtesy of
Kirk's Photo.).

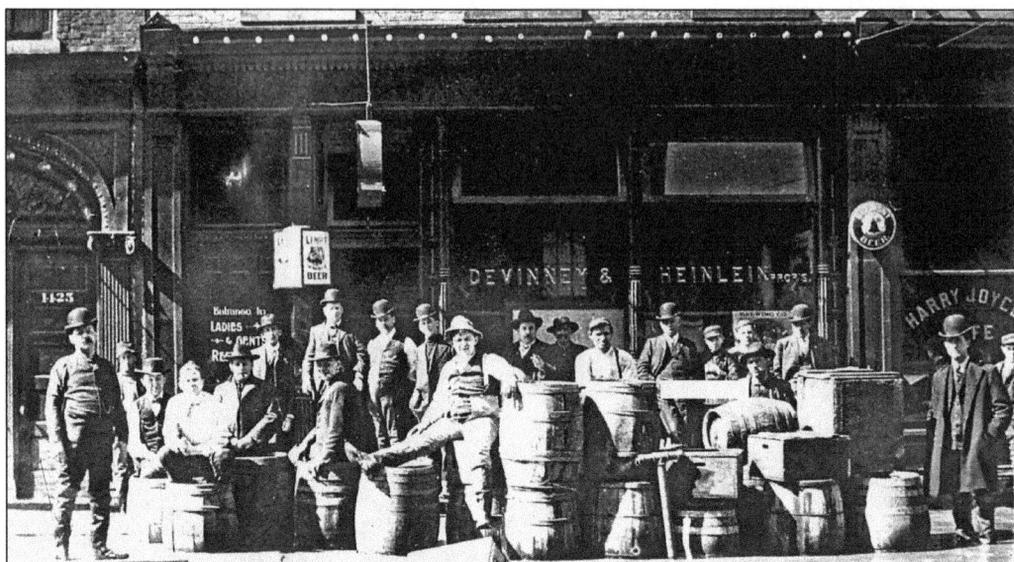

DEVINNEY & HEINLEIN SALOON, 1885. Wheeling was festooned with saloons around the turn of the century. Travelers about to head West on the National Road or those stopping briefly from a steamboat journey wanted to quench their thirst. Wheeling was more than ready to fulfill their needs. (Courtesy of Herb Bierkortte.)

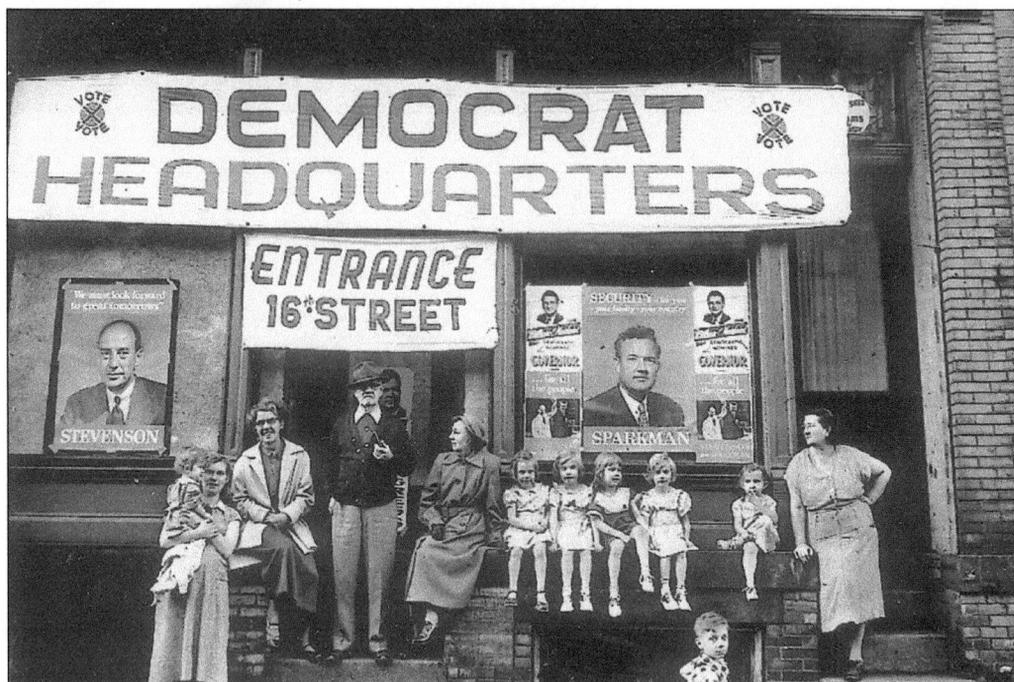

DEMOCRATIC HEADQUARTERS, 1952. This photo was taken on 16th Street during the presidential campaign of Illinois governor Adlai Stevenson and his running mate, Alabama senator John J. Sparkman. Although Wheeling had many Democrats in its midst, it was not enough to help this tag-team. The writing above Senator Sparkman's picture speaks to the Cold War tension of the day. It reads, "SECURITY for your family—your country." (Courtesy of Margaret Brennan.)

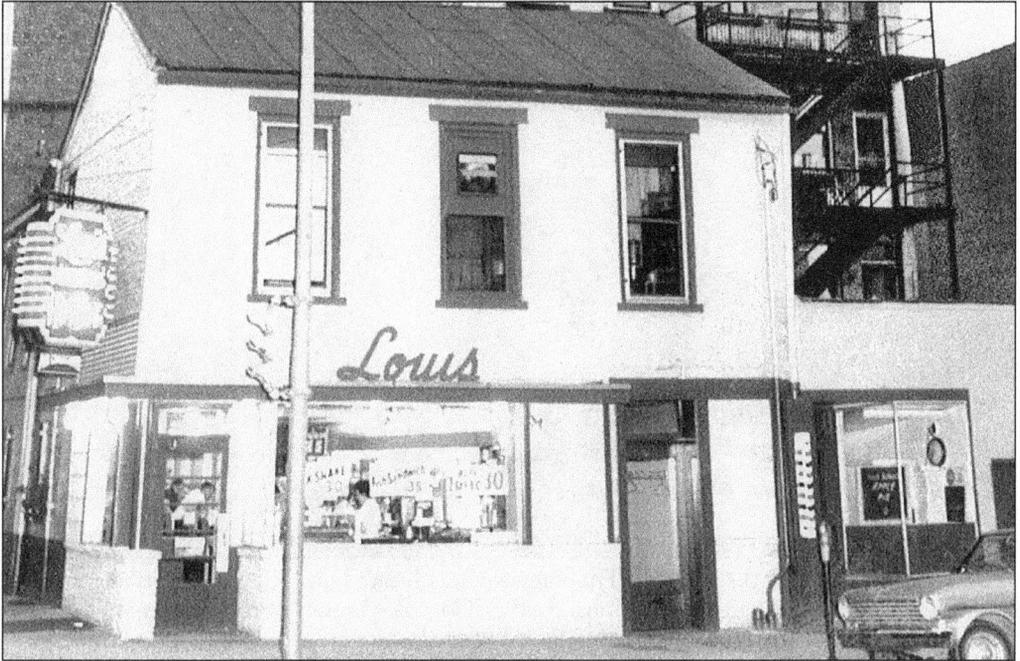

LOUIS HOT DOGS. This locally famous hot dog joint was at the corner of 11th and Chapline Streets. The Mamakos family has since moved this eatery to 8 Elm Terrace Shopping Plaza. Notice the signs that say, "Fish sandwich 35 cents and milkshake 30 cents." (Courtesy of Virginia Mamakos.)

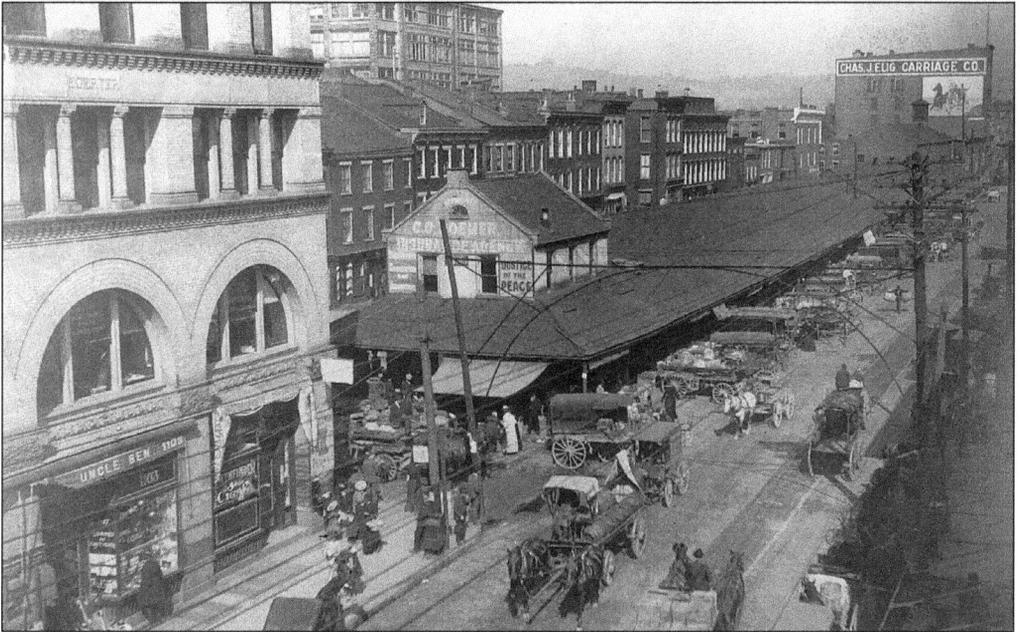

DAY AT THE MARKET, SATURDAY OCTOBER 1, 1901. The market was a vibrant place to buy almost anything. Notice the man walking down the street to the right carrying two barrels. Try to count all the wagons and imagine just how busy this place must have been on a Saturday afternoon. (Courtesy of Harry Parshall.)

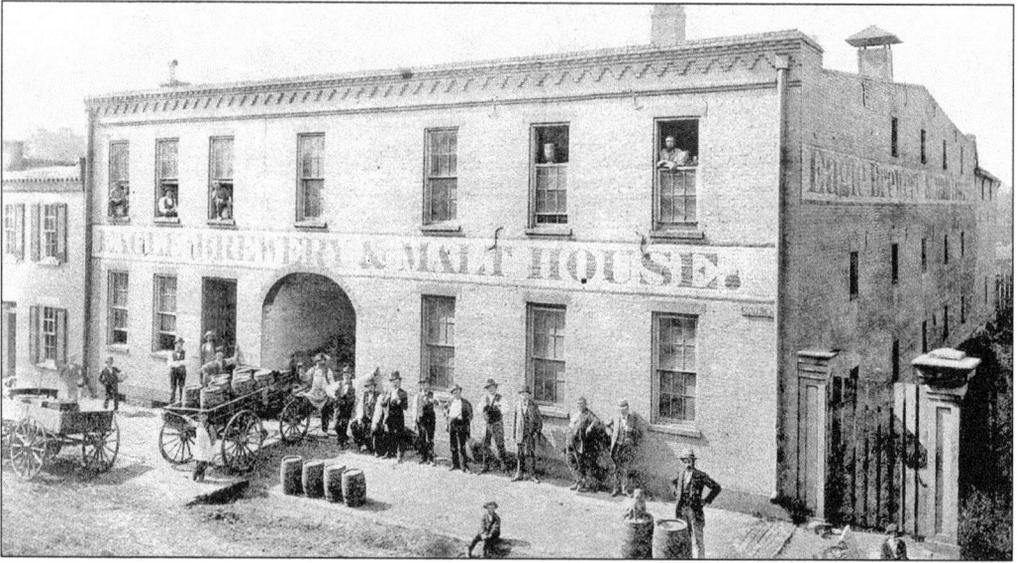

EAGLE BREWERY & MALT HOUSE. This brewery was located at 1425 South Street near the B&O depot. It was built in 1863 by John Reid & Co. Malt houses were listed in Wheeling as early as the 1850s. Local brew historian, Albert Doughty, stated that a partial list of breweries in Wheeling included the following: Franklin Brewery, Reymann Brewery, Beck Brewery, Market Street Brewery, North Wheeling Brewery, John J. Kenney Brewery, French Brewery, and Smith Brewery. Today the area has the River City Ale Works, which is upholding our proud and intoxicating tradition. (Courtesy of Betty June Weimer.)

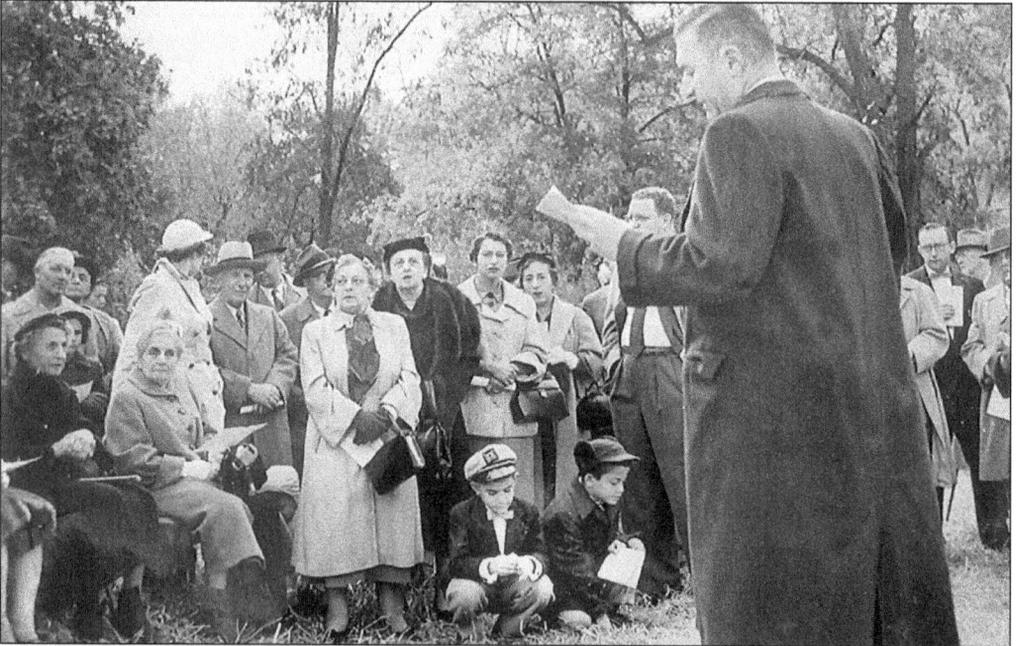

GROUNDBREAKING TEMPLE SHALOM, OCTOBER 1957. Approximately 150 people turned out to see Rabbi Joseph H. Freedman speak at the ground breaking of Temple Shalom at Bethany Pike and Edgewood Street. In 1998, Temple Shalom celebrated 150 years of Wheeling's Jewish Community. (Courtesy of Temple Shalom.)

Three

ON THE RIVER

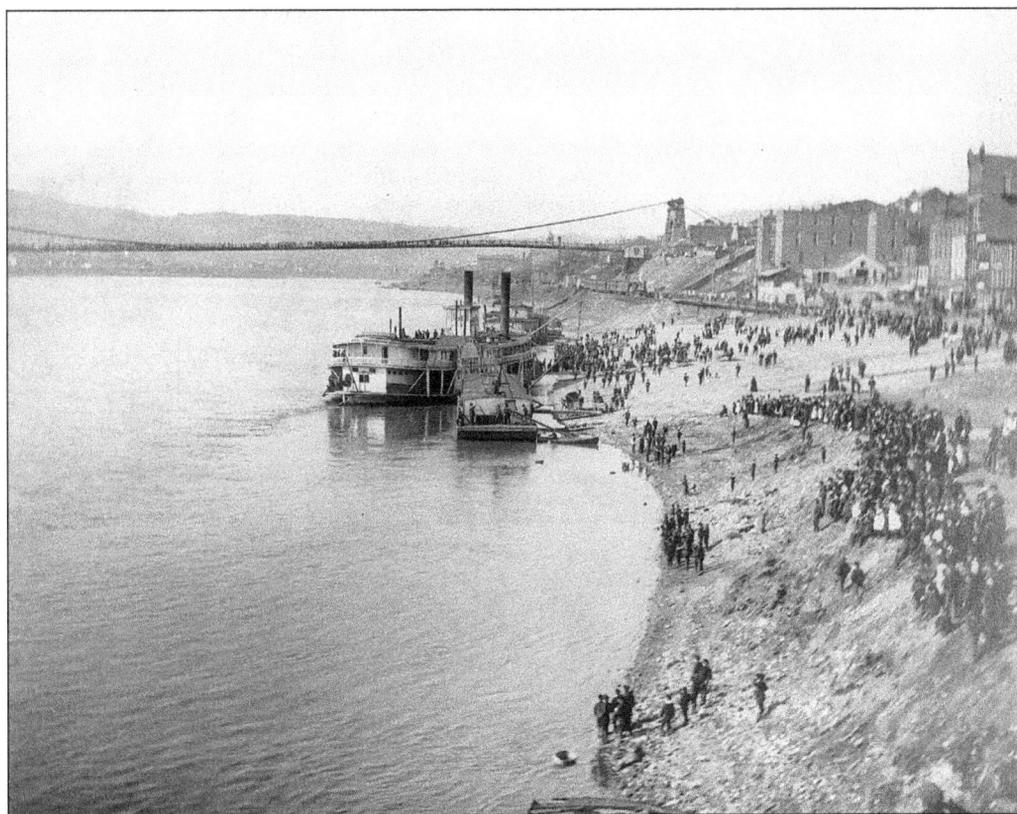

LONG DISTANCE SWIMMER, OHIO RIVER. On February 20, 1879, Captain Paul Boyton swam a distance of 90 miles from Pittsburgh to Wheeling in a "gum suit." The Wheeling crowds rushed to the riverbank to witness the finish of this remarkable athletic feat. This would have been before the Lock Island Dam was built. (Courtesy of Kirk's Photo.)

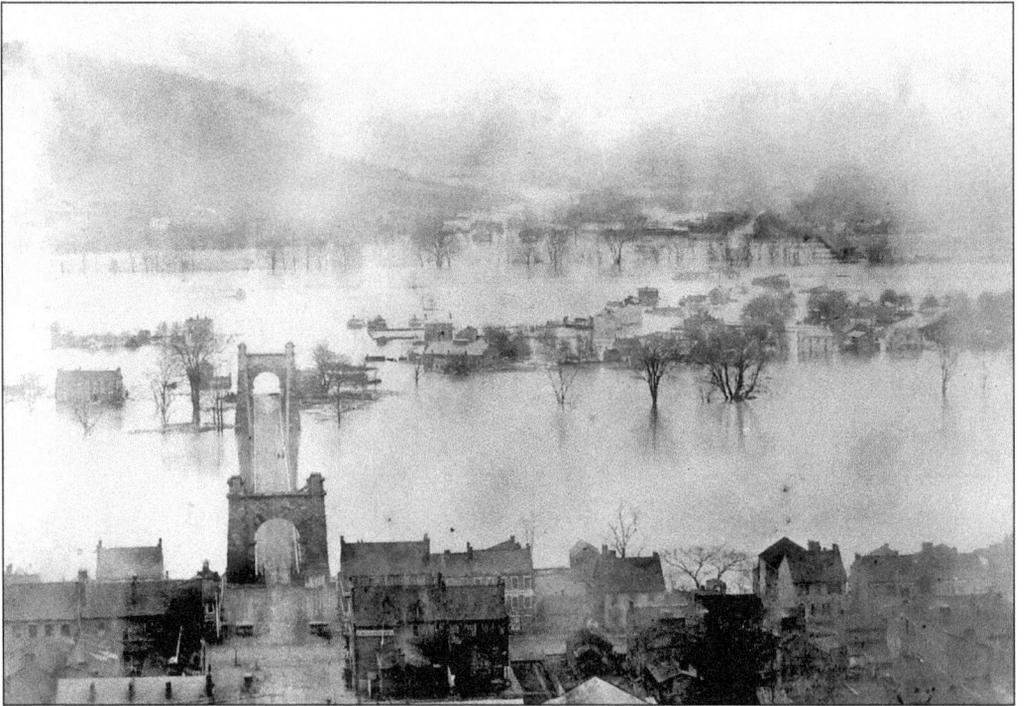

FLOOD OF 1852. This is believed to be the oldest existing photograph of Wheeling. This unique view was copied from an old daguerreotype made during the flood of 1852. The view is of 10th and Main Streets and a submerged Wheeling Island. A Conestoga wagon can be seen at the bottom. (Courtesy of Gary Zearott, Zee Photo.)

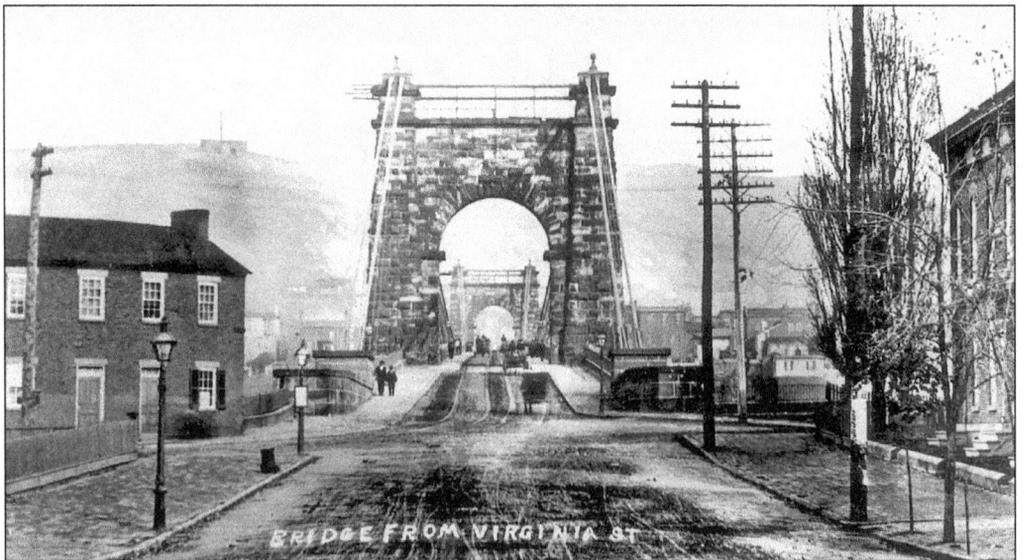

SUSPENSION BRIDGE FROM VIRGINIA STREET, 1890. The Suspension Bridge was designed by Charles Ellet Jr. and was finished in 1849. It is a National Historic Landmark, an American Society of Civil Engineers Landmark, and is listed with the International Council of Monuments and Sites. The house on the right was constructed in the 1880s. Notice the gas lamp posts and the dirt road. (Courtesy of Ohio County Public Library.)

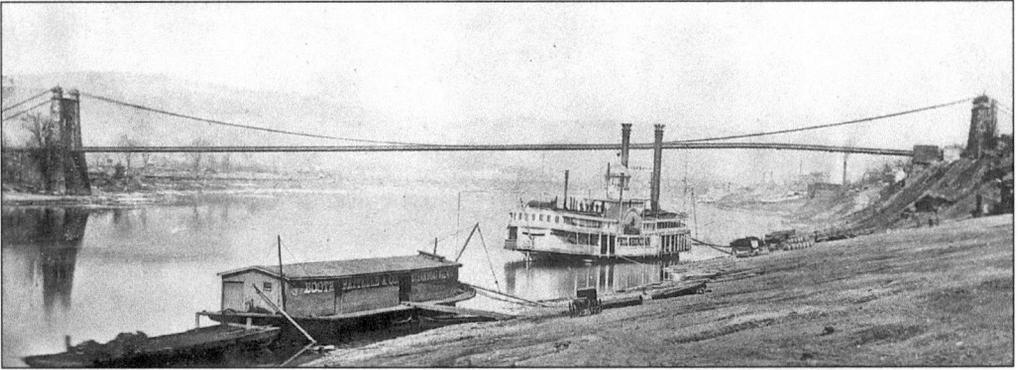

PHIL SHERIDAN, 1866. This mighty steamboat is at the Booth Battelle & Co. Wharf boat. This spot is assumed to be near the place where Lewis and Clark came ashore on September 7, 1803. They called Wheeling "a pretty considerable village of 50 houses." They picked up rifles and ammunition and dined with Dr. William Patterson. The men agreed to take the good doctor on their journey; however, the next day the doctor was too drunk and missed the boat.

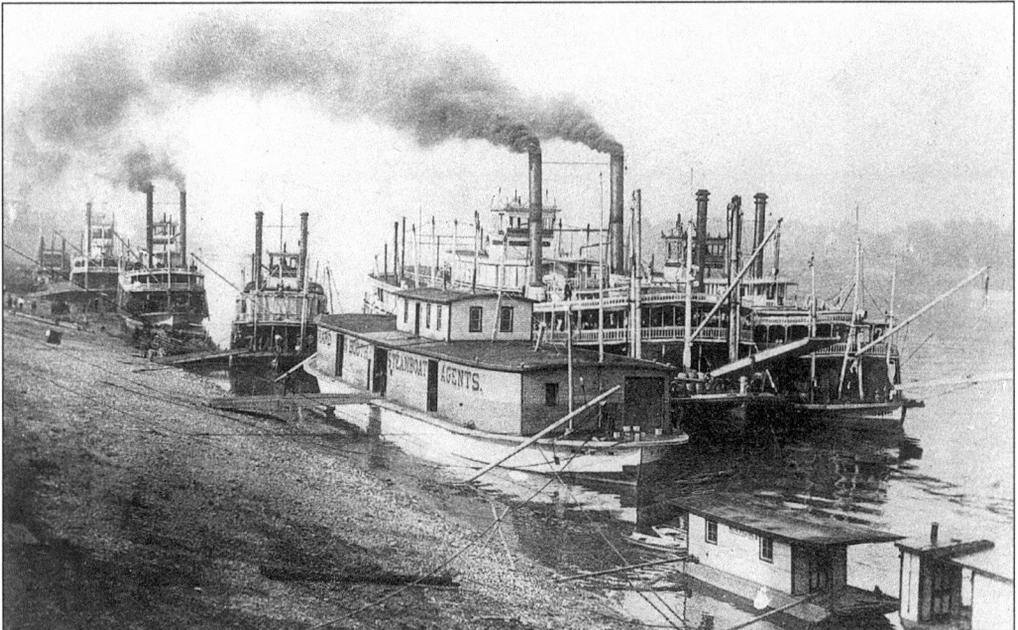

CROCKARD & BOOTH WHARF BOAT, 1910. The following was written on the paper attached to the above photograph, "STR. Virginia second from right. From left, Clerimond, Ben Hur, Lorena, Bessie Smith, Virginia, Ohio."

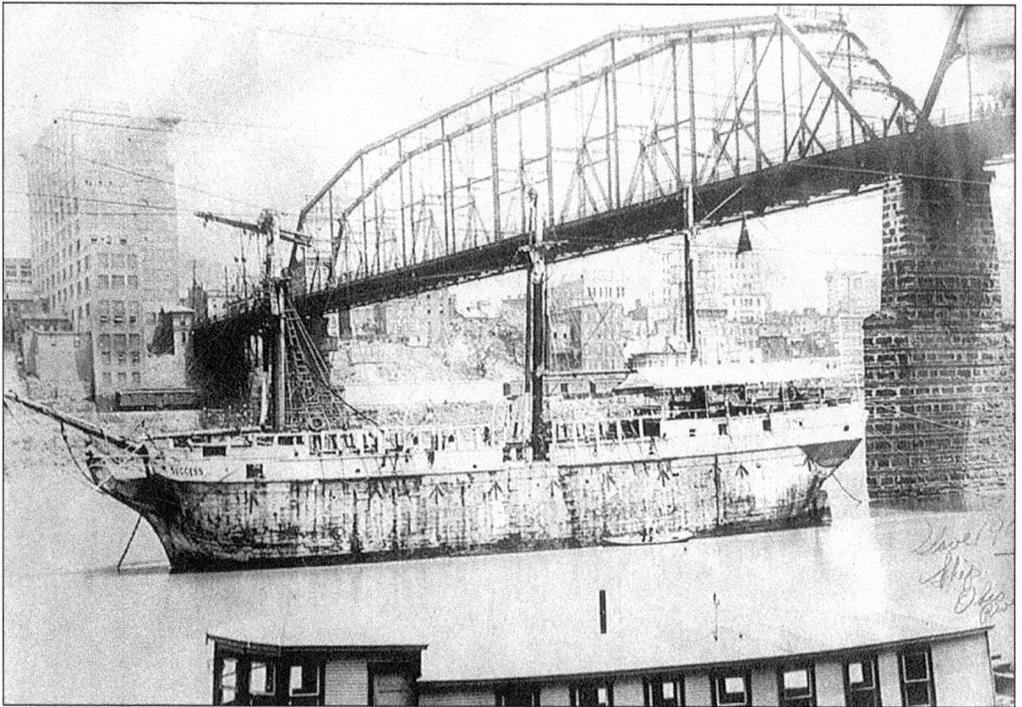

SLAVE SHIP SUCCESS, 1909. The *Success* was a slave ship and later a prison ship. It was built in Australia in 1790. The ship came too close to a local bridge and had to turn back at the last second. (Courtesy of Gene Long.)

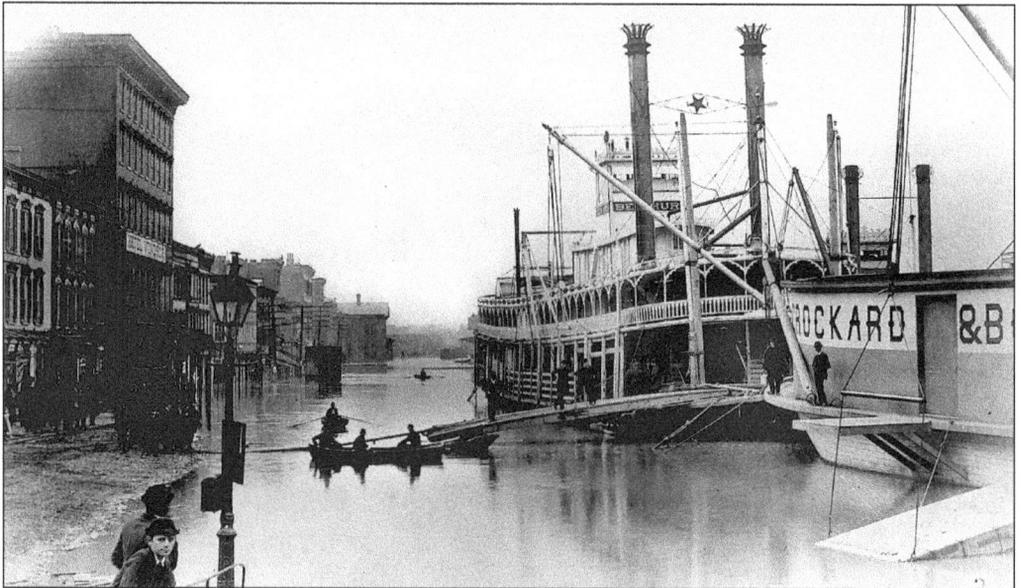

WATER STREET, FEBRUARY 19, 1891. This photo was taken during the flood of 1891. The Hotel Windsor can be seen on the left. The sternwheeler *Ben Hur* is sitting just behind the wharf boat of Crockard & Booth Steamboat Agents. The *Ben Hur* made tri-weekly trips from Wheeling to Parkersburg. In March 1916, she sank at Duckport, Mississippi. (Courtesy of Gary Zearott, Zee Photo.)

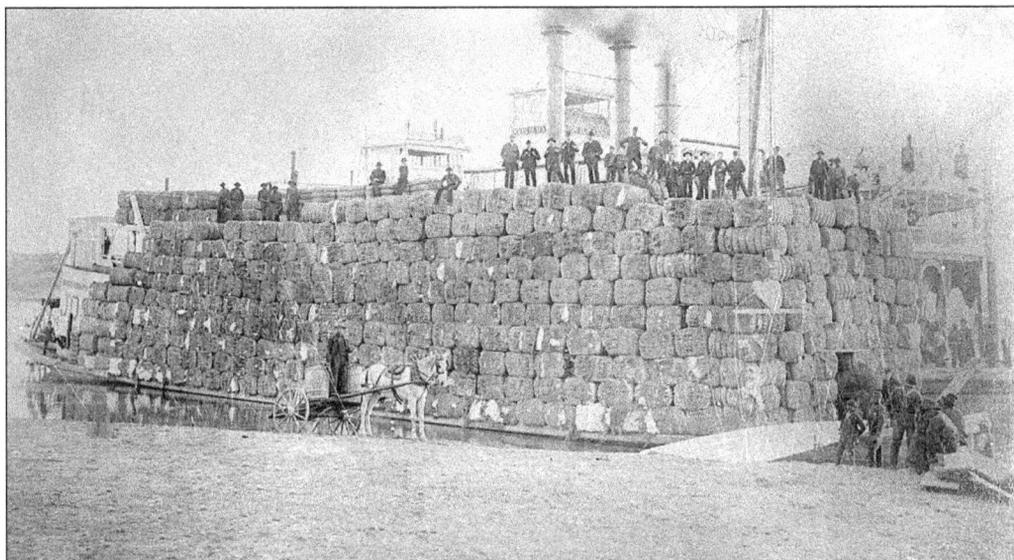

STEAMER JOSIE W. At one time, more cargo passed by Wheeling along the Ohio River each day than went through the Panama Canal. The following quote is from Samuel Cumings in *The Western Pilot*, from the year 1829. "The channel of the Ohio becomes deeper below Wheeling, in so much, that steamboats continue to run as high as this place, they cannot ascend the river above, and it affords a certain navigation for flats and keel boats in the lowest stages of water . . . Flat and keel boats are built here and of late a number of steam boats. There are many reasons to believe that this place will eventually become one of the most considerable on the Ohio." (Courtesy of Gary Zearott, Zee Photo.)

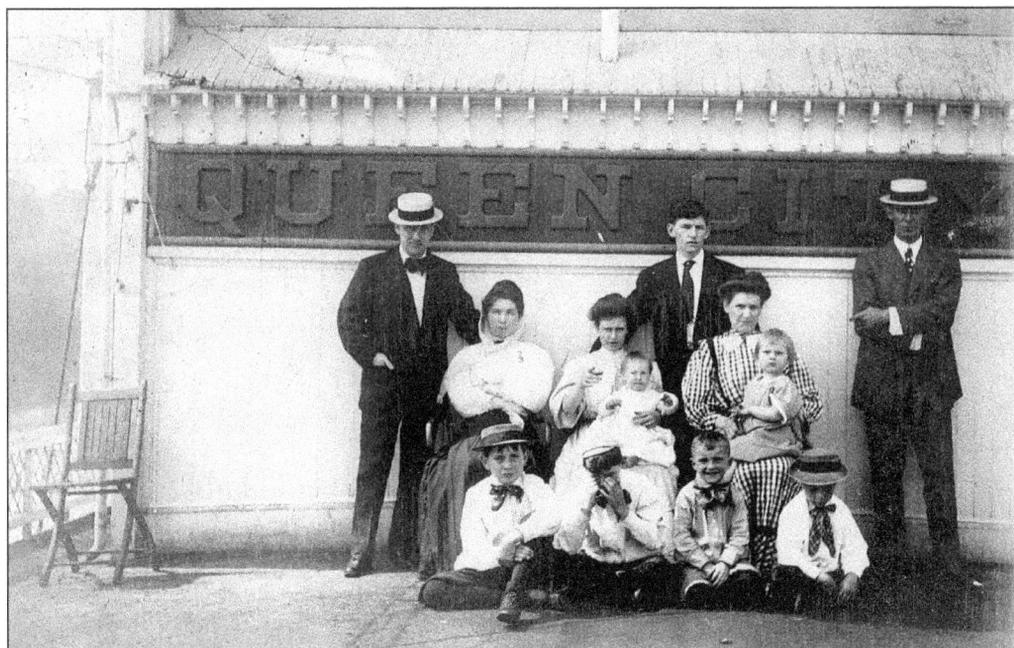

QUEEN CITY STEAMBOAT PASSENGERS. Taking a steamboat to Wheeling was considered high adventure during the Victorian age. These passengers are dressed in their Sunday clothes. Note the captain at the helm.

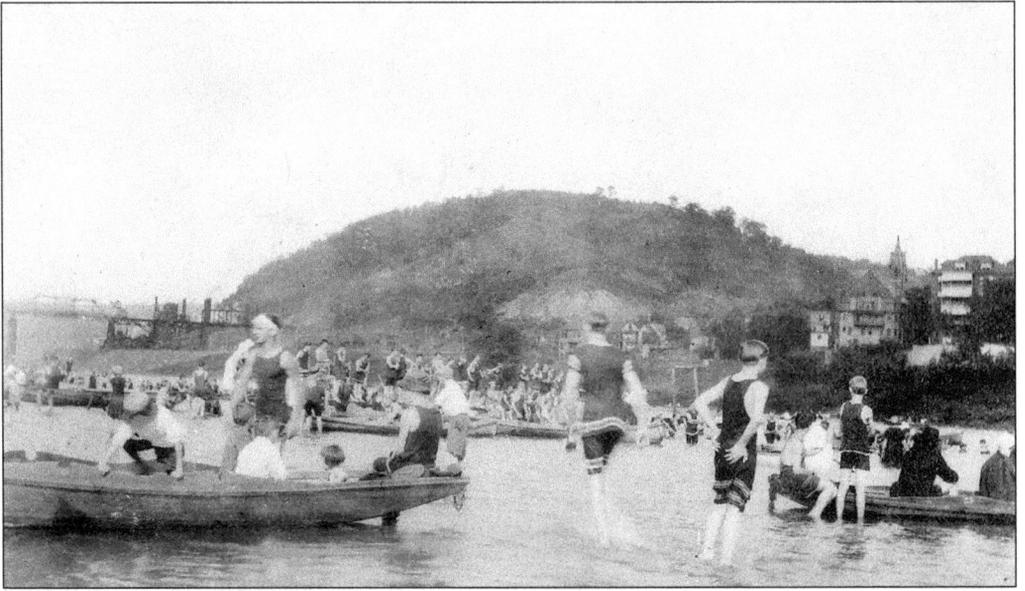

BELLE ISLE, AUGUST 24, 1913. Belle Isle was at the northern end of Wheeling Island and was Wheeling's best swimming beach. Notice the old style swim suits which are very modest compared to the standards of today. (Courtesy of Kirk's Photo.)

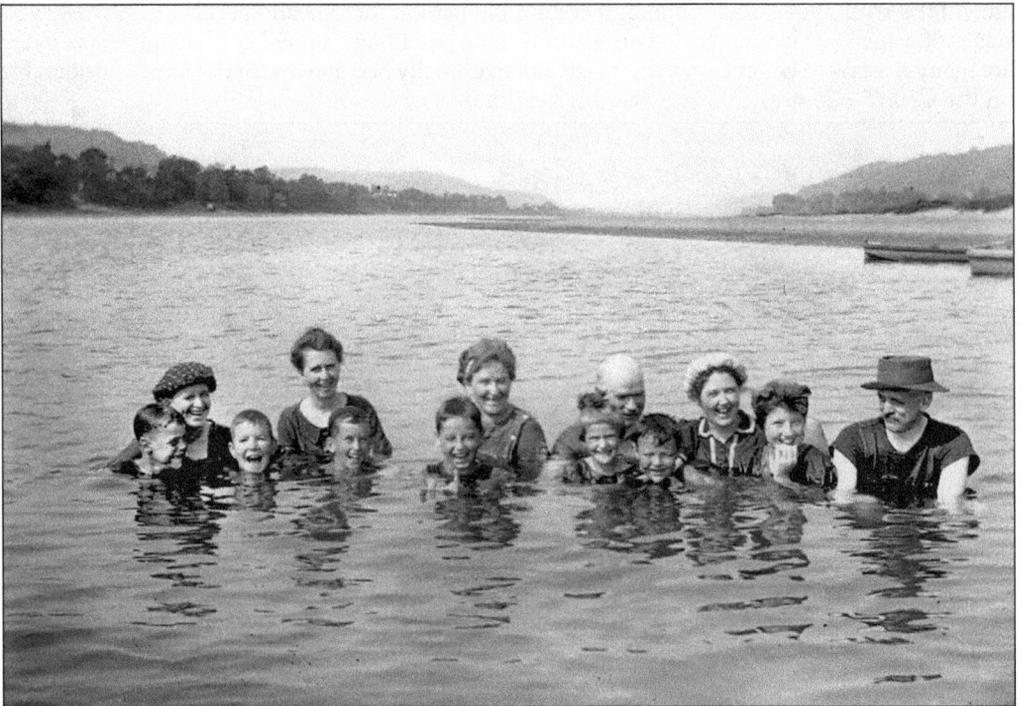

JOHN TURNER'S FAMILY KEEPING COOL, C. 1900. John Turner was a photographer who lived on Fourth Street in Martins Ferry, Ohio. He would bring his family to the Wheeling side of the river when the summers heat became too much to bear. Before the age of air conditioning, the river served not only as a place of commerce but also a natural way to keep cool. (Courtesy of Joseph A. Krehlik Jr.).

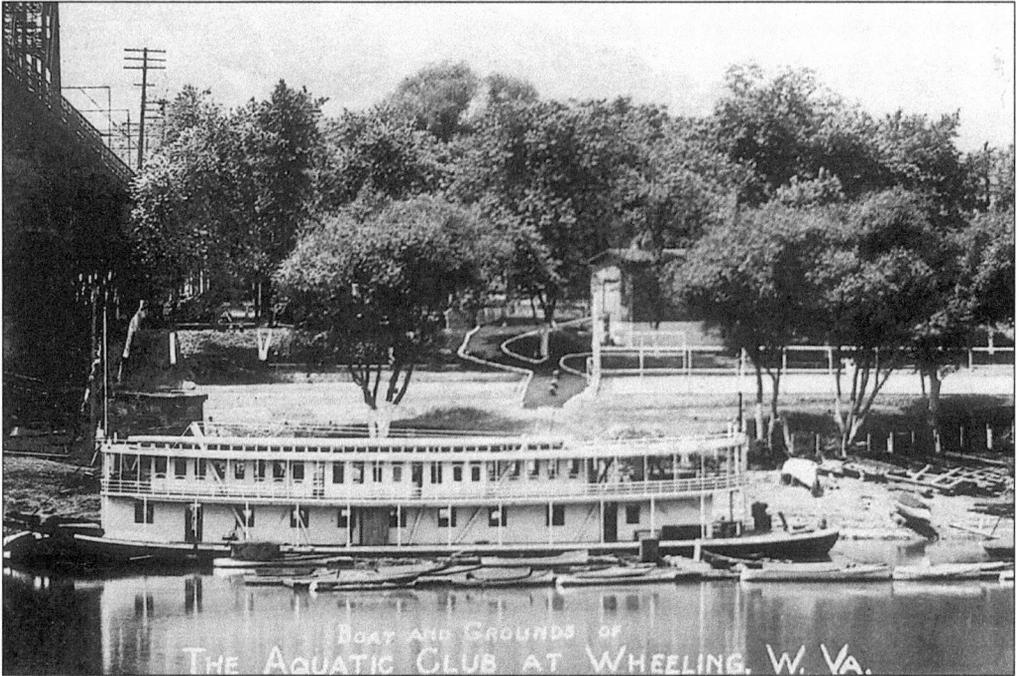

THE AQUATIC CLUB. This photo shows the boats and grounds of the Aquatic Club near the Steel Bridge in Wheeling. Such exclusive clubs were frequented by some of Wheeling's most well-to-do citizens. (Courtesy of Kirk's Photo.)

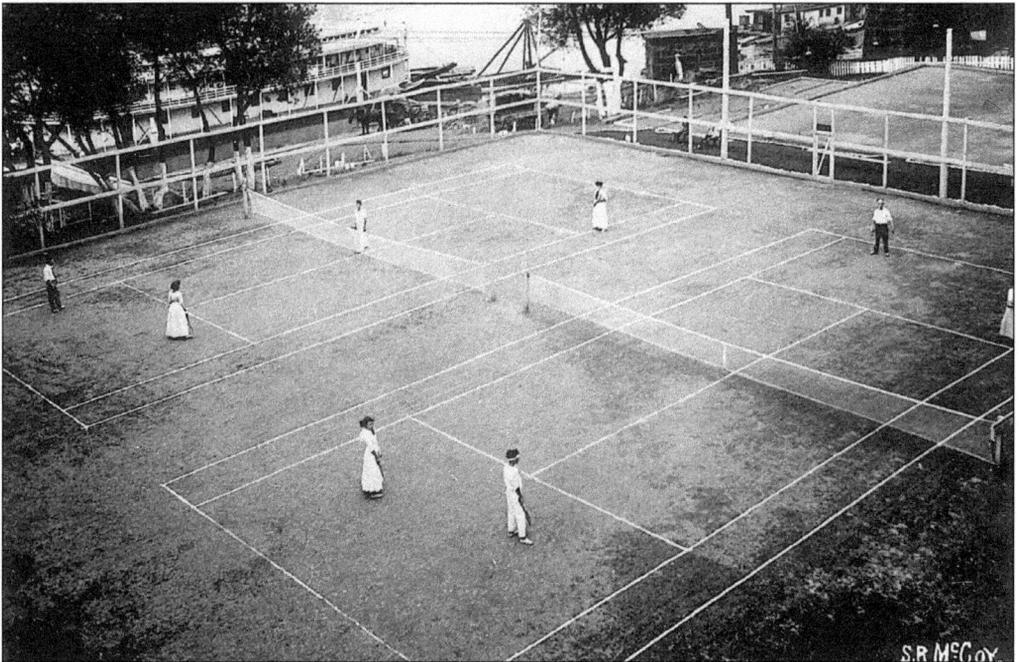

TENNIS COURTS AT THE AQUATIC BOAT CLUB. Boat clubs such as these offered entertainment and sports while were not using their boats. (Courtesy of Kirk's Photo.)

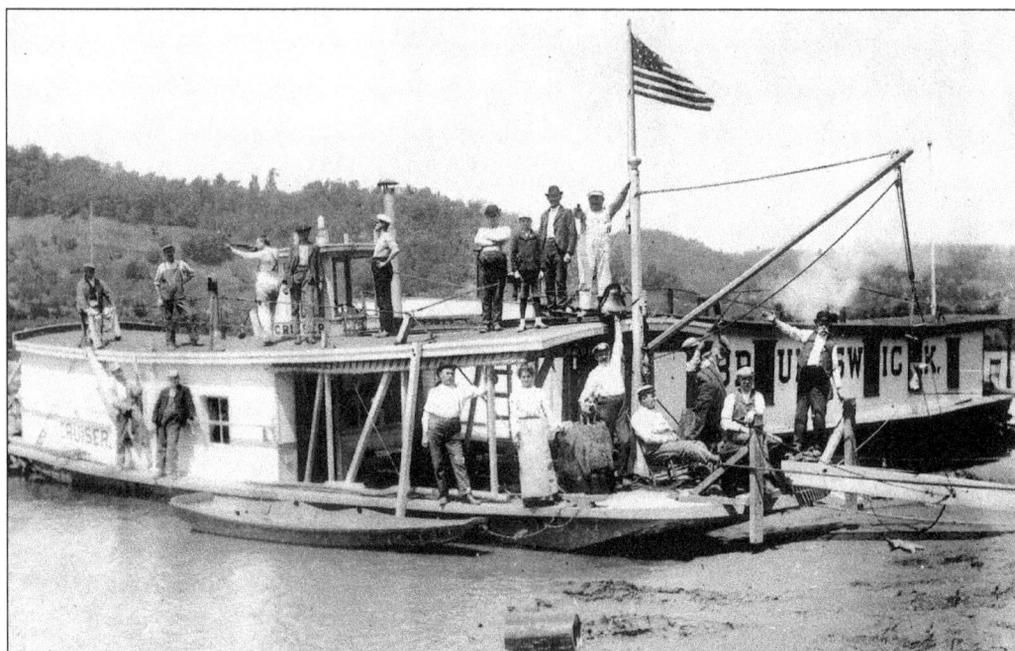

BRUNSWICK BOAT CLUB, C. 1910. These members seem less inclined to play tennis and more inclined to shoot their guns. Notice the man at the base of the flag has just fired his shotgun. The man at the top of the boat is just about to shoot his gun. In the photograph, the man ringing the bell is also holding a puppy. (Courtesy of Oglebay Institute Mansion Museum.)

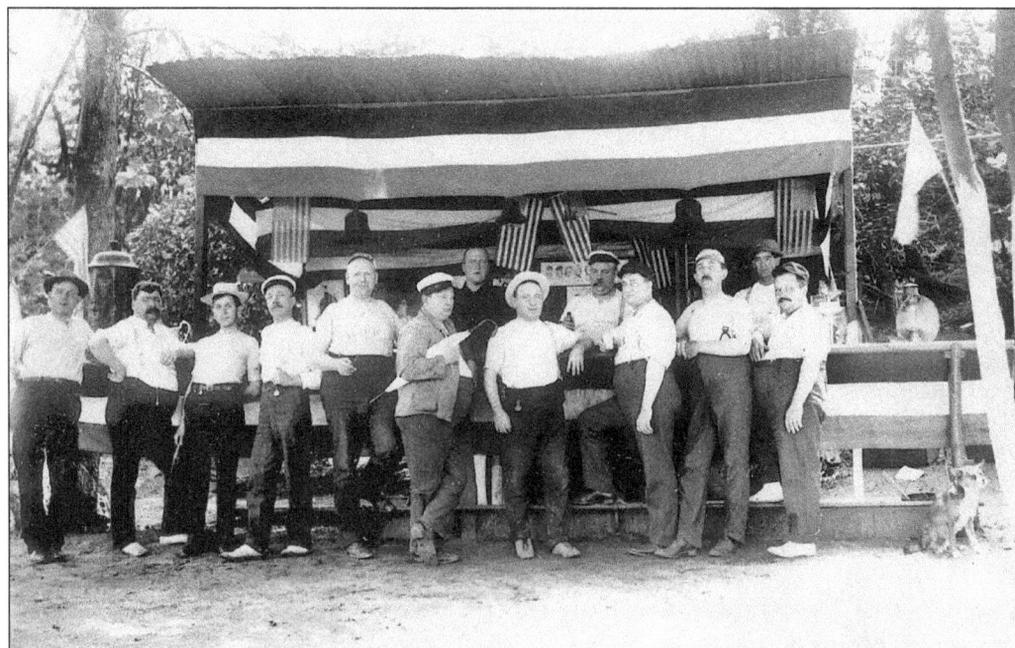

BEER STAND AT BOAT CLUB, C. 1910. These men appear to be members of the Central Fishing Club. After a hard day of boating and fishing, a beer or two was probably welcomed. (Courtesy of Oglebay Institute Mansion Museum.)

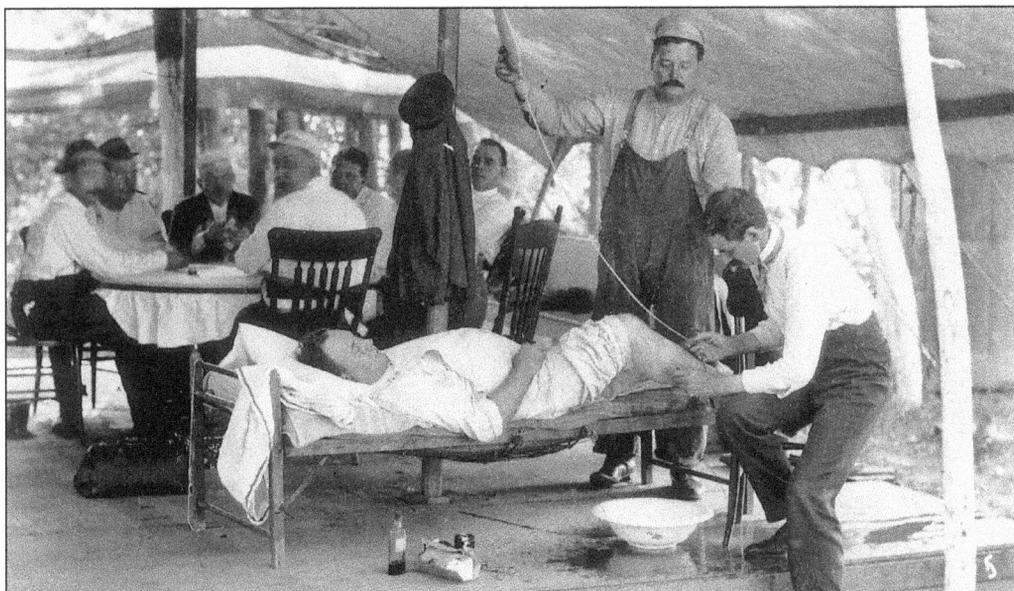

MEDICAL TENT, WHEELING BOAT CLUB, C. 1910. After a hard day boating and fishing and drinking, a visit to the doctor seems to be in order. This make-shift medical tent doubles for a poker palace. The poker players do not seem too concerned about their injured friend. (Courtesy of Oglebay Institute Mansion Museum.)

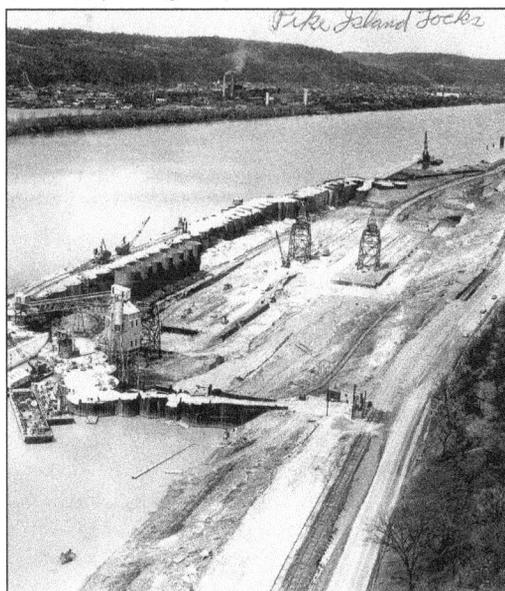

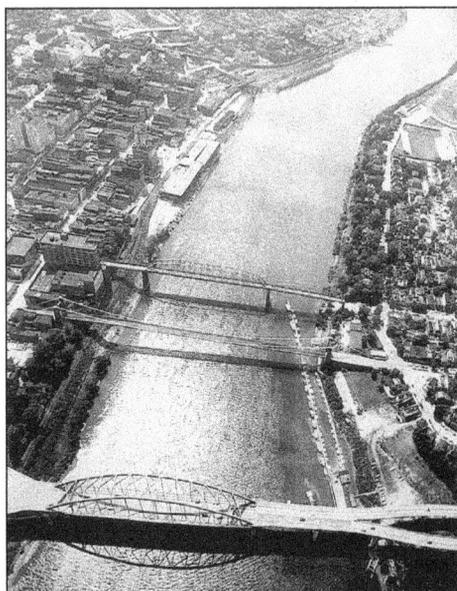

(above left) **PIKE ISLAND LOCKS AND DAM, SPRING 1961.** The Pike Island Locks and Dam provides a 30 mile pool just above Warwood on the Ohio River. The locks were built between 1959 and 1963. It was opened in November 1963. The dam, built between 1962 and 1965, is 1306 feet long. The dam sees 28 million tons of annual freight traffic. *(above right)* **WHEELING'S THREE BRIDGES, C. 1955–1962.** This is a rare photograph that captures the Fort Henry Bridge, the Suspension Bridge, and the Steel Bridge. One can also see small boats lined up on Wheeling Island. Also visible is the Wharf Parking Garage, which no longer exists. The Wheeling Civic Center has yet to be built. (Courtesy of Milt Gutman.)

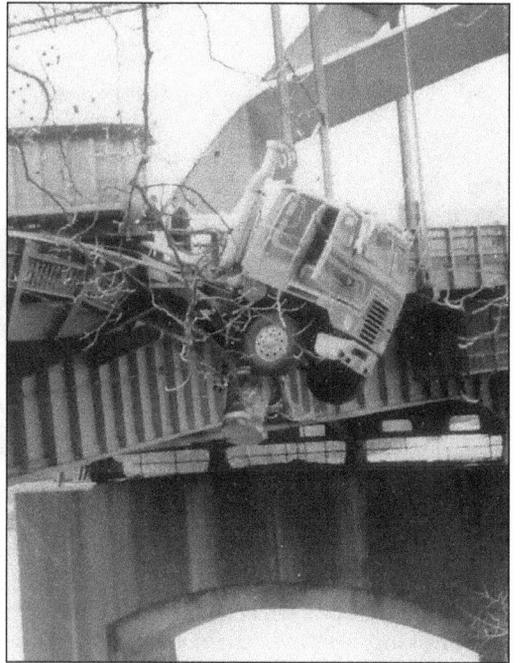

(*above left*) **FORT HENRY BRIDGE DEDICATION, SEPTEMBER 8, 1955.** Construction began on the Fort Henry Bridge, known then as the Ninth Street Bridge, in 1951. It was designed by Howard, Needles, Tammen & Bergendoff. It weighed 13,000 tons and cost 6.8 million to build. In October 1958, Raul Garcia, a 30 year old high diver from Acapulco, dove head first from the bridge and gracefully entered the water 105 feet below. (Courtesy of Robert W. Schramm.)
(*above right*) **TRUCK OVER FORT HENRY BRIDGE, C. 1975.** This 18 wheeler crashed on the east side of the Fort Henry Bridge. Nobody was killed but it must have been absolutely terrifying. Upon further examination, one can see the arm of the driver sticking out of the cab door holding on for dear life. (Courtesy of Kirk's Photo.)

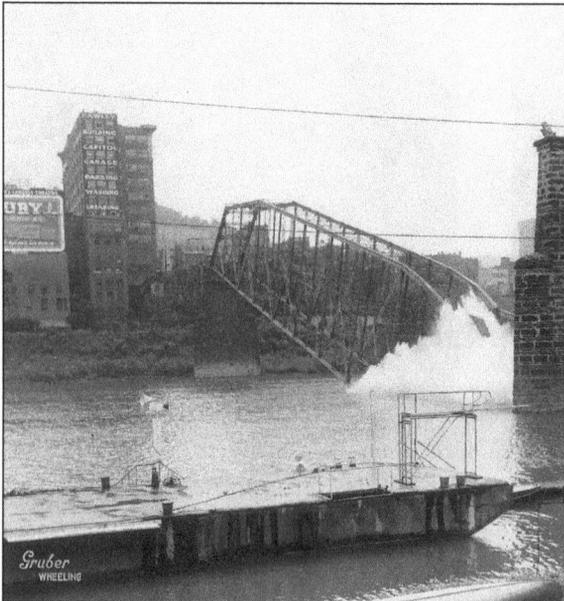

STEEL BRIDGE BEING DESTROYED, 1962. The Steel Bridge stretched from Ohio Street on Wheeling Island to Bridge Street in downtown Wheeling. In August 1955, the State Road Commission offered to sell the Steel Bridge to the City of Wheeling for one dollar. However, with the new Fort Henry Bridge and the historic Wheeling Suspension Bridge in place, there was little need for the Steel Bridge. Notice the men on top of the crane.

Four

SPORTS

BOBBY DOUGLAS, WRESTLER. Bobby Douglas wrestled for West Liberty State College. He won the Dan Hodge Trophy as collegiate wrestling's best performer. He was on several World Championship teams and two Olympic teams, in 1964 and 1968. He coached Arizona State to the 1988 NCAA Division I Championship and later he coached Iowa State to a national record 858 dual victories. In 1987, he was inducted into the Wrestling Hall of Fame. In 1992, he served as coach of the United States Freestyle Olympic Wrestling Team. (Courtesy of Gordie Longshaw.)

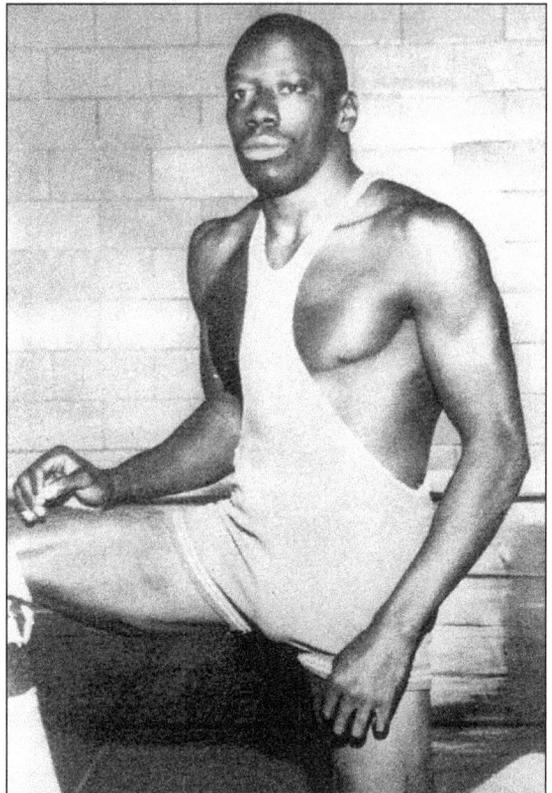

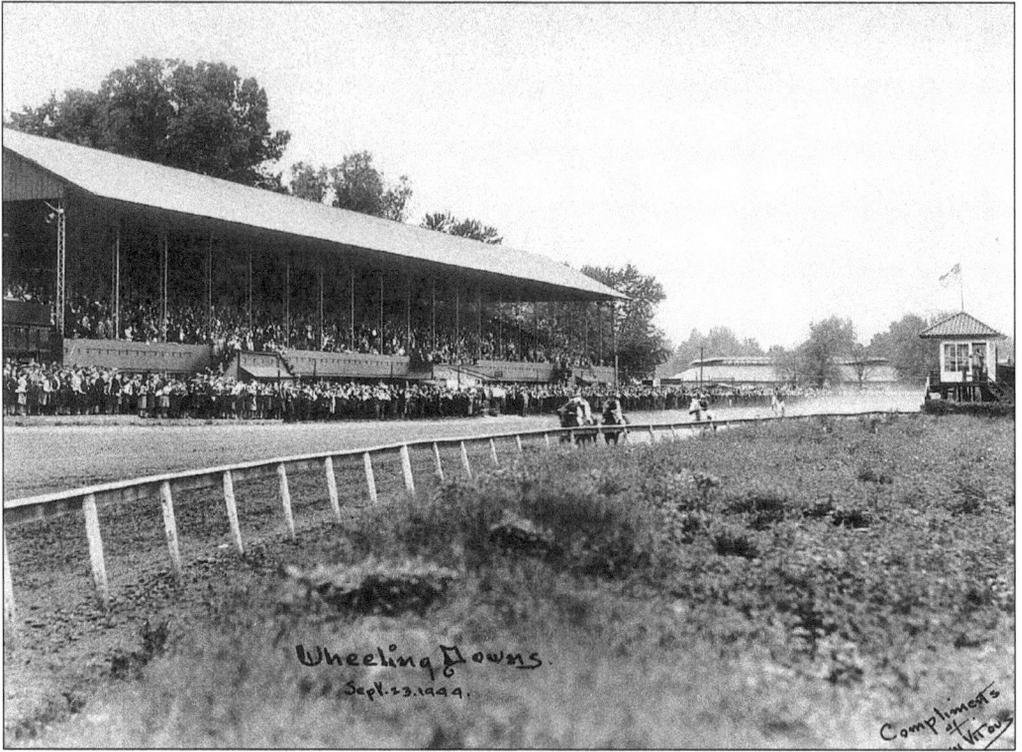

Wheeling Downs.
Sept. 23. 1944.

Compliments
of
Vitous

WHEELING DOWNS, SEPTEMBER 23, 1944. The gangster "Big" Bill Lias did a great deal to turn this racetrack into "the most beautiful half-mile track in the country" as it was known. Many famous jockeys raced here, including Willie Hartack, who is in the Hall of Fame. (Courtesy of Jerry Vitous.)

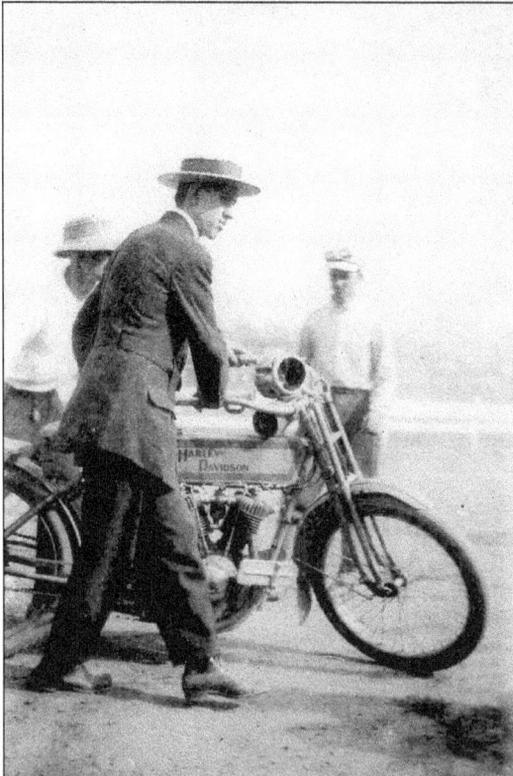

HARLEY DAVIDSON RACE, MONDAY, SEPTEMBER 1, 1913. This race took place on a dirt track on the south end of Wheeling Island. From the sequence of photographs, one can tell that this racer crashed and had to be helped off the track by a policeman. (Courtesy of Kirk's Photo.)

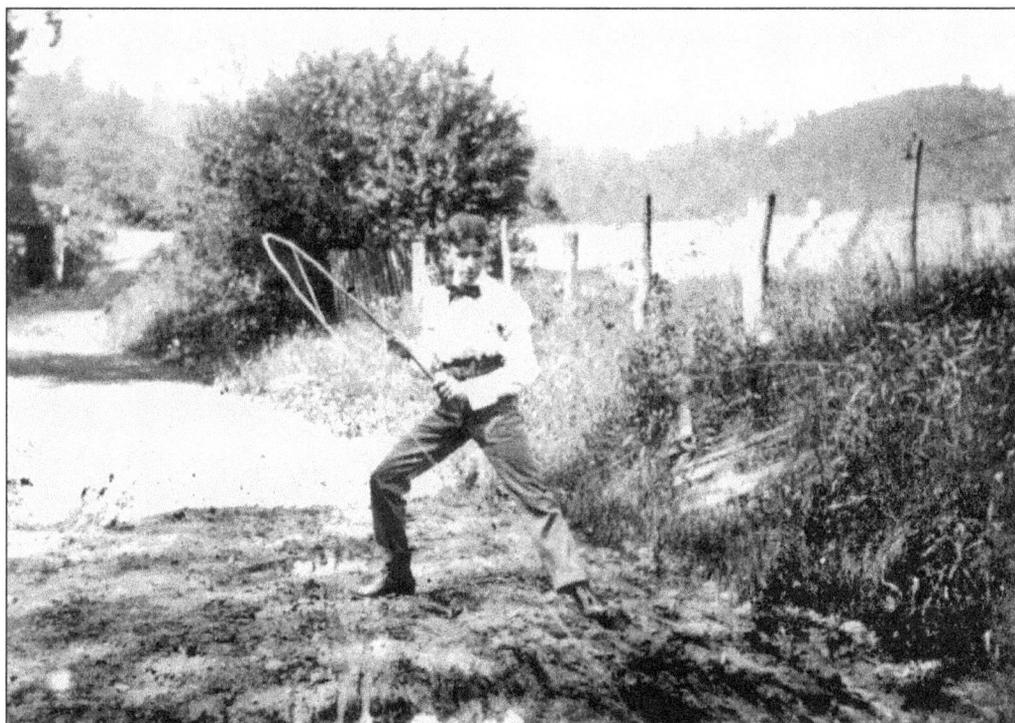

FISHING IN A WHEELING POT HOLE,
c. 1910. This muddy path would later
be renamed the Robert C. Byrd Muddy
Lane, which connected onto the Robert
C. Byrd Causeway. This led to Robert
C. Byrd Avenue that took one down the
Robert C. Byrd Boulevard. On this drive,
one would pass the Robert C. Byrd House
of Pancakes on the way to the Robert C.
Byrd Bus Terminal. (Courtesy of Oglebay
Institute Mansion Museum.)

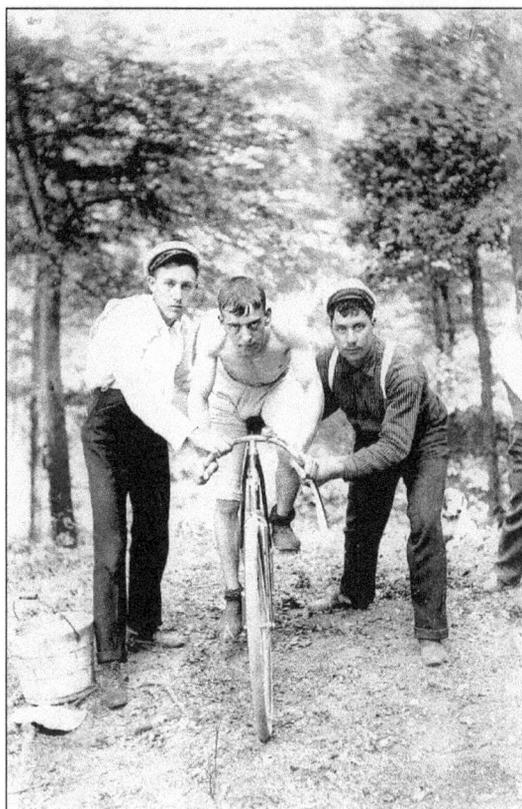

WHEELING BICYCLIST, c. 1900. This
man may have been a member of the
Wheeling Wheelmen, which was a group
of local bicycling enthusiasts around the
turn of the century. (Courtesy of the
Oglebay Institute Mansion Museum.)

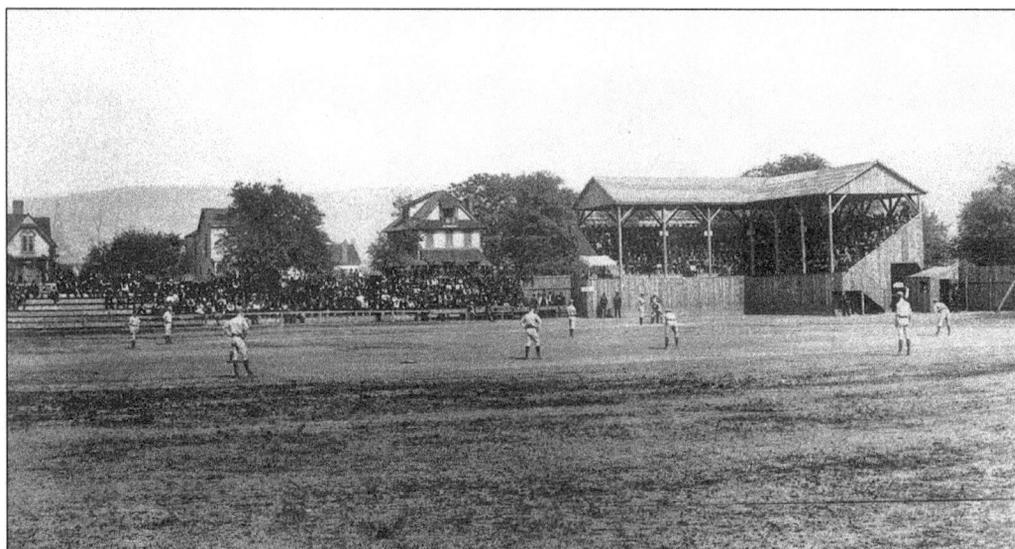

WHEELING NAILERS VERSUS LIMA OHIO, 1887. This game took place on the south end of Wheeling Island. Wheeling had a reputation for having great minor league baseball teams. Hall of Fame player, Jesse Burkett and Hall of Fame coach, Ed Barrow were some of Wheeling's greats. Mr. Barrow coached his Wheeling team to a 36-22 record in 1894. Later, in the Major Leagues, Coach Barrow discovered a young Honus Wagner and put Babe Ruth into the Red Sox lineup. (Courtesy of Dr. David Javersak.)

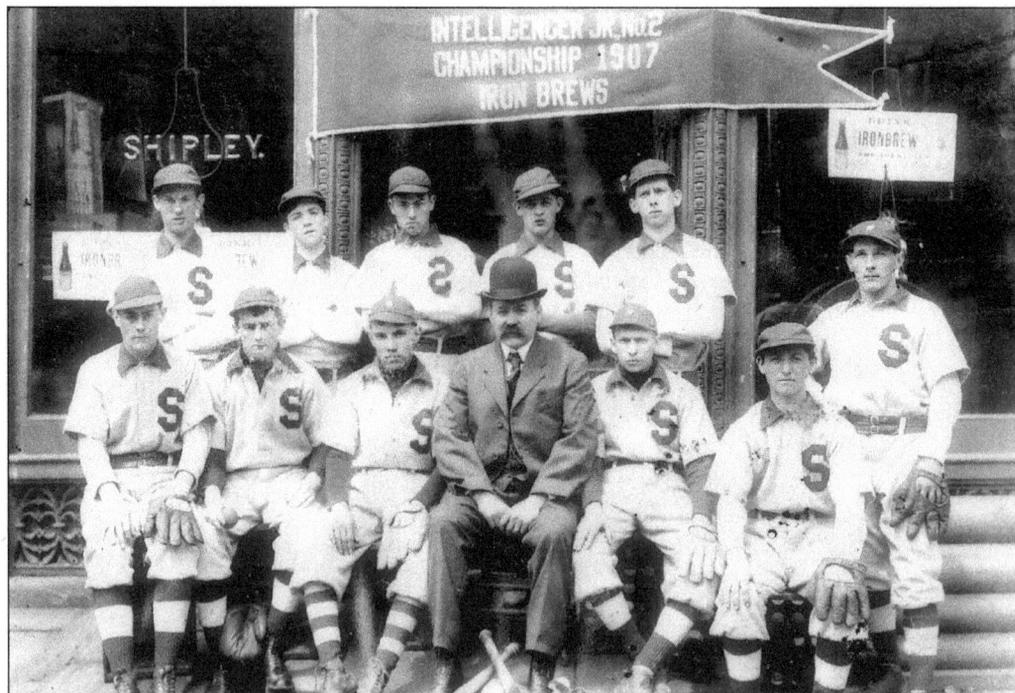

SHIPLEY IRON BREWS, 1907. This team of local workers must have won the Intelligencer Jr. No. 2 Championship in 1907. There were a plethora of minor league and company intra-mural baseball teams. Hall of Fame great Bill Mazeroski remembers playing pick-up ball in Wheeling, the town of his birth. (Courtesy of Dr. David Javersak.)

48

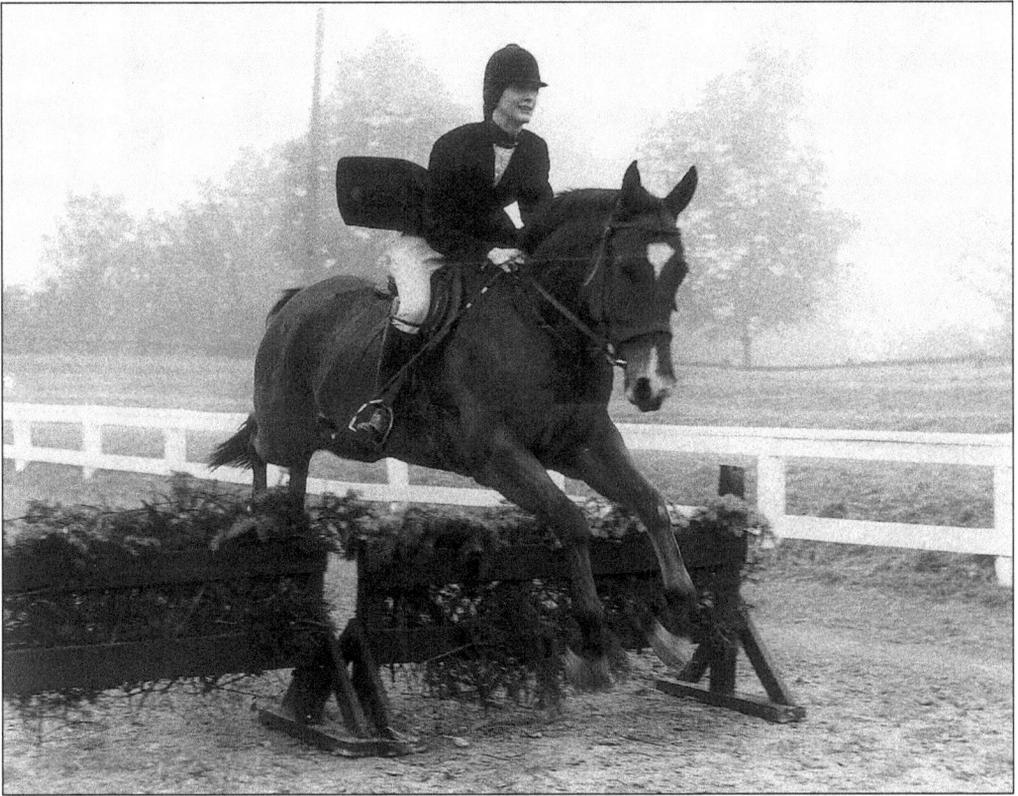

HORSE JUMPING, 1971. The Oglebay family members were avid equestrians and horses played a part in their daily lives. It was not surprising that horse stables were built on their property in the 1940s. These stables have produced many championship riders. (Courtesy of Wheeling Park Commission.)

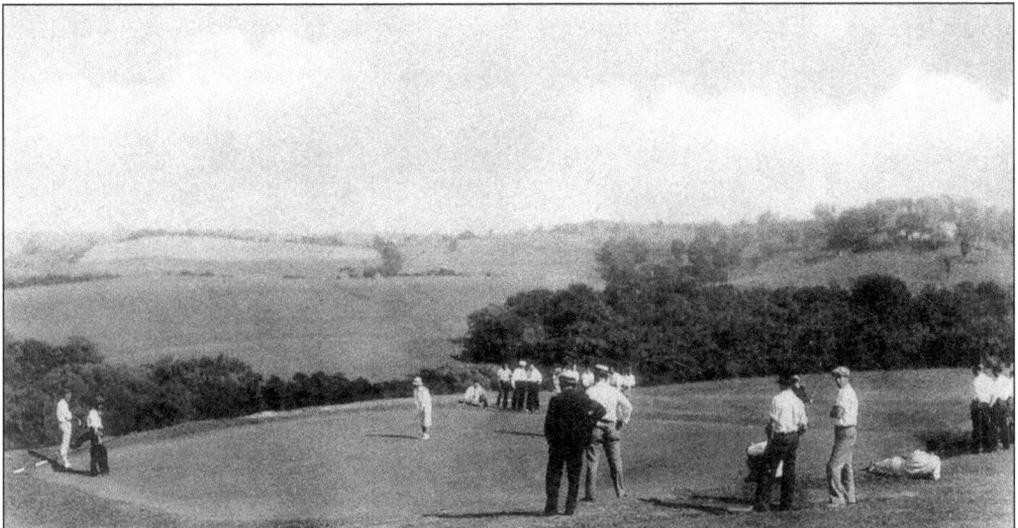

FRONT NINE AT CRISPIN GOLF COURSE, C. 1935. This course was dedicated on July 4, 1930. This photo was taken before the back nine was opened in 1938. For more than 50 years, the Bernhardts Amateur Classic was staged at Crispin. (Courtesy of Wheeling Park Commission.)

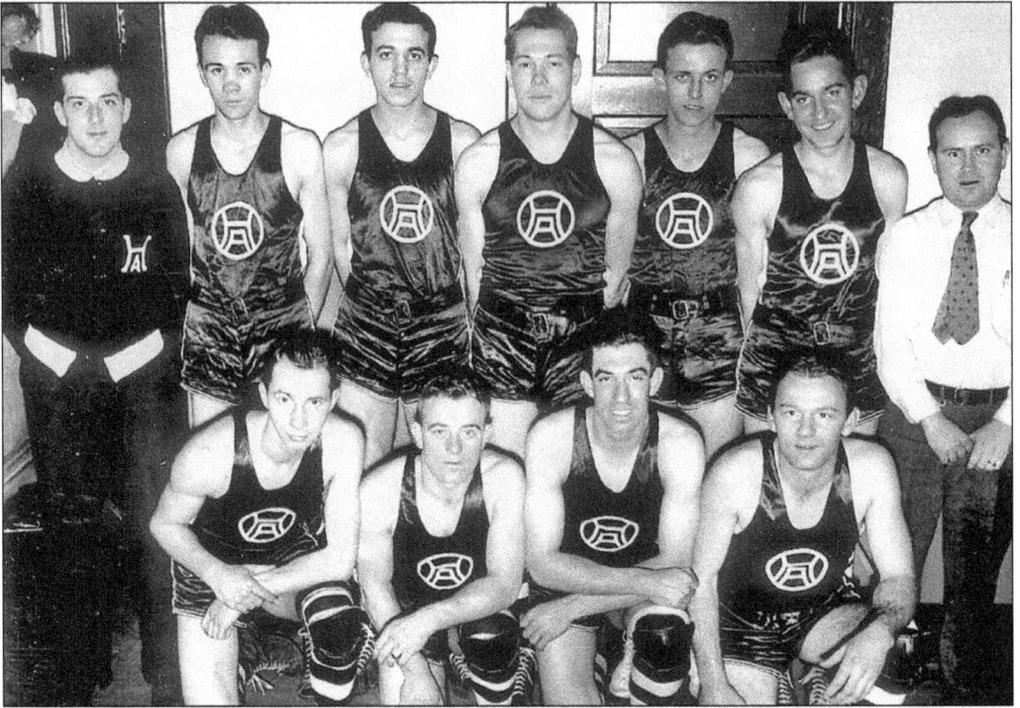

HAZEL-ATLAS BASKETBALL TEAM. In 1902, the Atlas Glass and Metal Company combined with the Hazel Glass Company to form the Hazel-Atlas Glass Company. In August 1930, the company released plans to build a new headquarters at the corner of Jacob and 15th Streets. On September 14, 1956, the Continental Can Company bought the Hazel-Atlas Company. The Continental Company donated the Hazel-Atlas Building to West Liberty State College. Today, it is the site of West Virginia Northern Community College's classrooms, laboratories and offices. (Courtesy of Kirk's Photo.)

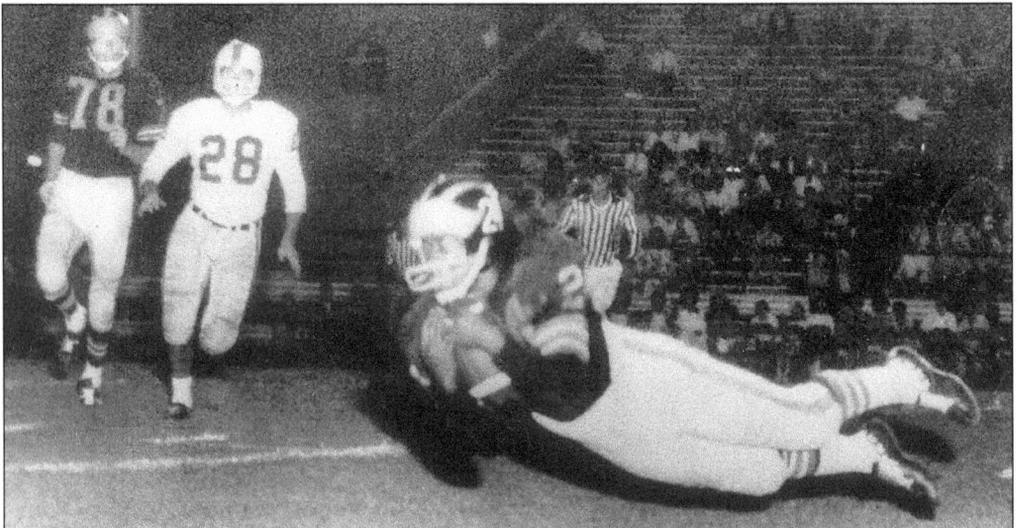

CLYDE THOMAS, CANADIAN FOOTBALL LEAGUE, 1961. Clyde Thomas played for the Wheeling Ironmen, the Philadelphia Eagles, and the British Columbia Lions. In this photograph, he is making a remarkable catch for a touchdown. (Courtesy of Anne Thomas.)

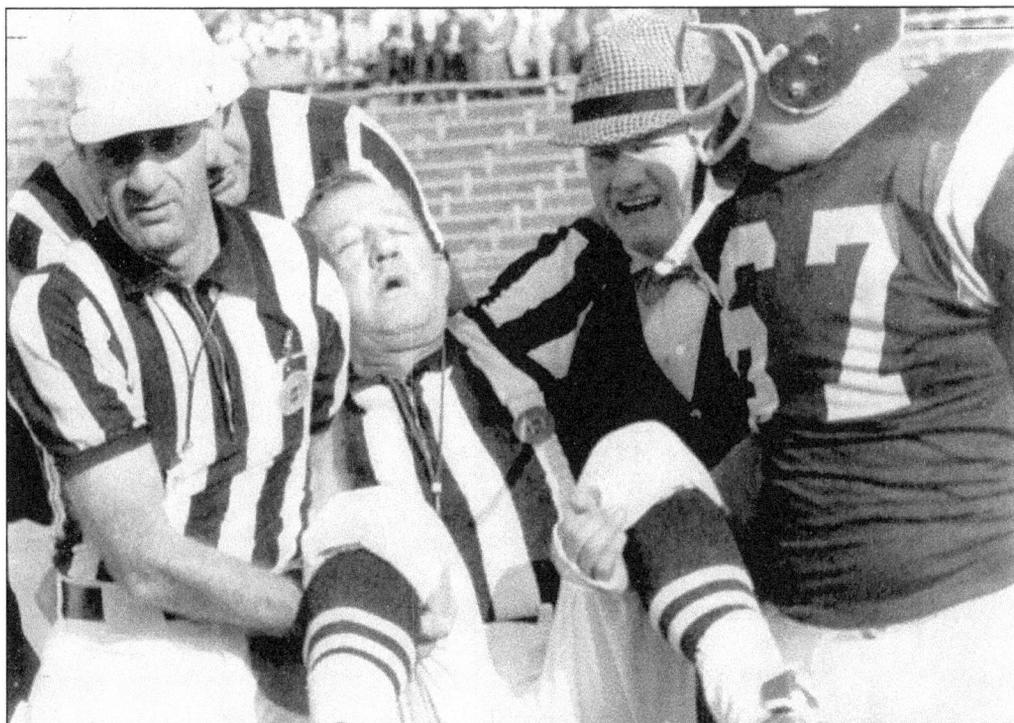

WHEELING IRONMEN REFEREE LEAVES THE GAME, 1963. Referee Lopeman leaves the game with the help of Wheeling Ironmen Leon Pajak and team physician Dr. Bandi. The referee later died from a heart attack. (Courtesy of Wheeling News Register.)

ART AND DAN ROONEY, WHEELING STOGIES, 1925. These two famous Pittsburgh brothers played for the Wheeling Stogies Baseball Club in the Mid-Atlantic League. Art was an outfielder and Dan, his brother, was the catcher. Art held many team records including the following: most games, 106; most runs scored 109; most hits, 143; and most stolen bases, 58. Art finished second in the Mid-Atlantic Leagues batting record. Dan later became a Franciscan priest and changed his name to Silas. Art went on to help establish the National Football League and owned the Pittsburgh Steelers during the Super 1970s. Art eventually was inducted into Football Hall of Fame. This artist rendition was done by Merv Corning. (Courtesy of Arthur J. Rooney Jr.)

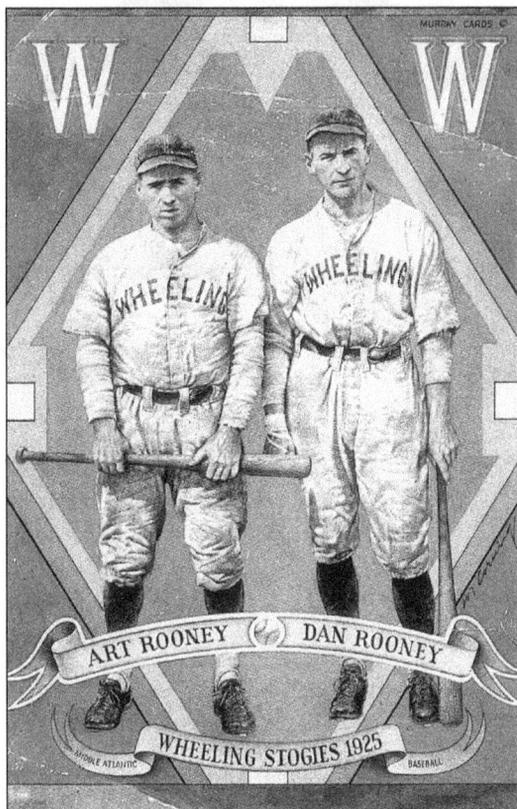

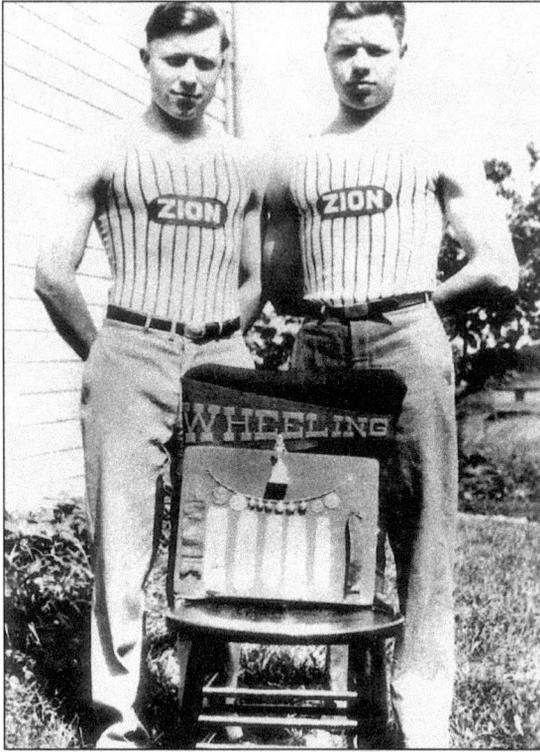

WALTER AND ROY REUTHER, WHEELING 1925. Walter and Roy became famous for their work with the labor unions. In this photo, they seem most proud of the trophies they won in Wheeling. Their father was a wagon driver for the Schmulbach Brewing Company. Walter Reuther became the president of the United Auto Workers and vice president of the AFL-CIO. Roy was in charge of political action and led the 1936–1937 sit-down strike against General Motors. (Courtesy of Walter P. Reuther Library, Wayne State University.)

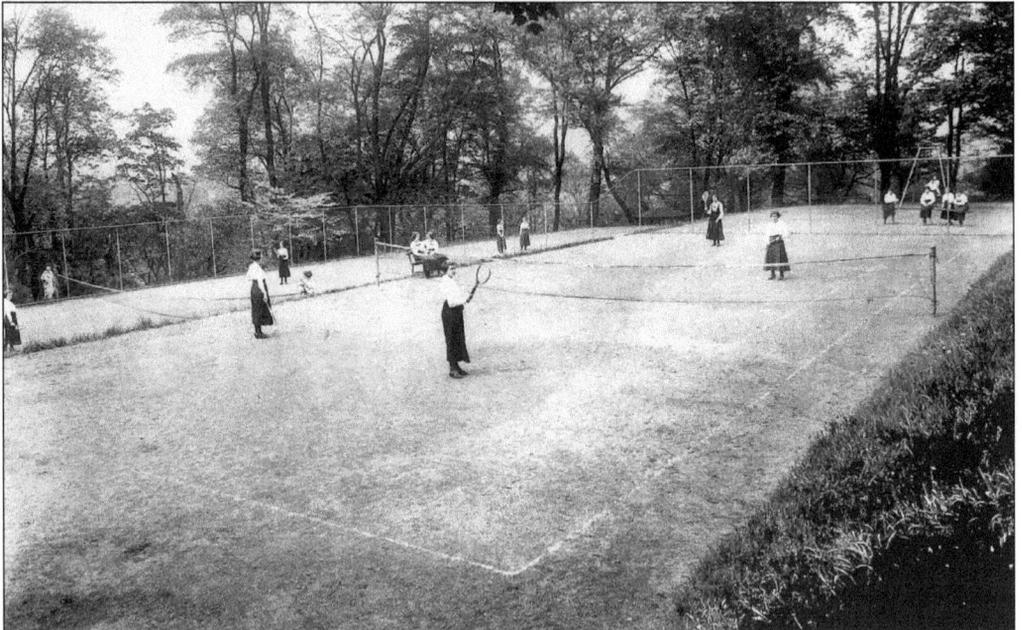

TENNIS GAME, MOUNT DE CHANTAL, 1902. Mount de Chantal Visitation Academy always stressed physical as well as mental exercise in their curriculum. There were two levels to the tennis courts. Mount de Chantal's gymnasium now sits on this spot. The statue of St. Joseph and Jesus can still be seen on the grounds of the Academy. (Courtesy of Mount de Chantal Visitation Academy.)

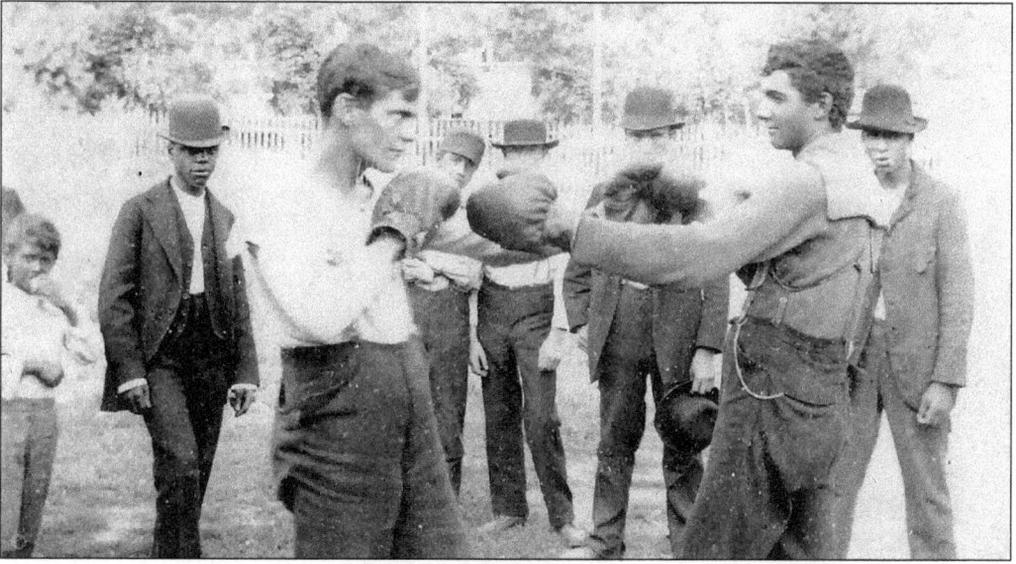

BOXING MATCH, C. 1900. Wheeling has played host to many boxing champions over the past 120 years. John L. Sullivan, also known as the "Boston Strong Boy," faced an unnamed opponent in October 1884. On October 13, 1893, Kid McCoy knocked out Jack Welsh in the ninth round. On November 22, 1899, Amos "Mysterious Billy" Smith defeated Mike Donovan in 20 rounds. On January 26, 1931, World Featherweight Champion, Freddie Miller knocked out Phil Zwick in the third round. (Courtesy of Oglebay Institute Mansion Museum.)

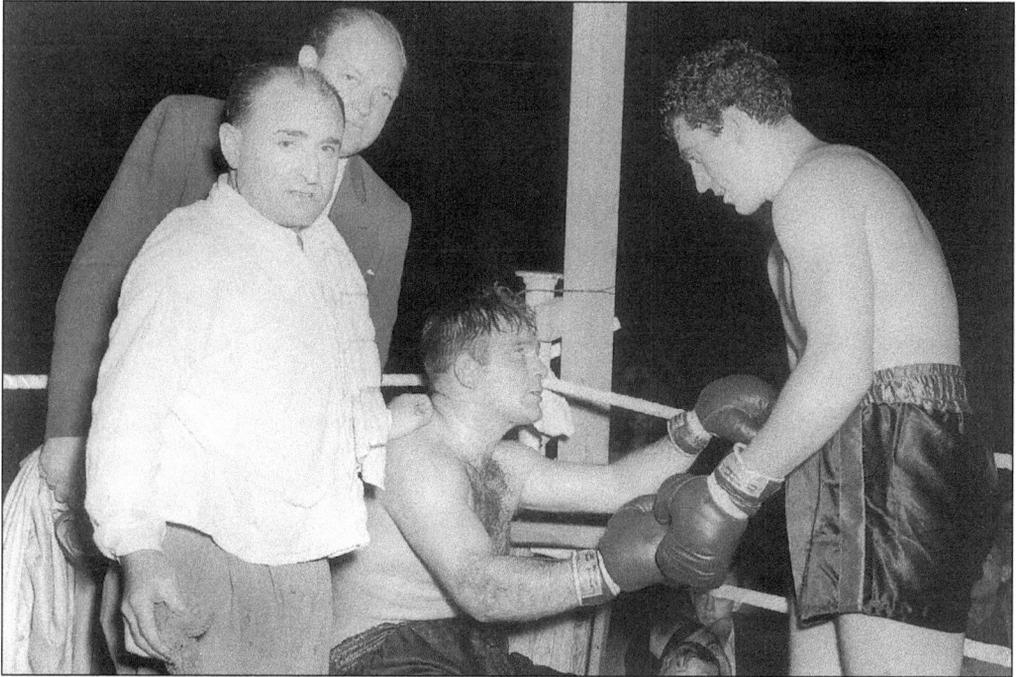

JOEY MAXIM CONSOLES CLARENCE JONES, SEPTEMBER 8, 1947. On September 8, 1947, Joey Maxim fought Clarence Jones at the Wheeling Market Auditorium. Joey knocked Clarence out in the fifth round. Former champion Jack Dempsey was the guest referee. Ringside seats went for $4 and general admission was $1.50. (Courtesy of Gary Zearott, Zee Photo.)

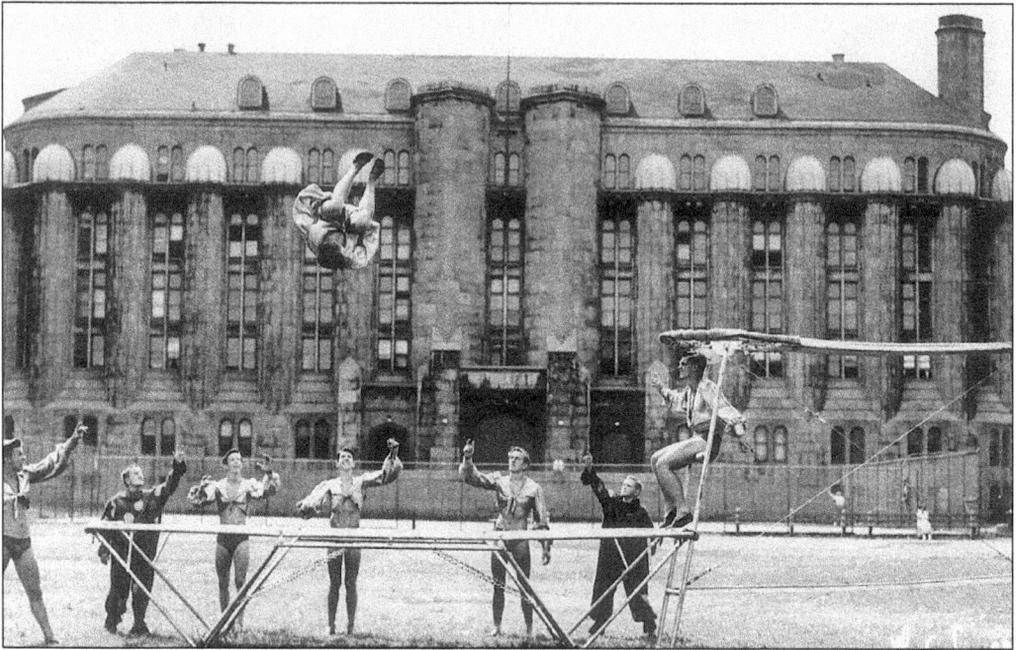

ALL AMERICAN BOYS, 1952. In 1949, YMCA Physical Director, Walker Dick, began training young boys from Wheeling in gymnastics. The tumbling and jumping turned into incredible acrobatic feats that included both trampoline work and juggling. They appeared on the Steve Allen Tonight Show, the Dave Garaway, Early Morning Today Show, and the Sealtest Bigtop Show. They taped for the Ed Sullivan Show but never made it on the air. This photo shows the boys performing in front of the Armory Building in Chicago. Wheeling resident Mickey Kryah is in mid-air. The boys finally broke up in 1956. (Courtesy of Mickey Kryah.)

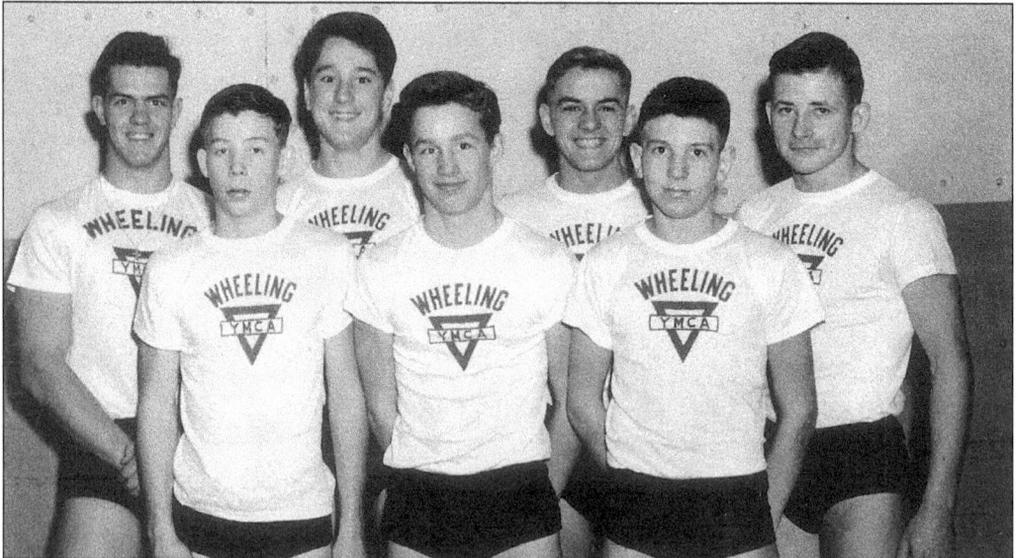

ALL AMERICAN BOYS. These boys were not only acrobats but also great athletes. In the back row, second from the left, is Super Bowl V Most Valuable Player, Chuck Howley. Pictured from left to right, are (front row) Don Gibons, Bill Nixon, and John McCurdy; (back row) Bill King, Chuck Howley, Mickey Kryah, and Mike Pickering. (Courtesy of Mickey Kryah.)

Five

THE ARTS

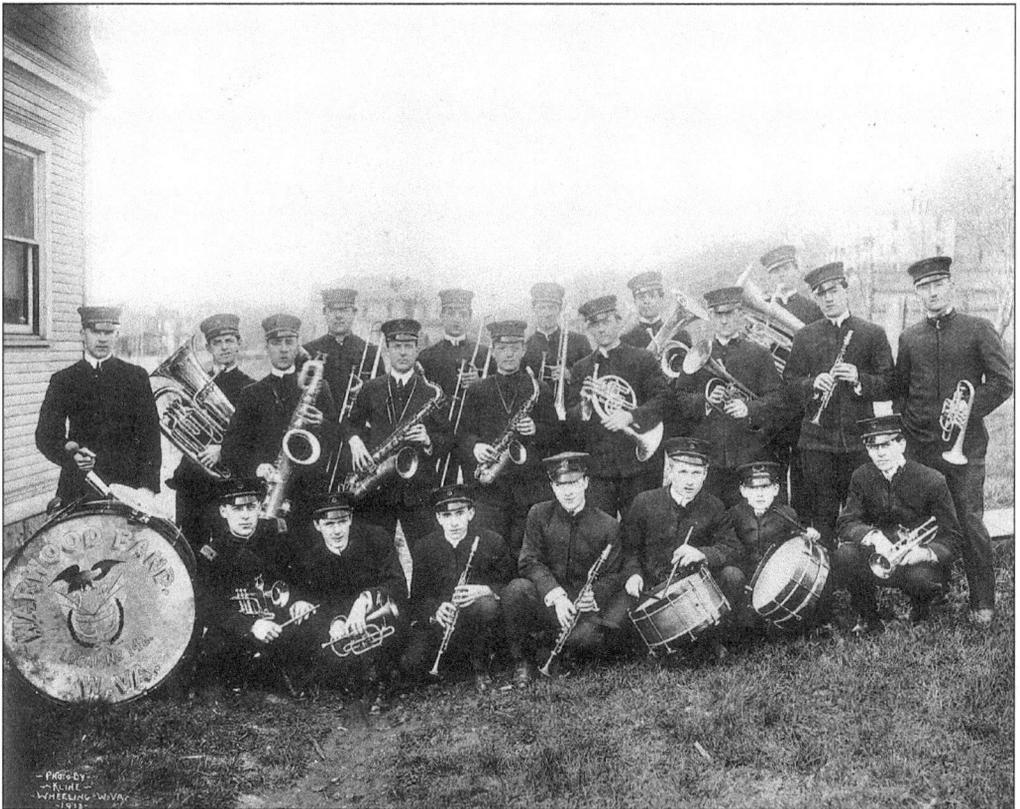

LOCAL 142 BAND, 1913. The photo shows the Local 142 of the American Federation of Musicians. This union was chartered on April 15, 1901. It is believed that the picture was taken on Warwood Avenue looking north. Today the Home for Aged Men would be clearly in view.

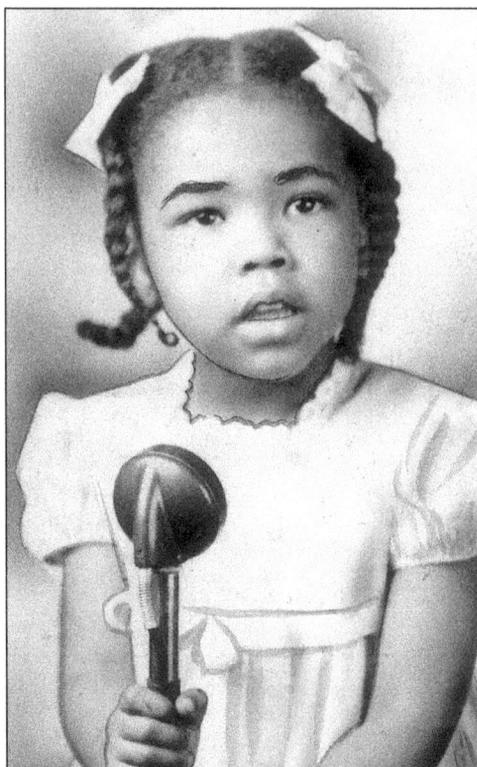

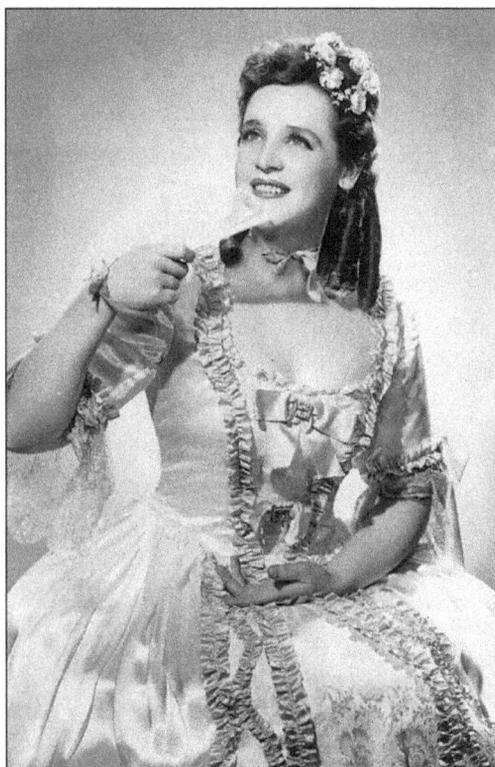

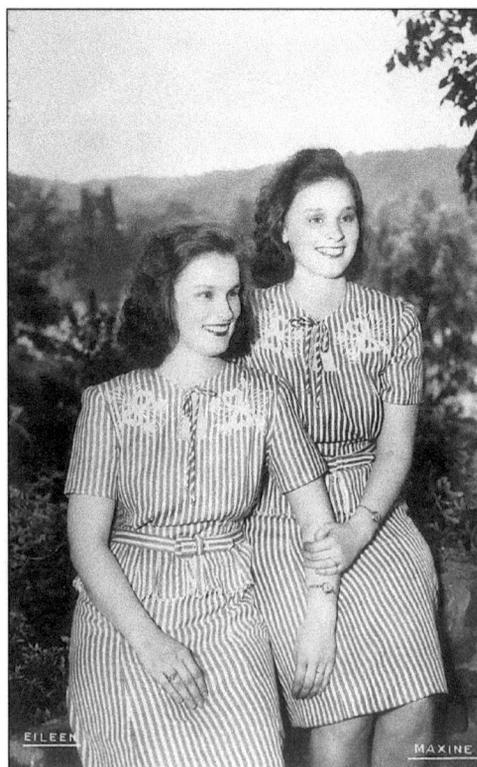

(*above, left*) **ANNE PRINCE, WWVA KIDDIE PROGRAM, 1942**. A young Wheeling girl, Anne Prince, sang "You are my sunshine" on the children's program for WWVA. These shows highlighted many young local talents. (Courtesy of Anne Thomas.)

(*above, right*) **ELEANOR STEBER**. This Wheeling citizen entered the New England Conservatory of Music where she studied under William L. Whitney. In 1940, she entered the Metropolitan Opera and during the next 24 years she took 42 leading roles. During her career, she received nine honorary doctoral degrees. She sang for 20 years on the Firestone, Telephone, and Ford radio programs and for 8 years on television.

THE SWEETHEARTS OF WWVA. Maxine and Eileen Newcomer were billed as radio's only singing blind twins. They were born on April 23, 1925 and lost their eyesight before the age of three. The pair joined the Wheeling WWVA radio show in 1941 with Curly Miller. They were a huge part of the early days of hillbilly/country music.

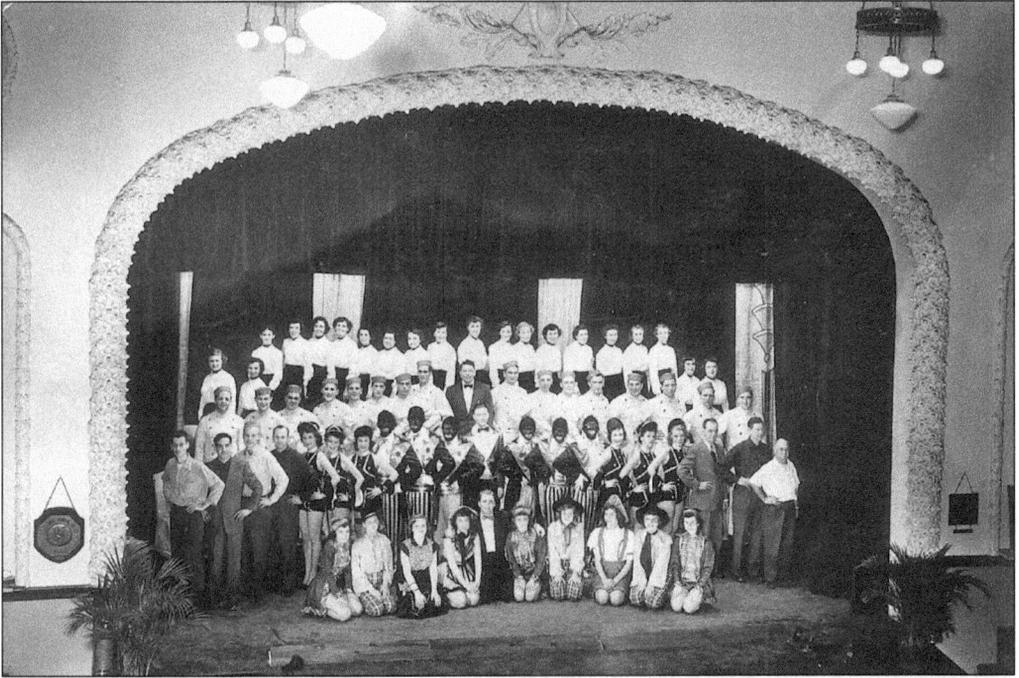

LION'S CLUB MINSTREL SHOW, DECEMBER, 1951. This very active service club held a minstrel each year to raise funds for their local projects. This picture was taken in Warwood High School. Famed high school band director J. Loren Mercer is wearing a bowtie and is standing in the middle of row three. To the right of the stage is a bronze plaque in remembrance of fellow student Ralph Imhoff who drowned in the Ohio River.

THE MIKADO, 1938. The Tri-State musical Association Inc. and the Wheeling Symphony Orchestra performed Gilbert & Sullivan's Mikado at Oglebay's Amphitheatre Tuesday, June 21 through Wednesday June 22, 1938. In 2003, the Wheeling Symphony celebrates its 75th year. Wheeling is the nation's smallest city with a metropolitan-class orchestra. (Courtesy of Wheeling Symphony, Inc.)

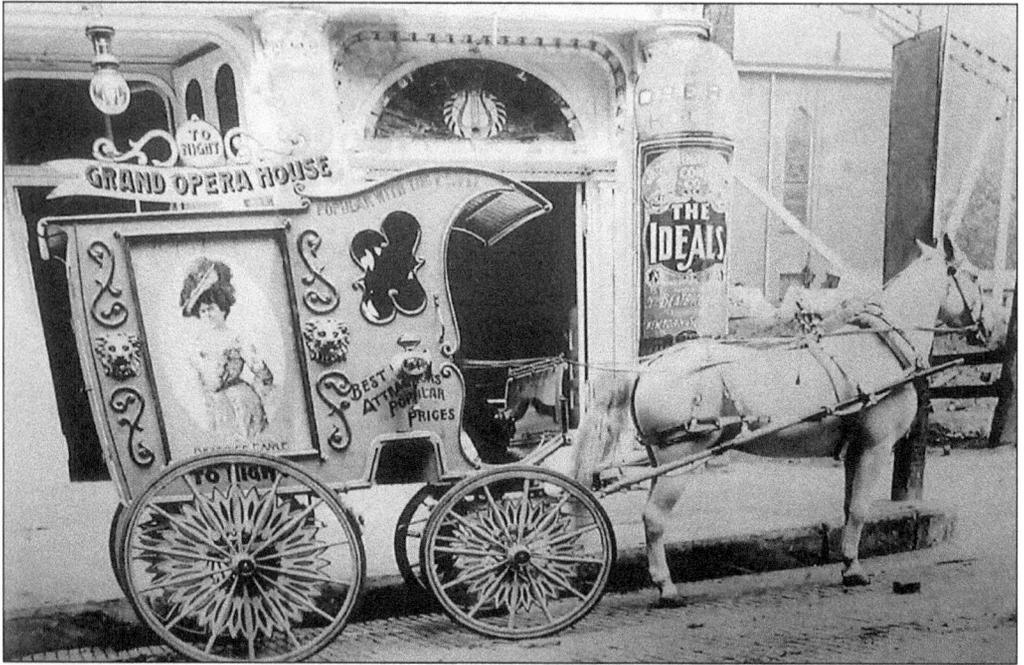

ADVERTISING WAGON FOR THE GRAND OPERA HOUSE, 1905. This famous photo shows just how far people were willing to go to promote the arts. The wagon reads "Popular with the People." Wheeling often had a carnival atmosphere with street venders, touring musicals, open-air plays, and operas. The Arion Society and the Beethoven Society were just two of the many groups that tried to bring the arts to the masses in Victorian Wheeling. (Courtesy of the Ohio County Public Library.)

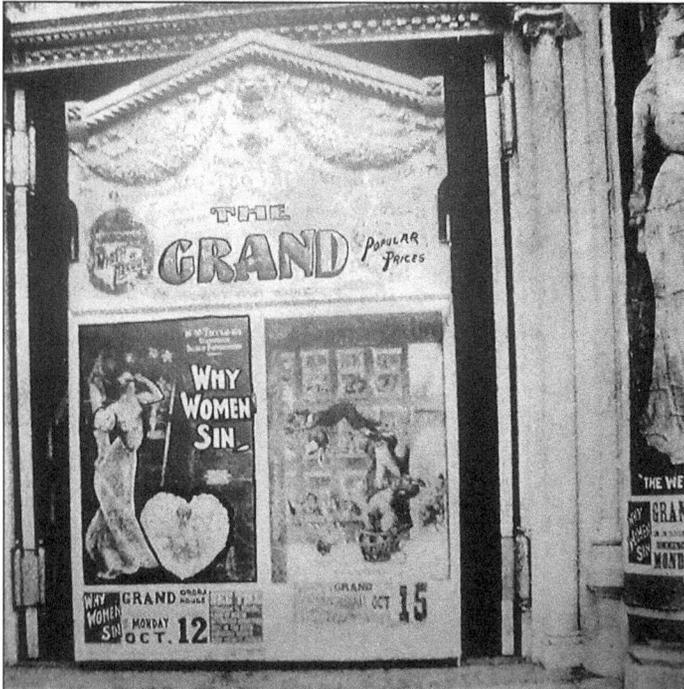

THE GRAND OPERA HOUSE, "WHY WOMEN SIN." Grand Opera House was located on 12th and Market Streets and was one of the principle attractions for theater goers in Wheeling. "Why Women Sin" was a melodrama written by Will C. Murphy and starring Miss Marie York and child actress, Miss Ida Mae. (Courtesy of the Ohio County Public Library.)

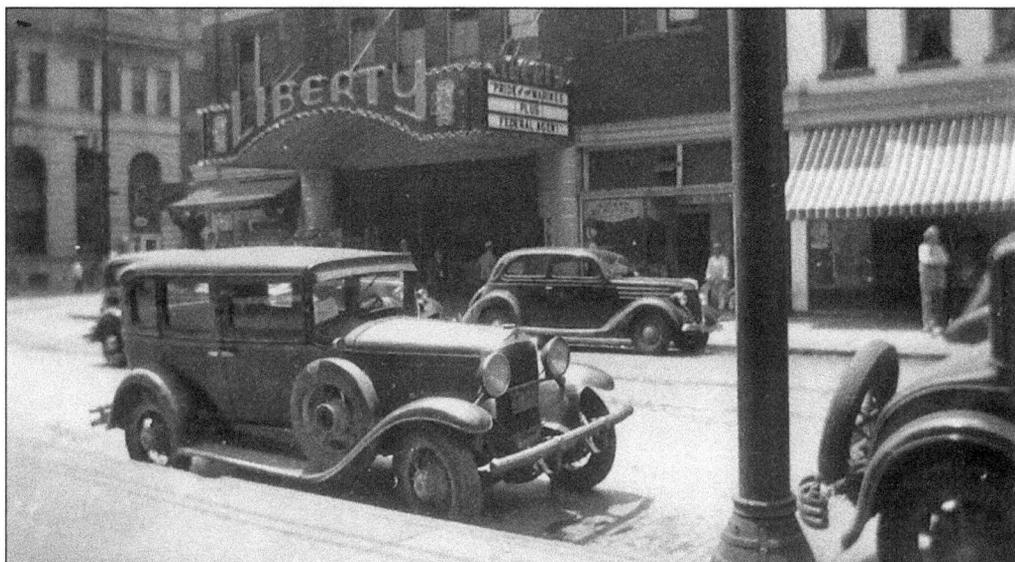

LIBERTY THEATER, 1937. The Liberty Theater was on the corner of Market and 16th Street and across from the Custom House. The automobiles in this photograph make it look like a scene from a gangster movie. (Courtesy of Kirk's Photo.)

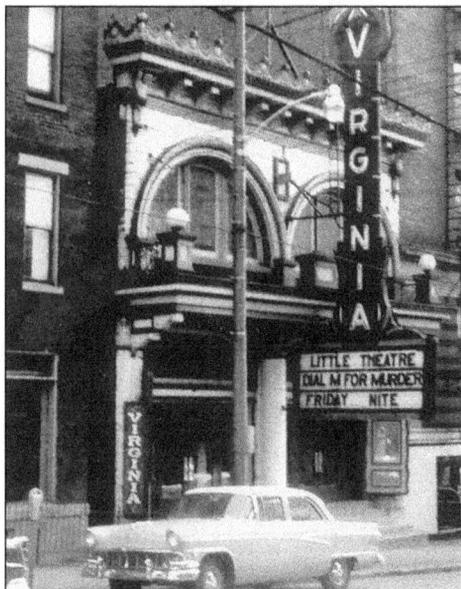

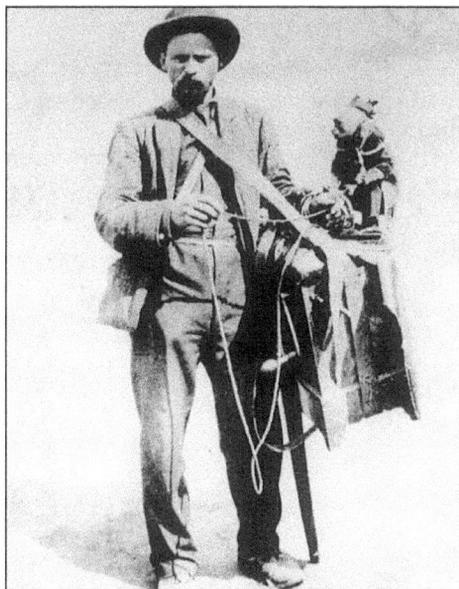

(above, left) **THE VIRGINIA THEATRE.** The Virginia Theatre was named after Mrs. Hiraim C. (Virginia) Miller, the daughter of the first owner, Charles Feinler. Famous performers who have graced this stage include Marian Anderson, Arthur Rubenstein, Olivia de Havilland, Beverly Sills, Benny Goodman, and even Amelia Earhart, who spoke to an audience in 1933. (Courtesy of Robert W. Schramm.)

(above, right) **ORGAN GRINDER WITH MONKEY, 1896.** The description beneath this well-known photo reads, "One of the first signs of spring in Wheeling was the organ grinder with a monkey. There were German bands that played on the street and passed the hat. Then there were performing bears, gypsies telling fortunes, and fakirs selling trinkets." (Courtesy of Ohio County Public Library.)

59

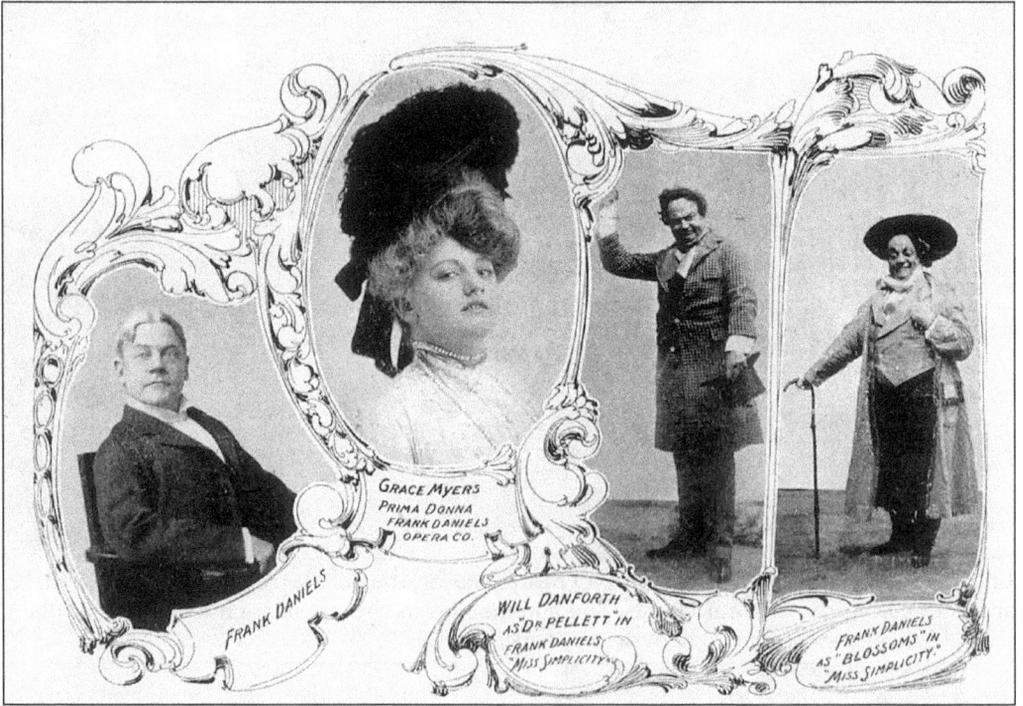

MISS SIMPLICITY, SEPTEMBER 1902. This musical comedy was the official opening play for the Court Theatre. This photograph came from an elaborate Court Theatre program that was distributed to interested citizens.

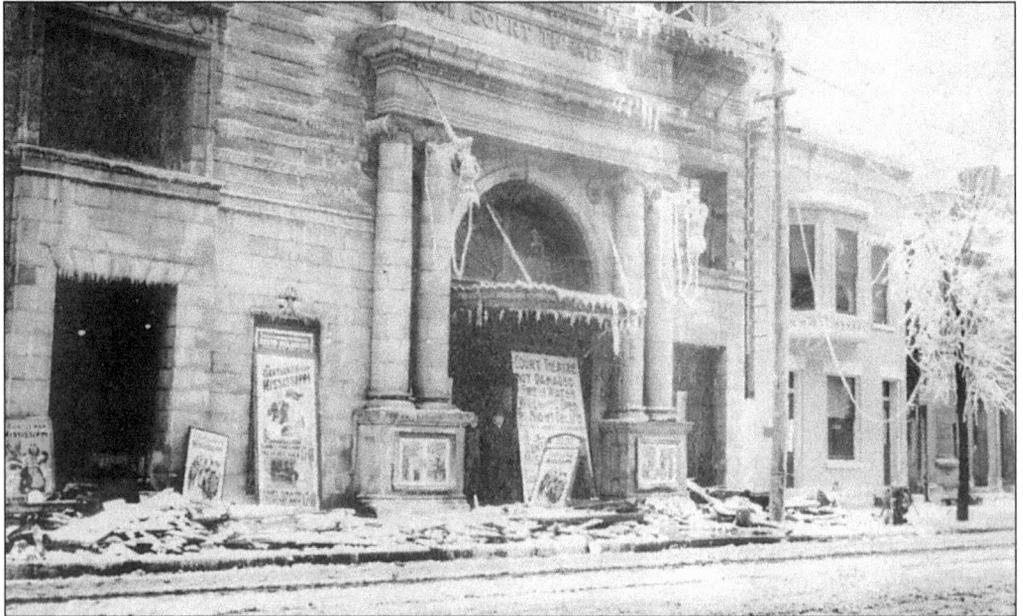

COURT THEATRE OBVIOUSLY NOT DAMAGED BY FIRE, 1908. This bizarre photograph shows a frozen and burnt Court Theatre with rubble on its sidewalks. However, the sign in the entrance says "Court Theatre Not Damaged by Fire or Water. Will positively open Friday night, December 17." (Courtesy of Kirk's Photo.)

THE SHOW MUST GO ON, 1971.
David Judy was about to direct
Luigi Pirandello's *Six Characters in
Search of an Author*, on February
11, 12, 13, March 26, and March
27, 1971. However, he became ill
and the responsibility turned to
artistic director Harold O'Leary.
This photo shows OVGH Practical
Nurse Ann Spencer taking David's
pulse while Hal takes notes.
Towngate Theatre, located at
2118 Market Street, had its first
production, *Cat on a Hot Tin Roof*,
in November 1969. In the summer
of 1981, Oscar winner Francis
McDormont directed the *Parcel
Players* for the Towngate Theatre's
summer program. Over 100,000
people have enjoyed performances
at this community theatre.
(Courtesy of Hal O'Leary.)

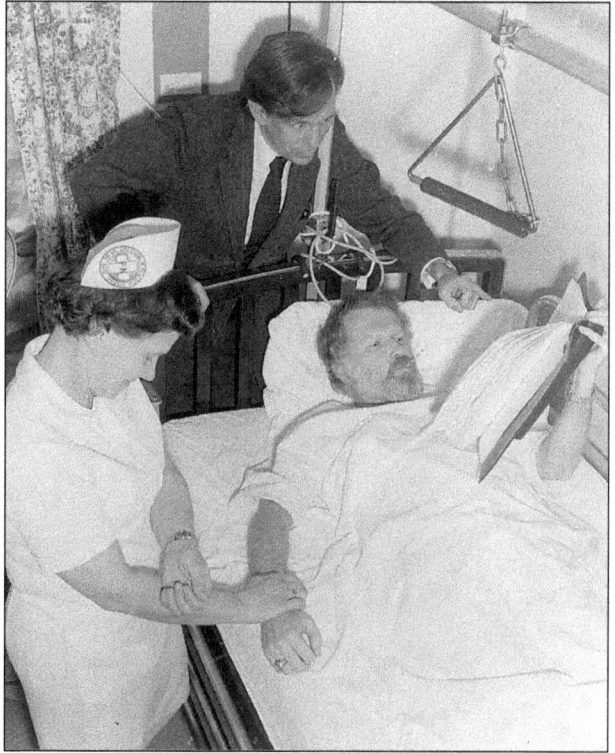

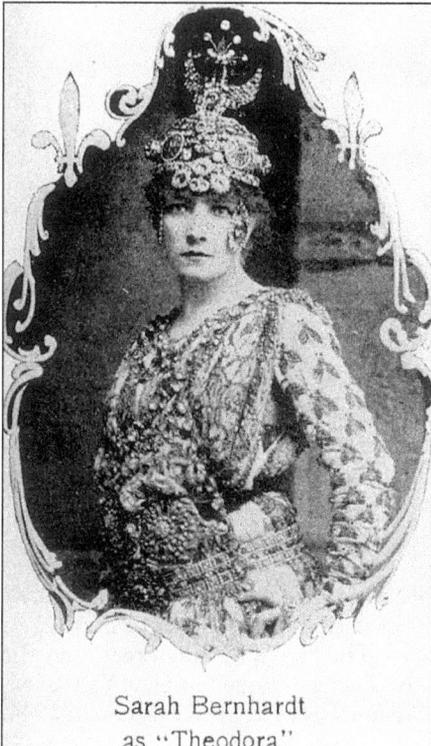

Sarah Bernhardt
as "Theodora"

SARAH BERNHARDT, 1906. This star of the
French stage came to the Court Theatre in 1906.
She made 10 movies from 1900 to 1923. During
the Victorian era, Wheeling brought in many of
the greatest actresses of the day including Ethel
Barrymore, Margaret Anglin, and Fanny Ward.

61

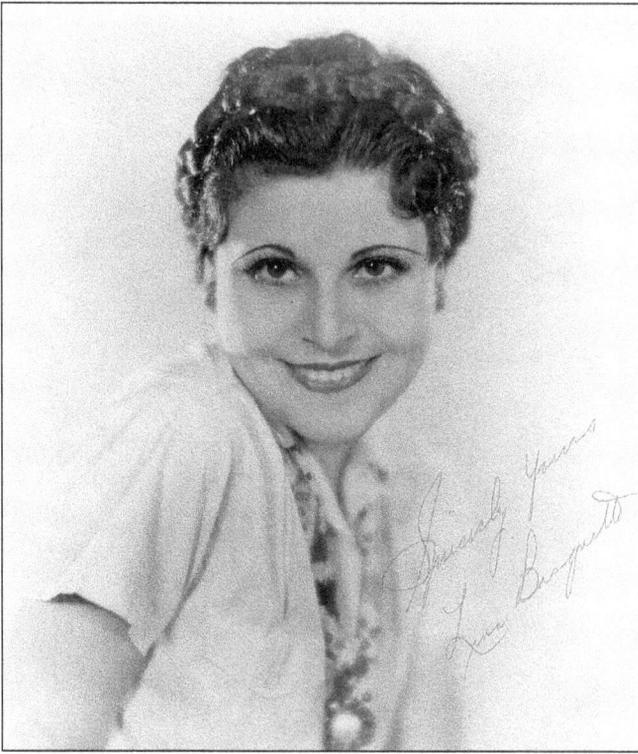

LINA BASQUETTE, C. 1930. This star of 43 movies and the Ziegfeld Follies came to live her latter years in Wheeling. She died of lymphoma in Wheeling on September 30, 1994. She was married to boxing champion Jack Dempsey, Hollywood mogul Sam Warner, and once went on a date with Adolf Hitler. Lina once commented on Hitler's attempt to seduce her saying "Maybe if I hadn't been so fastidious, I might have changed history. But, oh, that body odor of his."

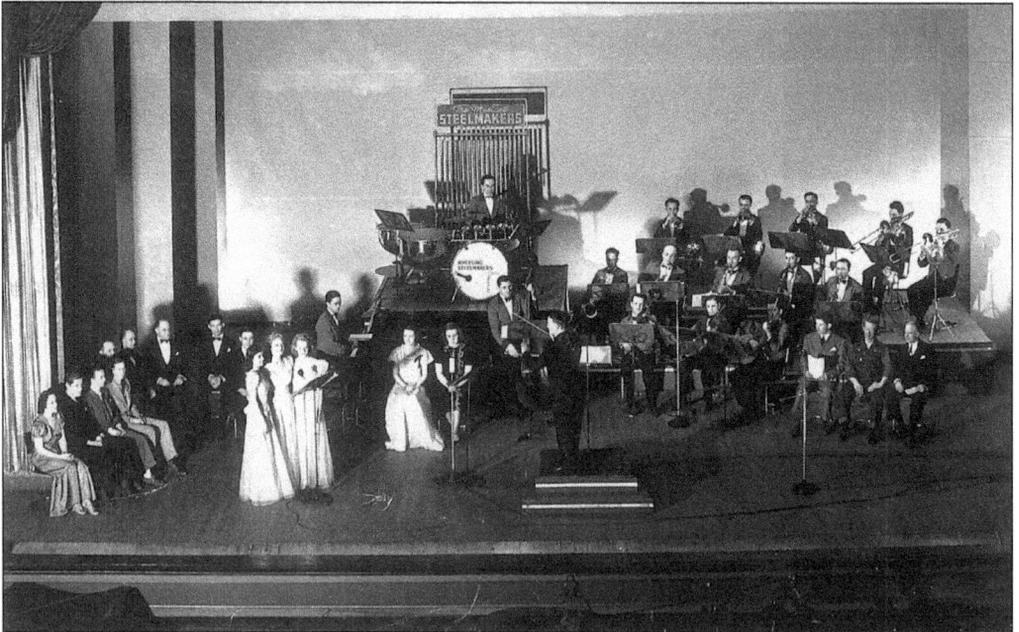

MUSICAL STEEL MAKERS. In 1931, Wheeling Steel Corporation got the idea of putting on a radio program using the musical talent of its employees. The "Its Wheeling Steel" and the "Listen to the Mill Whistle" programs enthralled listeners. They performed in New York City's Court of Peace for the 1939 World's Fair. The 326th program was performed on June 6, 1944. (Courtesy of Earl Summers Jr.)

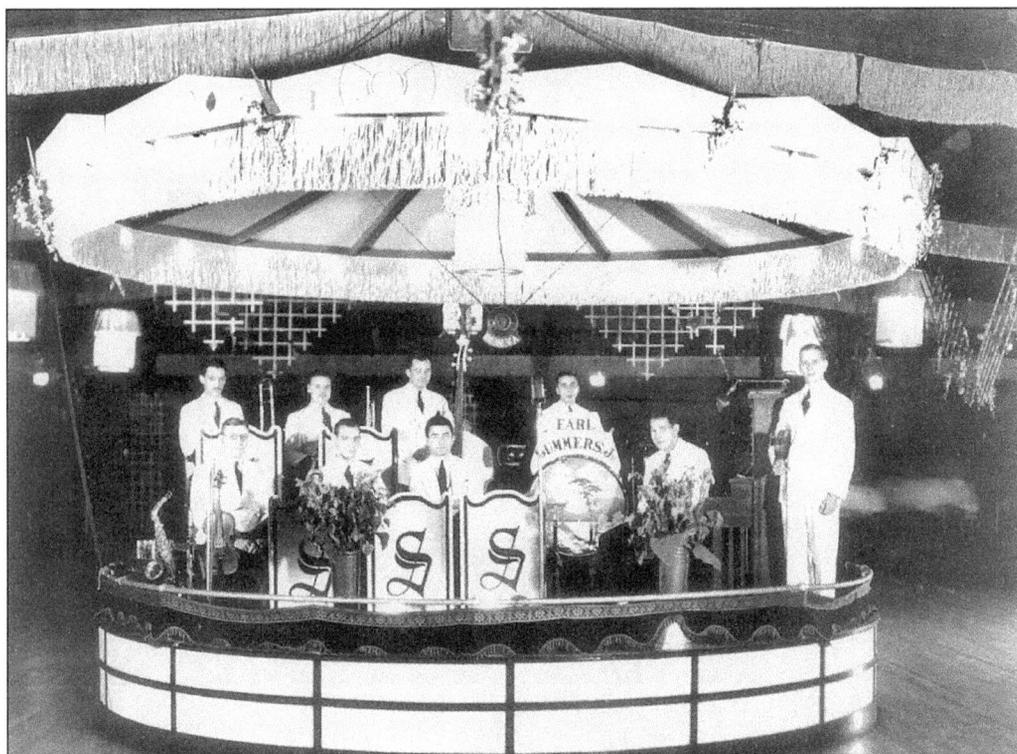

EARL SUMMERS JR. BAND. This lively band performed on WWVA and in many places around the valley. Earl Summers Jr. performed for local theater orchestras, played with the WWVA staff band, and was concert master of "Its Wheeling Steel" radio program from 1936 to 1944. He also performed in Wheeling Symphony's first concert in 1929. (Courtesy of Earl Summers Jr.)

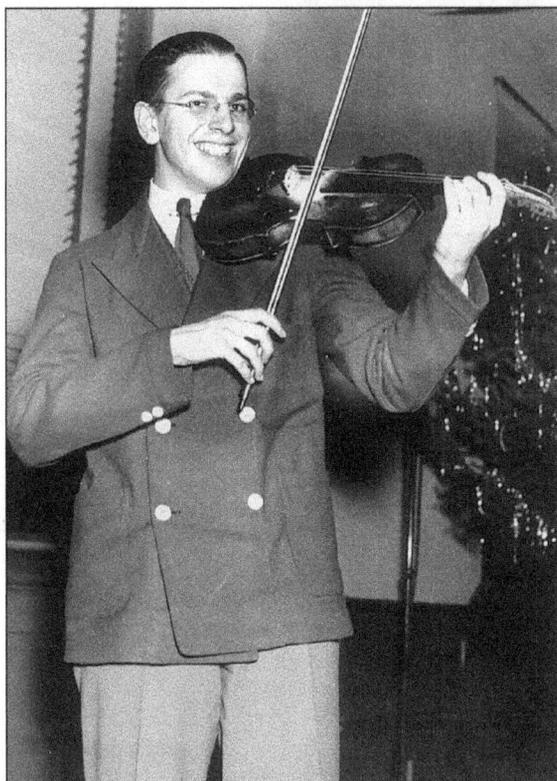

EARL SUMMERS JR. He held the titles of concert master emeritus of the orchestra and president emeritus of Local 142 American Federation of Musicians. He was the first violinist of the Columbus Symphony Orchestra, the Pittsburgh Opera Orchestra, and the Pittsburgh Ballet Orchestra. Mr. Summers once played with Fats Waller. He was arrested with Red Skelton for playing in a burlesque show at the Empire Theater in Wheeling. At the time, Earl was 14 years old. (Courtesy of Earl Summers Jr.)

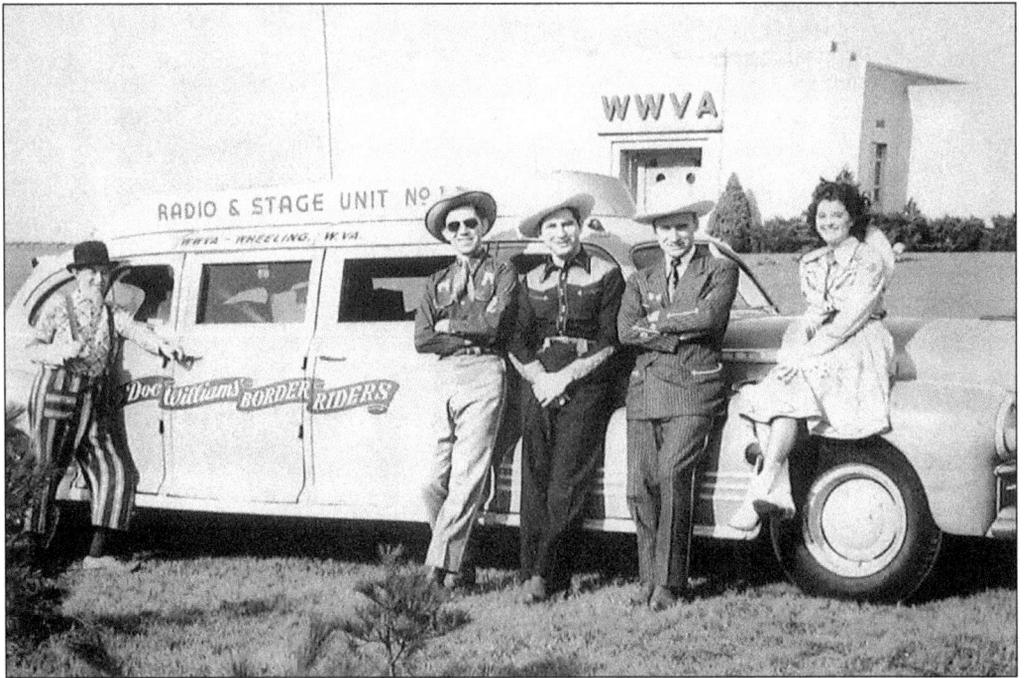

DOC WILLIAMS, 1947. This photo shows Doc Williams, Chickie Williams, and the Border Riders. Doc Williams, born Andrew John Smik, has been associated with the WWVA Jamboree since 1937. He is the oldest living member of Jamboree USA. Doc was listed by gubernatorial proclamation as "West Virginia's Official Country Music Ambassador of Good Will." While I was living in Japan, I had the opportunity to meet Japan's number one country music star, Charlie Nagatani, at his bar in Kumamoto. When I told him that I was from Wheeling, West Virginia, he said "Oh, you must know Doc Williams." (Courtesy of WWVA.)

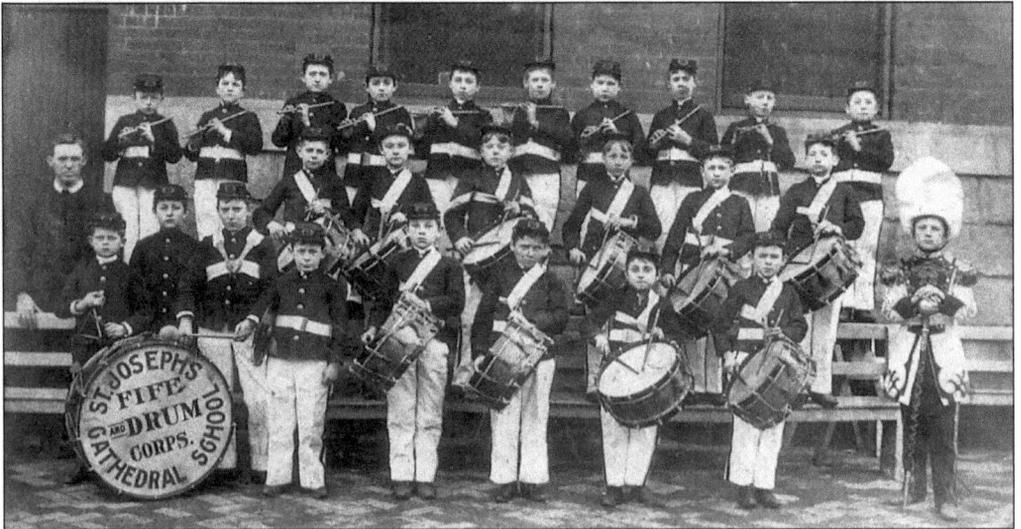

ST. JOSEPH'S CATHEDRAL FIFE AND DRUM CORPS, C. 1920. The first church on this site was St. James Church constructed in 1847 and 1848. When Wheeling became a diocese in 1850, St. James became a cathedral. It was renamed St. Joseph's Cathedral in 1872. (Courtesy of the Wheeling-Charleston Diocese.)

Six

BLUE COLLAR

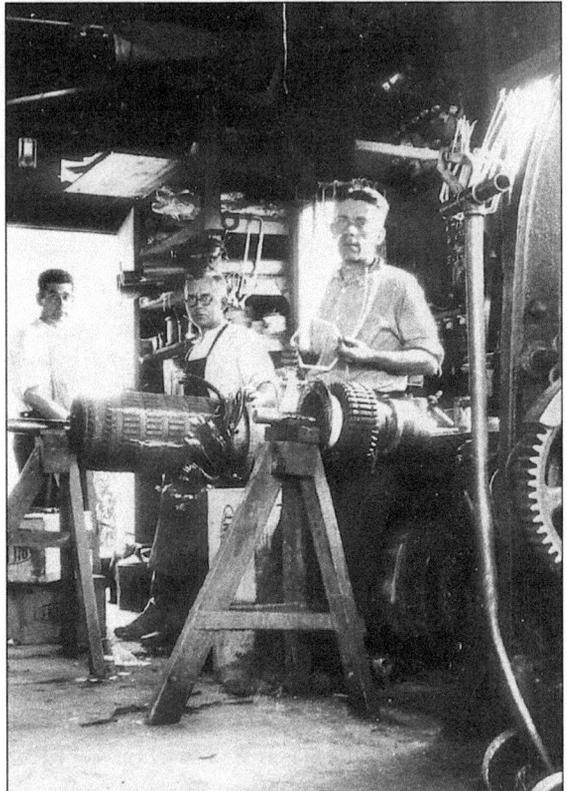

WARWOOD ARMATURE REPAIR.
Raymond Thalman is the man
standing in the middle rewinding a
DC armature machine. He founded
this company in 1927 in his garage at
431 Hazlett Avenue, which is where
this photo was taken. The family still
operates this successful business in
their modern factory at 128 North
Seventh Street. (Courtesy of Warwood
Armature Repair.)

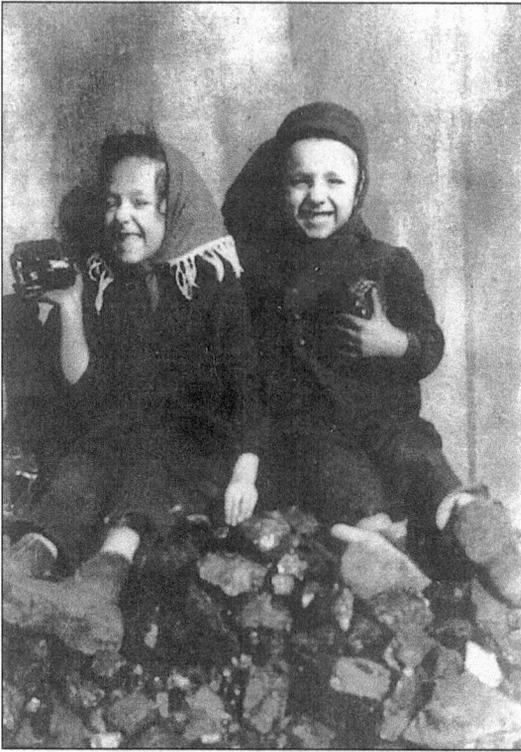

KIDS IN A COAL BIN, 1944. While their father was off fighting in the Pacific, these two children from Orchard Avenue are playing in their new shipment of coal. Families received one load to last the winter, which was shoveled through a small door under their steps. Upon seeing this photo, the girl on the left, immediately noticed her "Year Three Coat." During the lean years of WWII, an extra large coat would be bought, which came to the fingertips. The next year the same coat would be at the wrist and the third year it would be mid forearm.

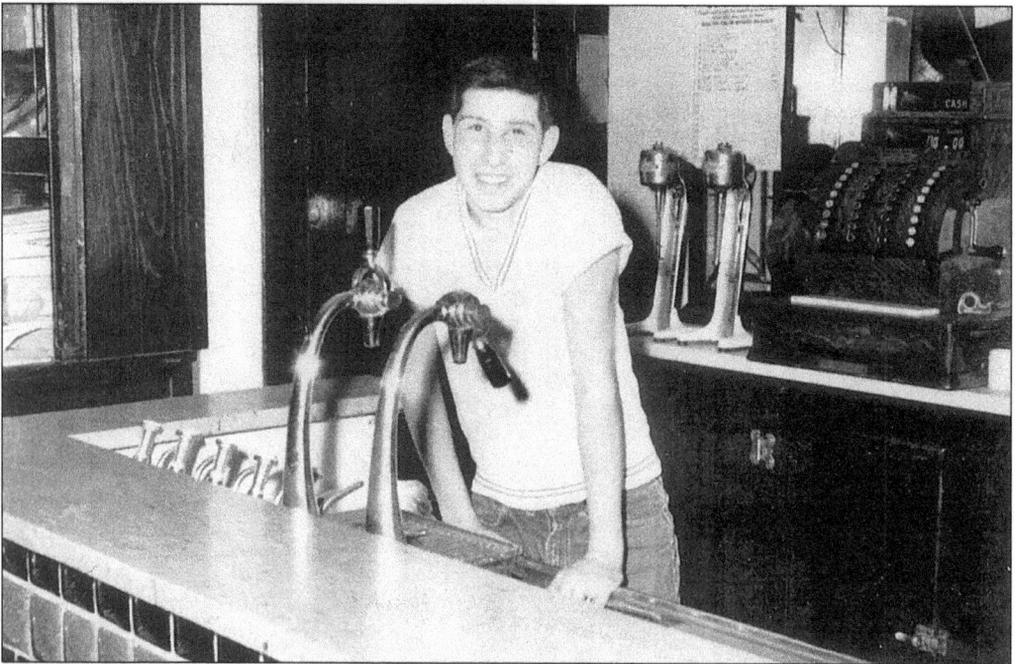

SODA JERK. This photo was taken on October 28, 1954 and shows Lee Wigal working at Hoge Davis Drugstore on 17th and Warwood Avenue. Mr. Wigal was a basketball player for Warwood High School and this was his after-school job. He would later work for Wheeling Pittsburgh Steel for over four decades. (Courtesy of Lee Wigal.)

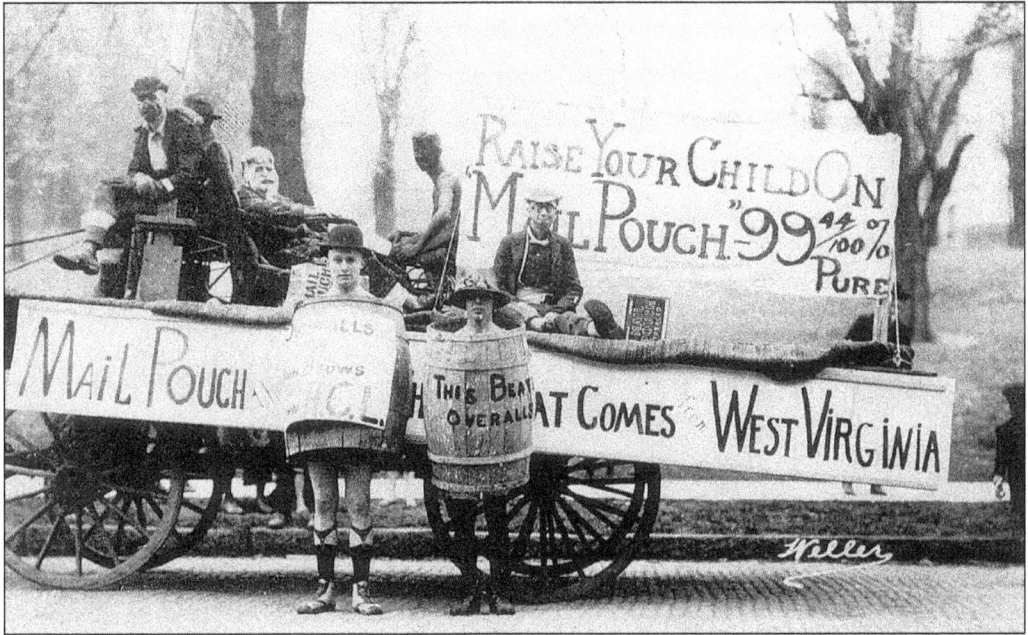

RAISE YOUR CHILDREN ON MAIL POUCH. Although the Bloch Brothers were famous for advertising on the sides of barns, they never missed an opportunity to place their product before the buying public. The float in the photo was probably for the 1913 State Semi-Centennial and was meant to bring a smile the audience. (Courtesy of Creative Impressions.)

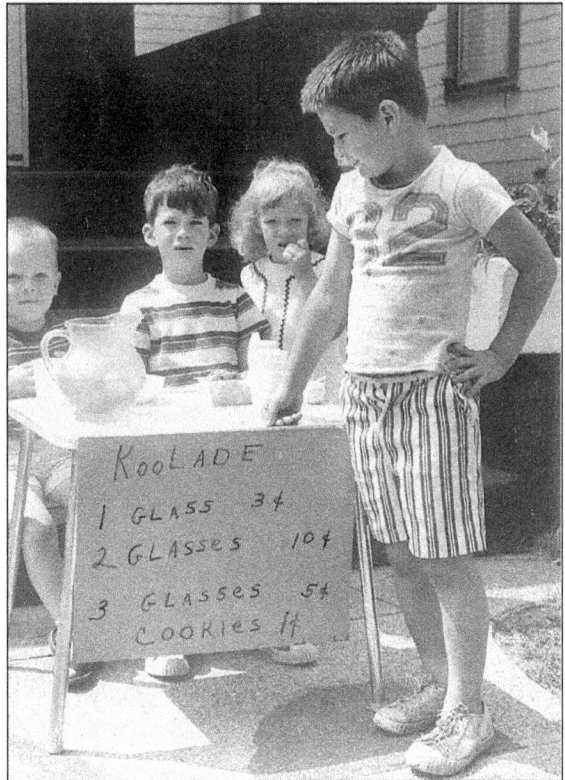

KOOL-AID STAND, HOT SUMMER DAY. This stand on North 18th Street had some unusual pricing. A nickel was larger than a dime or penny so it must be worth more. This article from Wheeling appeared in newspapers around the country. Connie Stuart, Mrs. Nixon's personal secretary, brought this photo to the First Lady's attention to show her kids from Connie's hometown. (Courtesy of Skip Olsen.)

LA BELLE PLANT OF WHEELING PITTSBURGH STEEL CORPORATION. A worker is placing a feeder rod into a hand-fed cut nail machine. Wheeling was famous for making quality cut nails, which had four sides and square corners. This city has always led the nation in cut nail production. (Courtesy of the Library of Congress.)

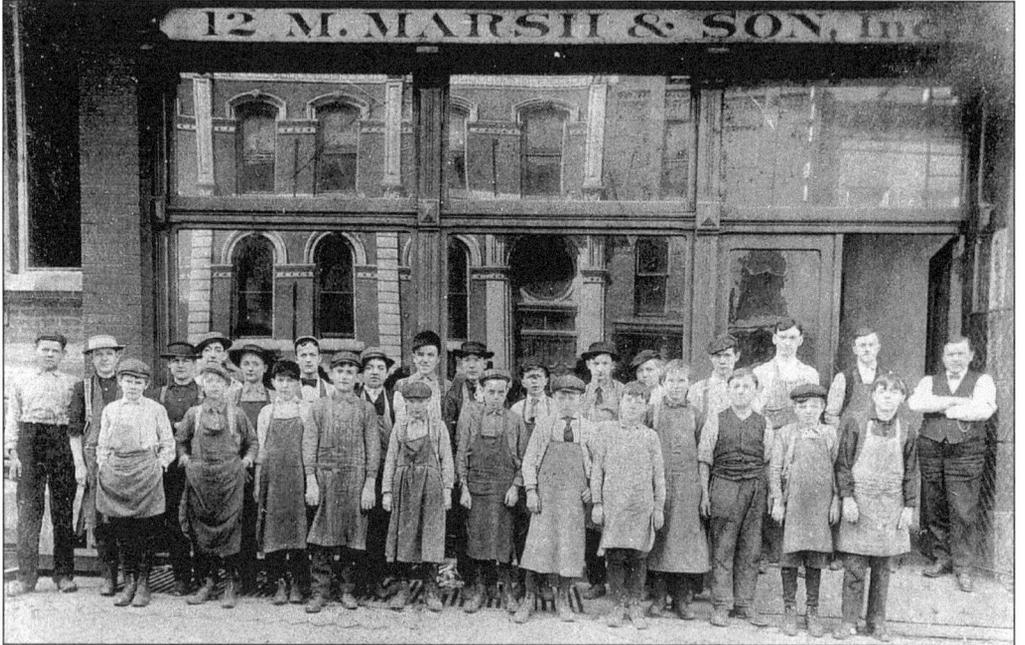

M. MARSH & SONS, INC. This stogie manufacturing company was founded in Wheeling in 1840. Mifflin Marsh began selling hand-rolled cigars out of a market basket to passengers and crews of steamboats. By 1900, Wheeling had nearly 100 small and large stogie companies. M. Marsh stands in the doorway keeping watch over his under age employees. This photo was taken before West Virginia enacted its child labor laws.

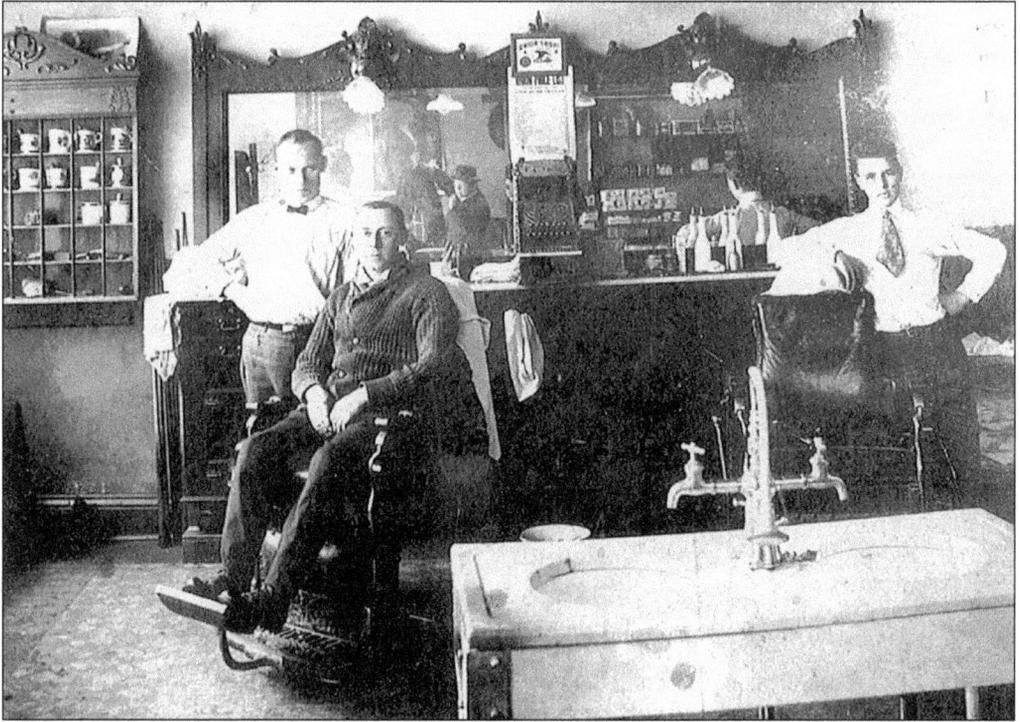

DITTMAN BARBERSHOP, C. 1908. Howard Dittman's barbershop was located at 21 22nd Street and speaks to a time when the barbershop was an all-male hangout. Notice the reflection of the photographer in the mirror. (Courtesy of Ray Huff.)

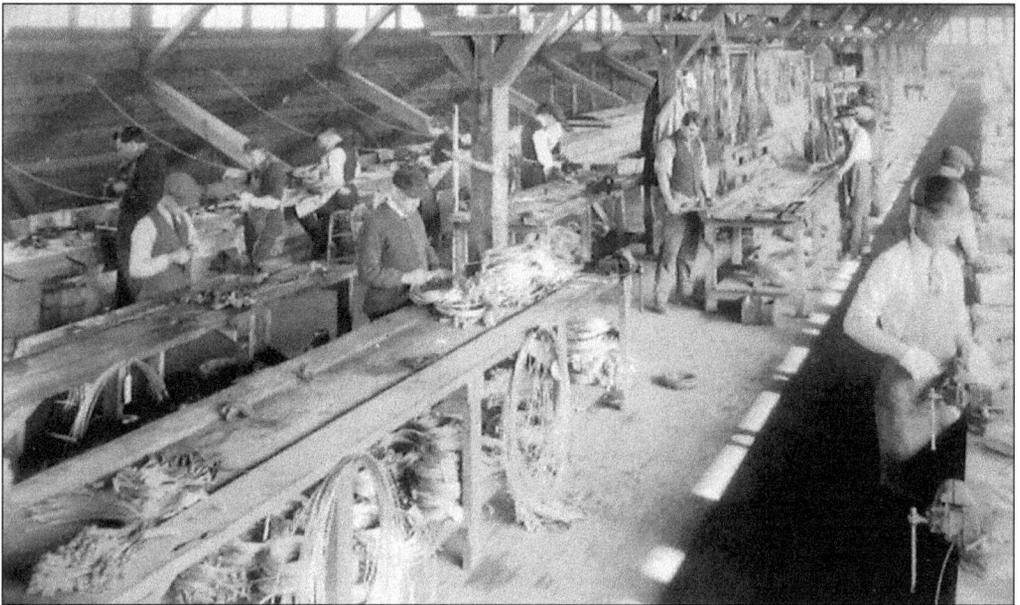

WIRE DEPARTMENT, WEST VIRGINIA AIRCRAFT COMPANY, NOVEMBER 1918. This company lasted roughly from 1917 to 1925. During the brief time in business, they supplied vital airplane parts for the Allies during WWI. They also made parts for the West Virginia Flying Corps, which was located in Beech Bottom. (Courtesy of David B. McKinley.)

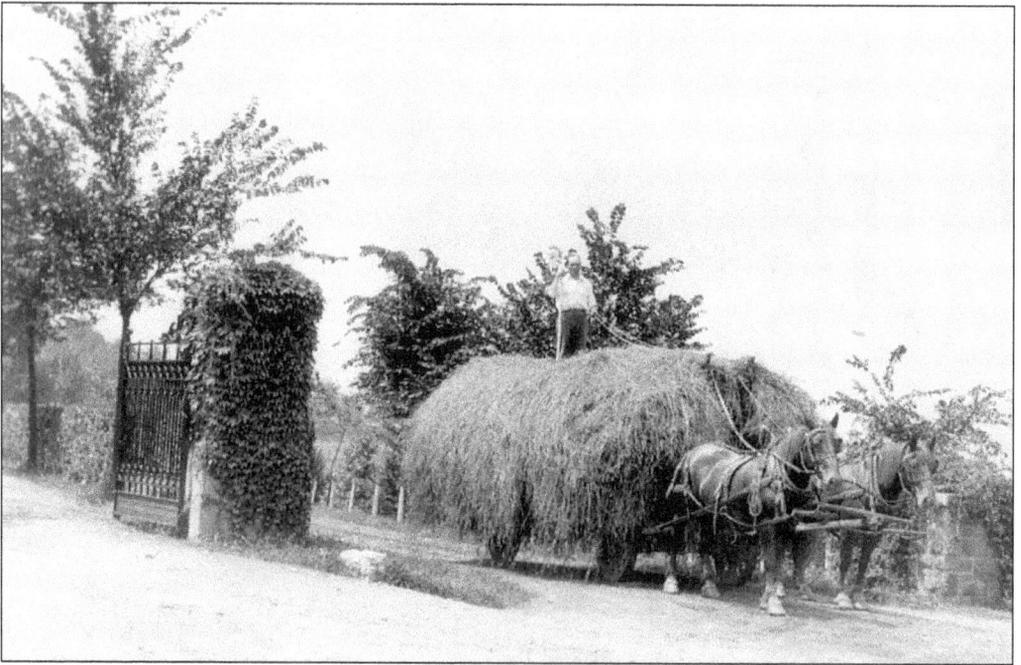

ALFALFA FARMER, OGLEBAY PARK, 1915. This alfalfa wagon is heading north on Route 88 and is preparing to turn into the gates of Waddington Farm. This photo was taken at the top of Serpentine Drive, which no longer exists. From 1900 to 1926, Waddington Farm was a working farm and many laborers were needed to care for the land. (Courtesy of Wheeling Park Commission.)

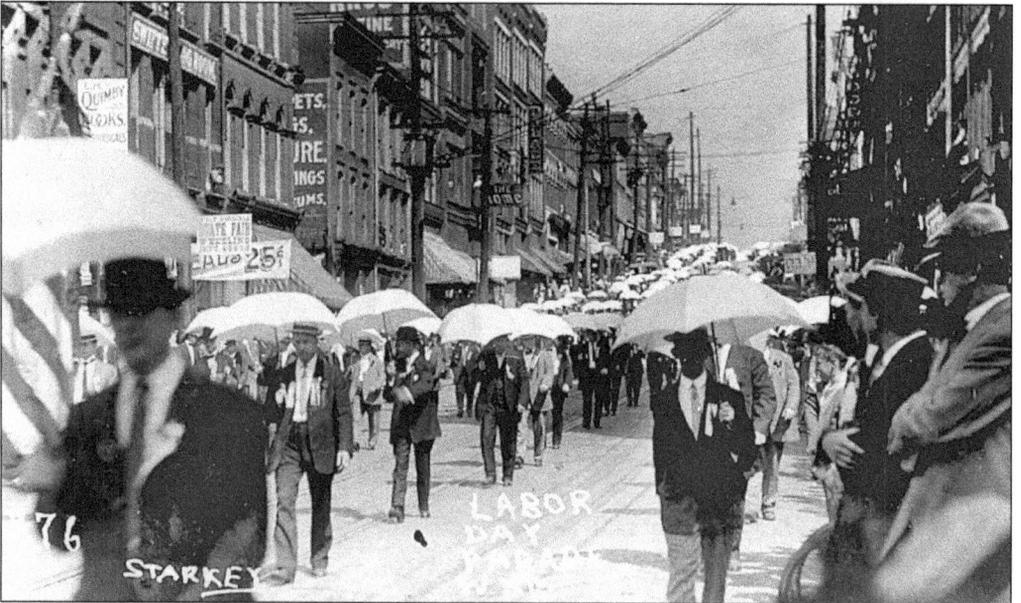

LABOR DAY PARADE, SEPTEMBER, 1918. At the beginning of the 20th century, Wheeling was the biggest industrial power in the state and labor unions were very visible. The largest labor organization of the day was the Ohio Valley Trade & Labor Assembly. West Virginia's labor history is both bloody and proud. Did you notice the sign on the left that offers meals for 25¢?

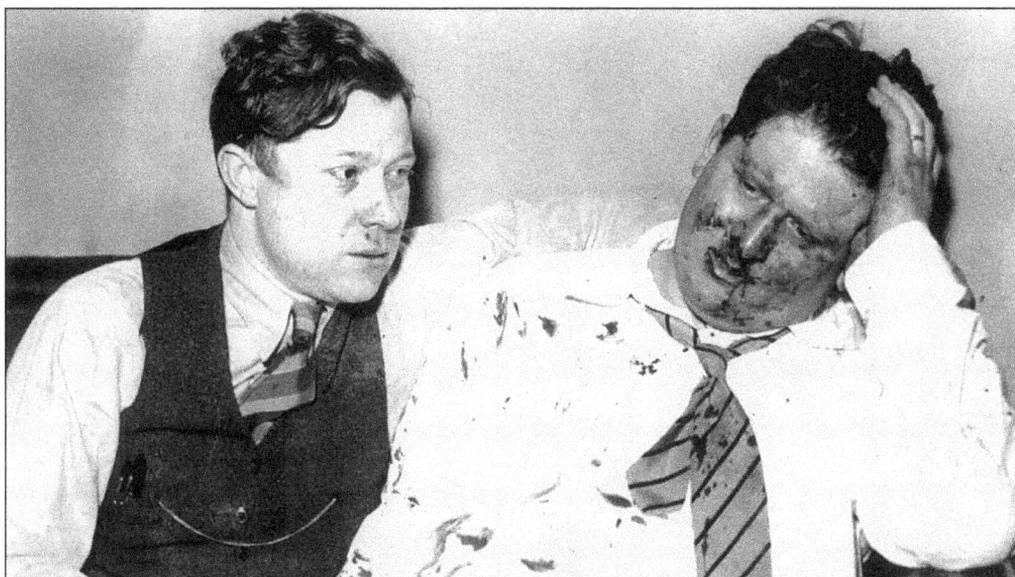

WALTER REUTHER, MAY 26, 1937. A bloody Walter Reuther, left, consoles his friend Richard Frankensteen after the famous "Battle of the Overpass." This battle had men from the Ford Service Department attack United Auto Workers organizers. Walter Reuther (1907–1970), was born in Wheeling and began working in our steel mills at the age of 16. In 1946, he became the president of the UAW and in 1952 became the president of the Congress of Industrial Organizations. He spoke at the March on Washington and had influence on civil rights leaders as well as with the President of the United States. (Courtesy of Walter P. Reuther Library, Wayne State University.)

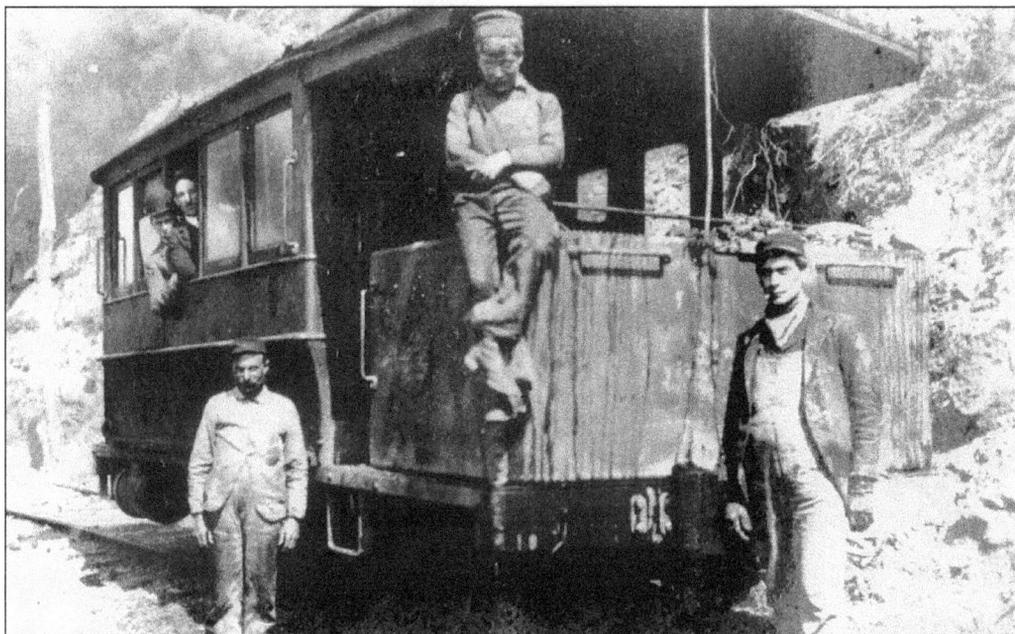

RAILROAD REPAIR CREW, C. 1905. These men could be called out at any time of the day to fix any problem with the track or train. The job was dirty, dangerous, and underpaid. (Courtesy of Tom Daily.)

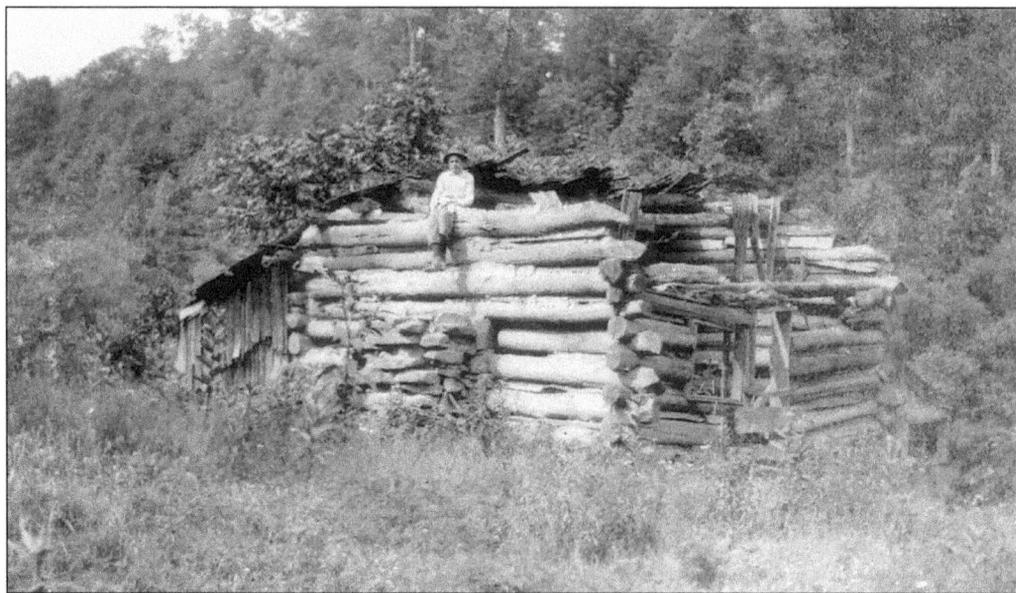

LOG CABIN, BIG WHEELING CREEK, 1912. Well in the 20th century old log cabins could still be seen. Many were still in use around Wheeling. Many of Wheeling's workers used their handyman skills to make these century old structures livable. (Courtesy of Kirk's Photo.)

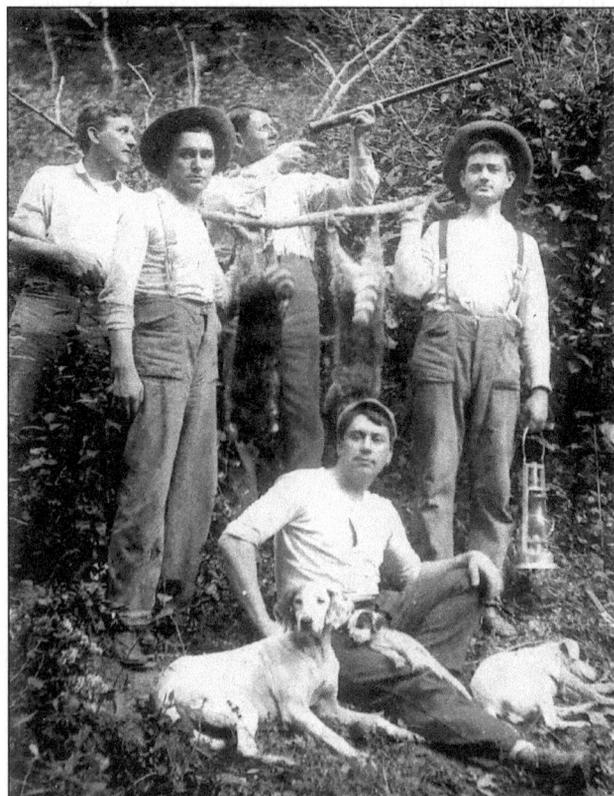

WHEELING HUNTERS, C. 1900. The woods around the city were so lush with game that they have always been a valuable resource. The name Wheeling is an Indian word meaning "place of the skull." Legend has it that the name came to be when a group of Indians killed a settler near Wheeling Creek for invading their sacred hunting ground. These men have caught two raccoons while two of their hunting dogs are catching a nap. (Courtesy of Oglebay Institute Mansion Museum.)

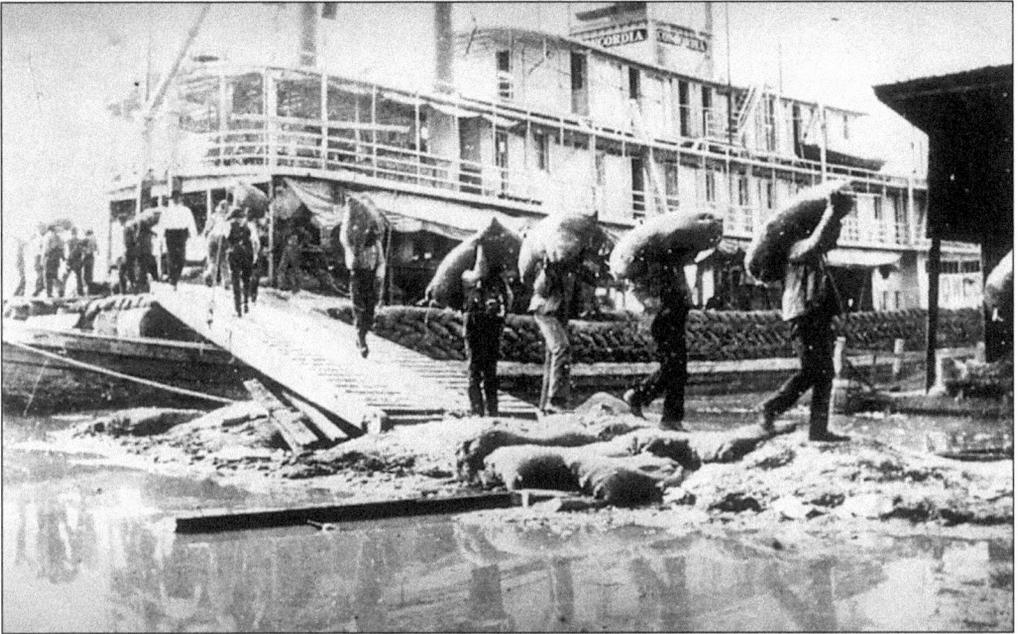

DOCK WORKERS, 1888. These men are unloading cotton from the "Concordia" in 1888. This job was also extremely dangerous. All of the cargo that Wheeling received from the river traffic had to be carried ashore and these men performed that thankless job. (Courtesy of Herb Bierkortte.)

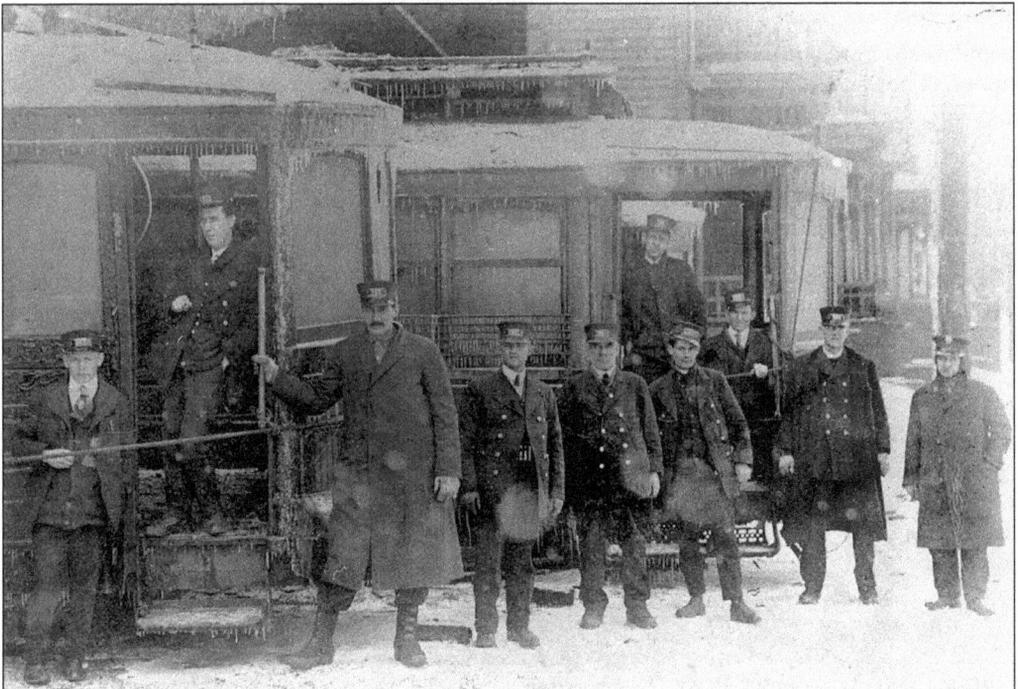

STREETCAR WORKERS, C. 1910. These men are trying to repair their cars after a brutal fire and then snow disabled them. They did take time to pose for this picture, especially the man standing inside the car to the left. (Courtesy of Gary Zearott, Zee Photo.)

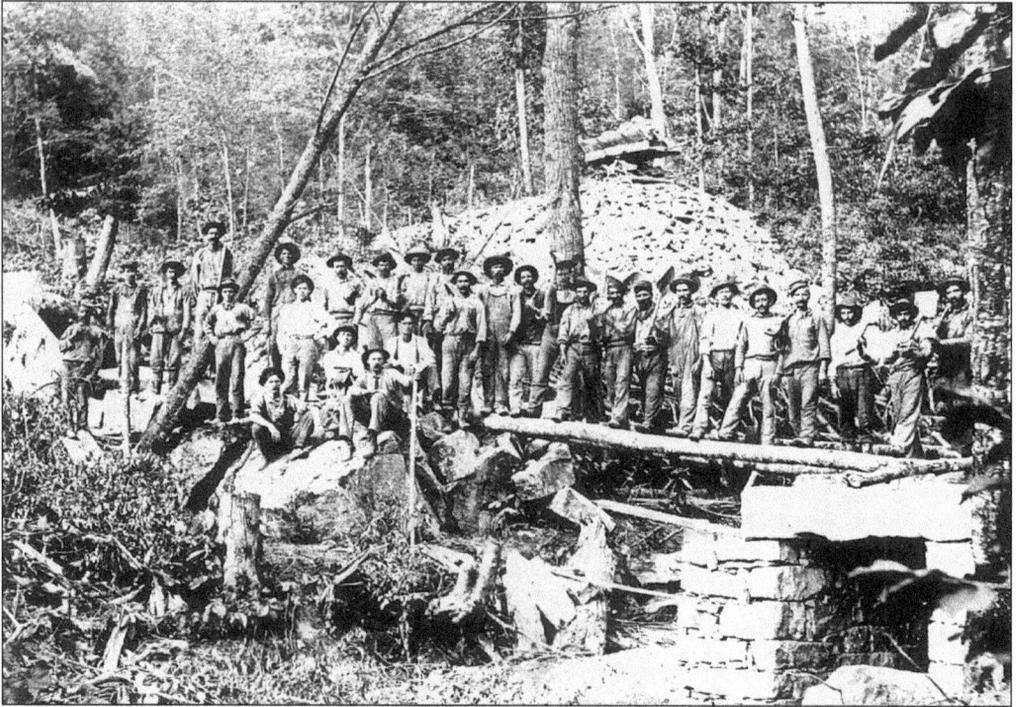

GREEK COAL MINERS AT WORK, 1895. These Wheeling coal miners were among the many Greek citizens who left their country at the turn of the century. An indifferent upper class, a 10% to 40% income tax, and mandatory military service combined to make for a very unhappy populace. Many came to the Ohio Valley for the numerous jobs along the river, rails, and in the mines. (Photo courtesy of Saint John the Divine, Greek Orthodox Church.)

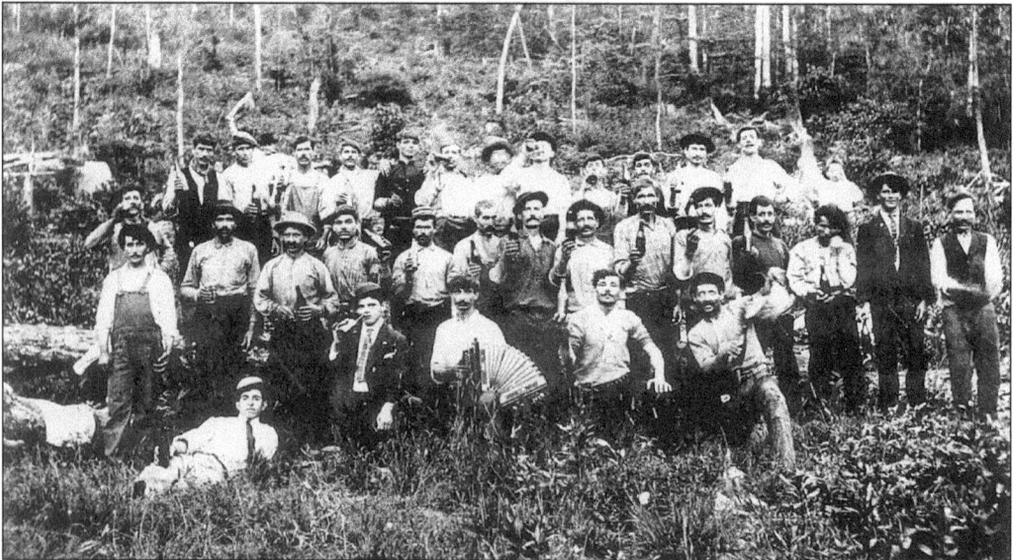

GREEK COAL MINERS AT PLAY, 1895. After a hard day in the dark mines, a local Wheeling beer, some music, and the clean outdoors seems like a great idea. Did you notice the accordion, the beer bottles, or the underage boy in the upper right taking a shot of brew? (Photo courtesy of Saint John the Divine, Greek Orthodox Church.)

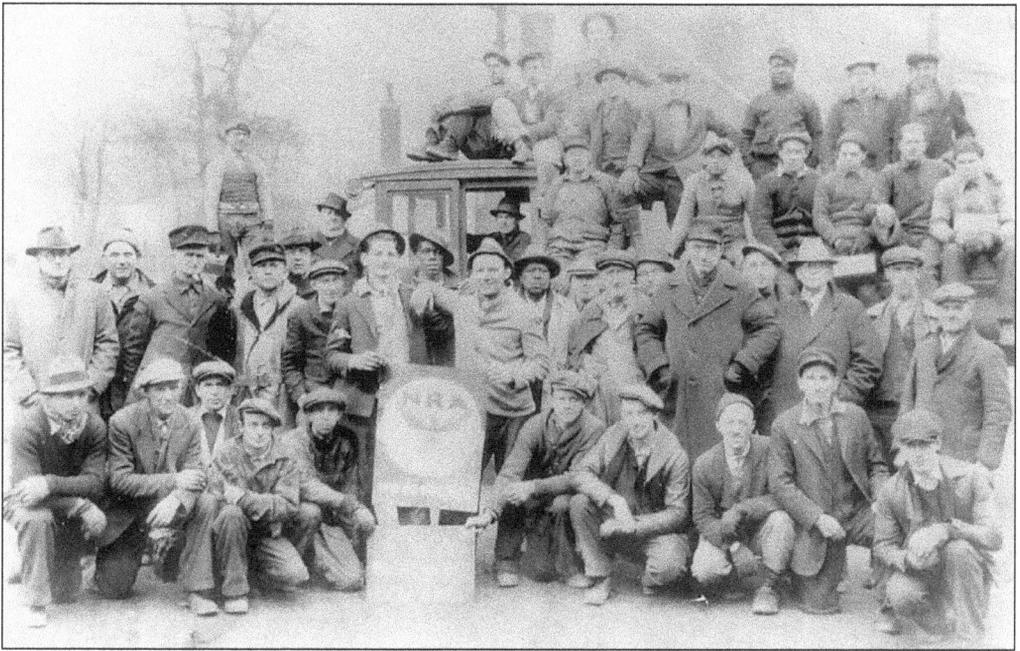

NRA Workers, 1937. This photo shows local workers from a National Recovery Administration (NRA) project on Wheeling Island. The NRA was a group of agencies from Franklin D. Roosevelt's New Deal program that tried to spur economic growth during the Great Depression. The blue eagle and "WE DO OUR PART" slogan on the sign were seen everywhere the program was in work. The handwritten CWA on the lower sign testifies that the men were working for the Civil Works Administration which built 225,000 miles of roads, 30,000 schools, and 3,700 ball fields during this time. (Courtesy of Kirk's Photo.)

Marsh Stogie Rollers, 1921. These men are hand-rolling Wheeling's famous Marsh Stogies. The arrow points to Mr. Raymond Schlag. Marsh stogies have reportedly been smoked by President Monroe, President Adams, President Lincoln, Sen. Henry Clay, Sen. Daniel Webster, General Lafayette, Gen. Sam Houston, Gen. Santa Anna, P.T. Barnum, Black Hawk, John Wayne, Andrew Mellon, Annie Oakley, and Moondog. (Courtesy of Eva Marie.)

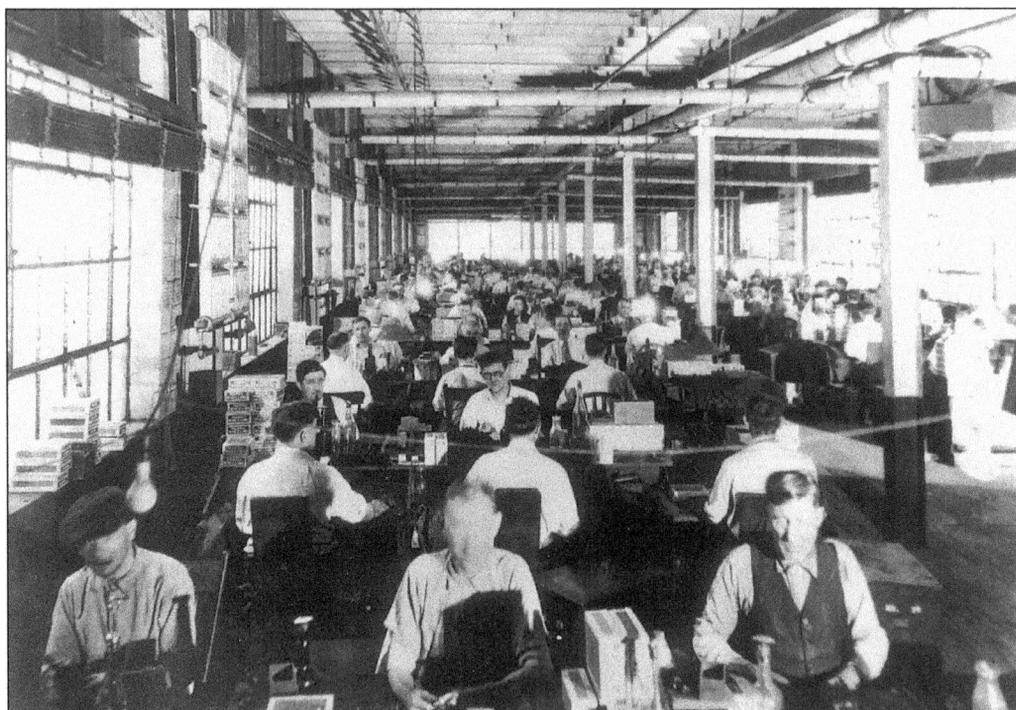

MARSH STOGIE ROLLERS, 1930. This photo was taken at the 914 Main Street building. At this time, Marsh had over 500 rollers. The Marsh Stogies box has appeared in several movies including *Jaws, Missing, How the West Was Won, Fool's Parade* and was where the mouse lived in *The Green Mile*. (Courtesy of Dorothy Parshall.)

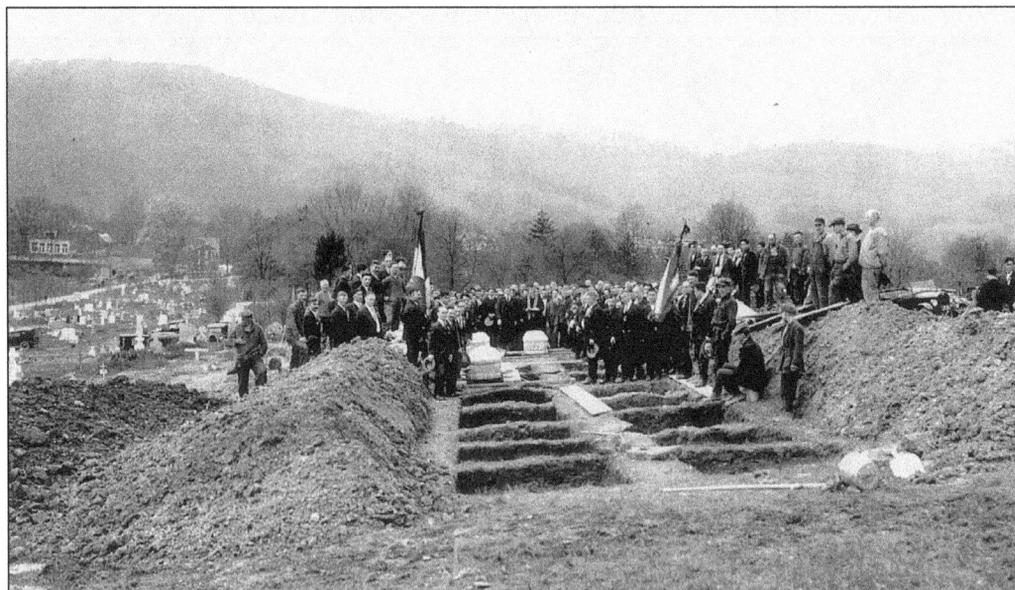

BENWOOD MINE DISASTER. On April 28, 1924, 119 men entered the Benwood Mine of the Wheeling Steel Corporation. At 7:05 a.m. the mine exploded killing all of the men. The photo shows the burial of 22 of the victims at Mount Cavalry Cemetery in Wheeling on May 5, 1924. This was the worst disaster for the local Wheeling area.

Seven

WHITE COLLAR

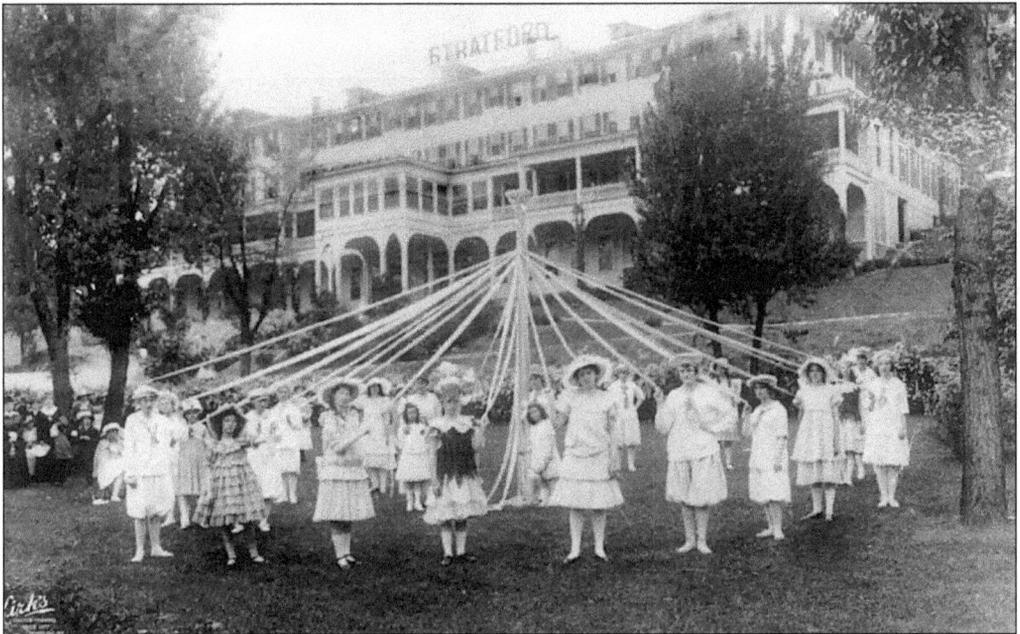

AROUND THE MAYPOLE, STRATFORD SPRINGS. May Day was celebrated by singing and dancing in circles around a maypole festooned with brightly colored ribbons. These young ladies are standing in front of the Stratford Springs Hotel. It officially opened on May 1, 1907 in the Woodsdale neighborhood in Wheeling. This grand old hotel had 84 guest bedrooms, which were used by some of Wheeling's wealthiest citizens. Many spent winters here because it was one of the few heated hotels in the area. It burned down in 1918 and was not rebuilt. (Courtesy of Kirk's Photo.)

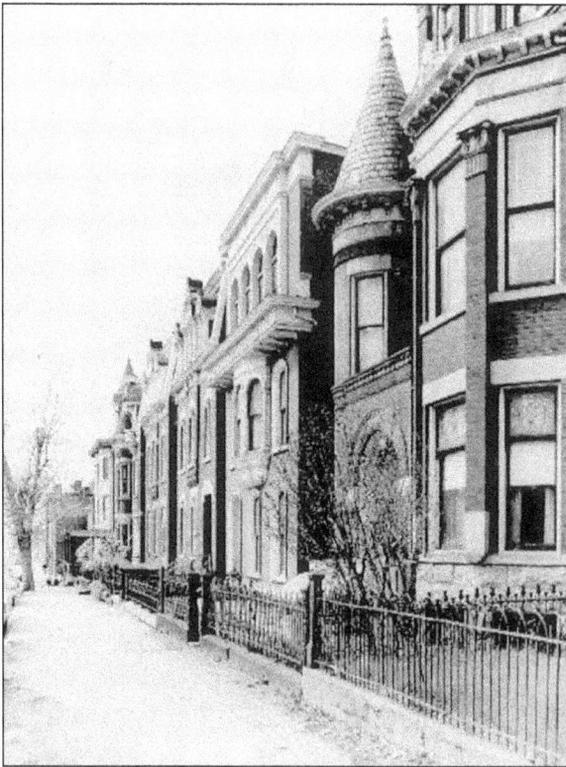

VICTORIAN WHEELING. This is a 1977 photograph of 2307 through 2319 Chapline Street. This block housed some of the wealthy merchants lived at the turn of the century. The millionaire Henry Schmulbach had an ostentatious dollar sign over his door and another on his gate. Most of the mansions on this street had a ballroom on the top floor for entertaining large parties. (Courtesy of the Library of Congress.)

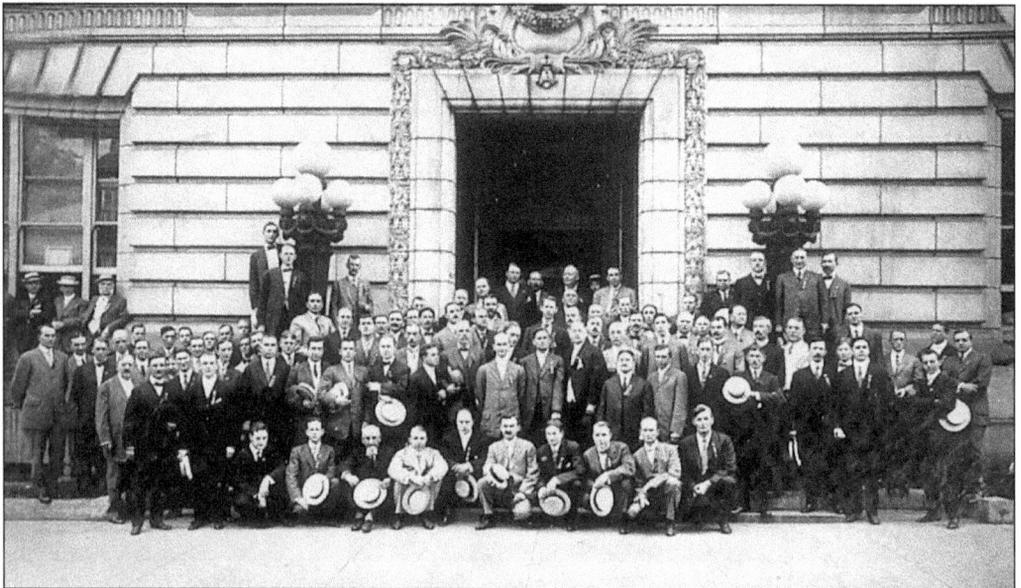

SIXTEENTH ANNUAL BANKERS CONVENTION. This group photo was taken in front of the old post office on 12th and Chapline Streets on June 16, 1909. During this time, Wheeling citizen William B. Irvine served as the president of the West Virginia Bankers Association and the National Bank of West Virginia. The latter is the oldest financial institution in the state. The convention served as a vehicle to promote both professional and social activities as well as holding seminars of taxation and investing. (Courtesy of Kirk's Photo.)

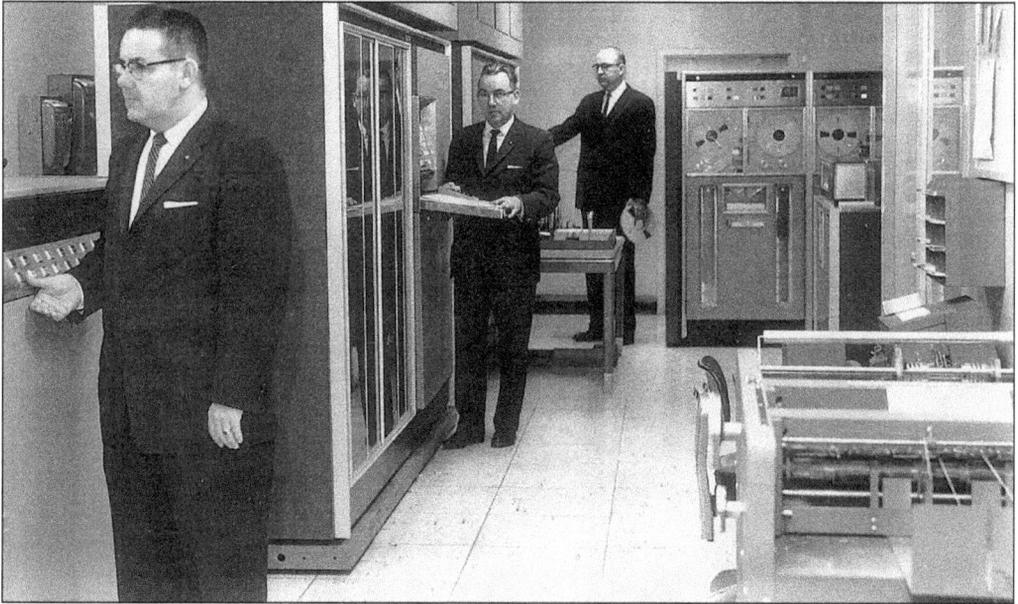

UNIVAC Computer. The Wheeling Pittsburgh Steel Corporation was quite proud of this Remington Rand UNIVAC Solid State 80 computer. Pictured are the following: William A. Carney Sr., supervisor of data processing; Albert H. Stender, commercial transactions accounting manager; and Joseph D. Adlam, manager of systems and procedures. The average laptop computer has more power than all of the machines pictured in this room.

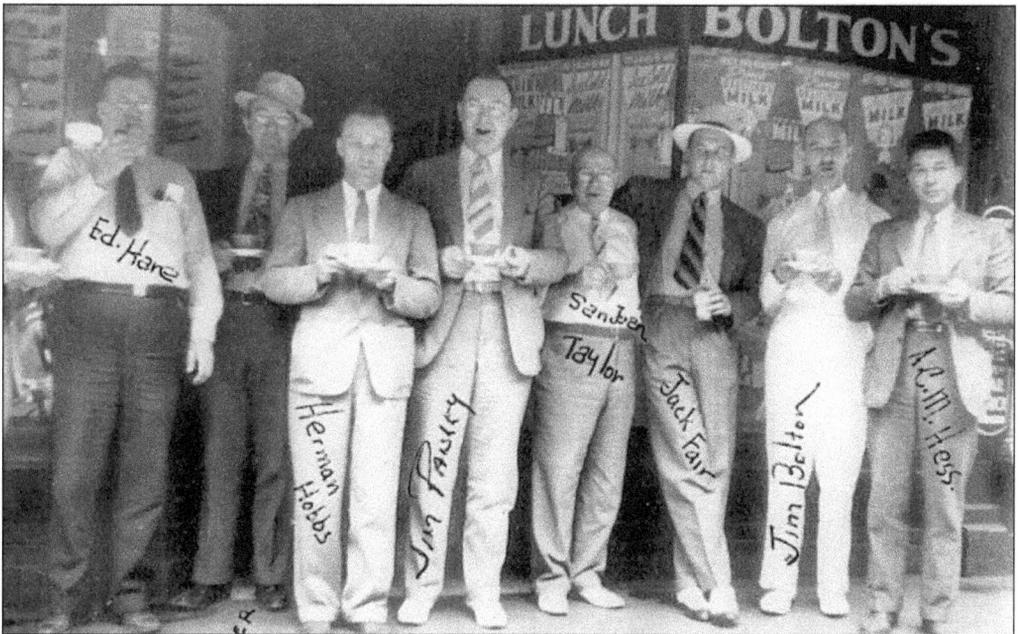

The Umbrella Club, Friday, June 2, 1939. The Umbrella Club was a group of local businessmen who would meet regularly at Bolton's on Market Street to discuss politics, sports, women, or whatever happened that day. Members from left to right are Ed Hare, A.R. Brewer, Herman Hobbs, Jim Paisley, San Juan Taylor, Jack Fair, Jim Bolton, and A.C. Hess. (Courtesy of Chris Hess.)

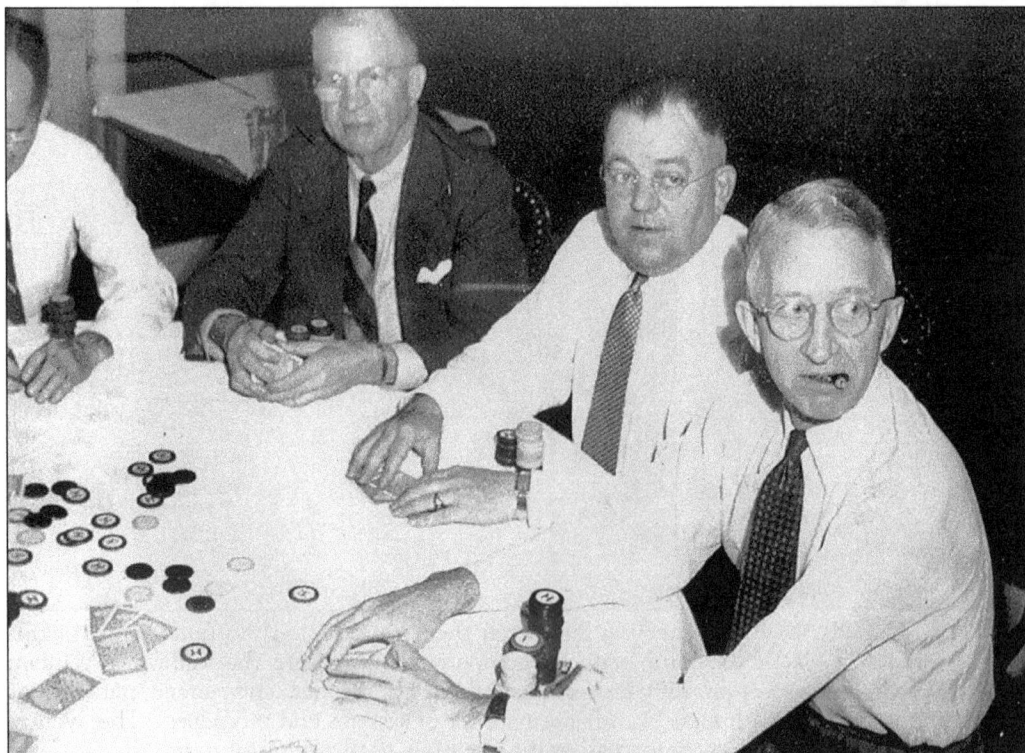

POKER GAME AT THE FORT HENRY CLUB. Wheeling's elite businessmen would meet here for dances, dinner, and five card stud. The club was founded in 1890 and closed its doors to women in 1891. (Courtesy of Fort Henry Club.)

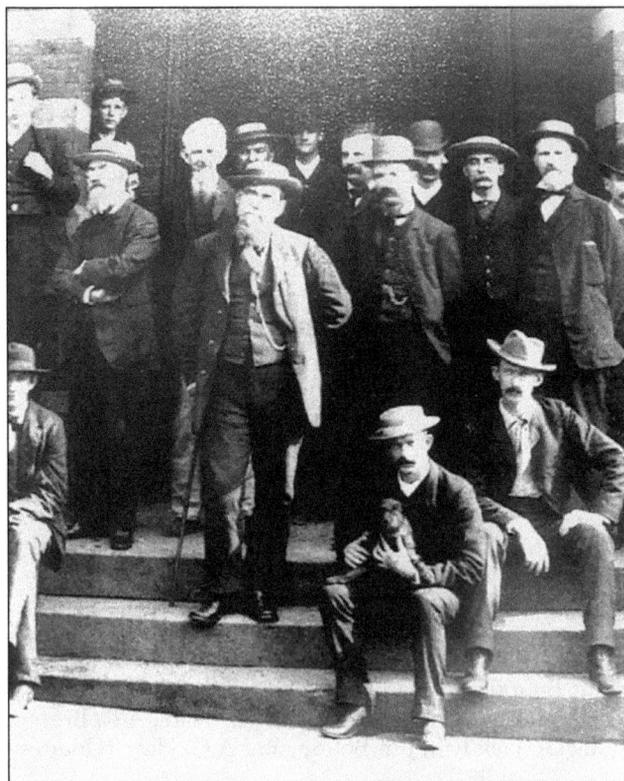

CITY LEADERS, C. 1870S. This photograph was taken on the east side of the old Court House Building. These city leaders included Mr. Heimburg, Mr. Pete Bosley, Mr. Seth Daris, Mr. John Voltz, Colonel W.P. Adams, Mr. Scrogins, Mr. Joseph R. Miler, Mr. Samuel Miller, Mr. Butler, and Mr. Wilmuth. The man with the cane is Col. Thomas O'Brien. The Colonel was an honorary title. (Courtesy of Frank O'Brien.)

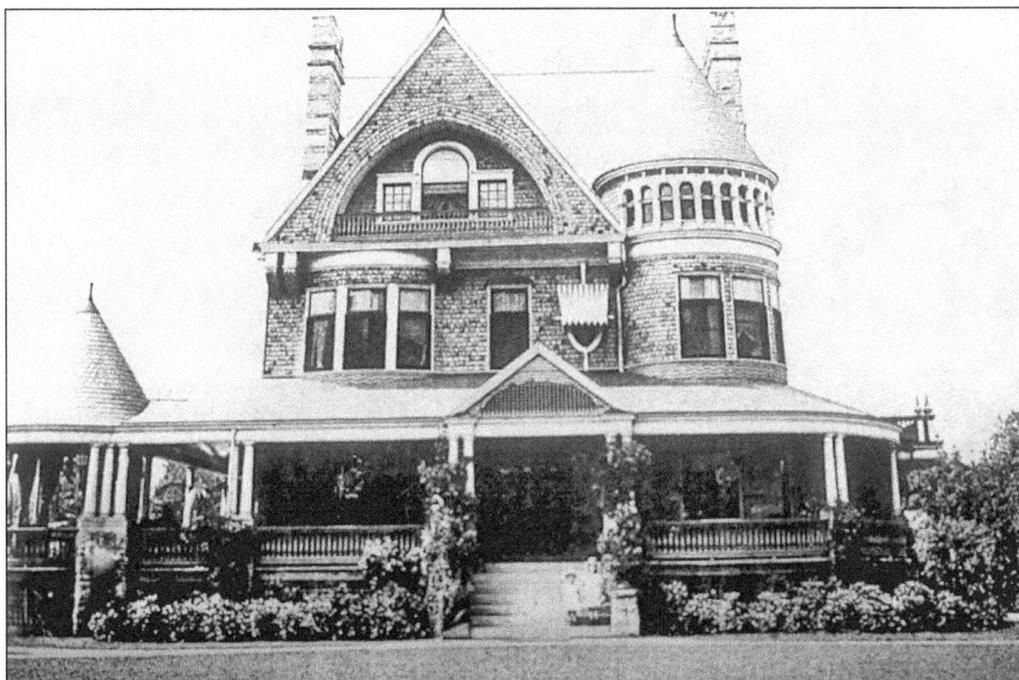

ELMHURST MANSION, 1902. Samuel Bloch, owner of Mail Pouch Tobacco, built this house and named it Elmhurst because of all the elm trees that surround it. The Queen Anne–style architecture was extremely popular during the Victorian era. This building, with its modern additions, still sits on National Road and is now a retirement community called Elmhurst, The House of Friendship. (Courtesy of Herb Bierkortte.)

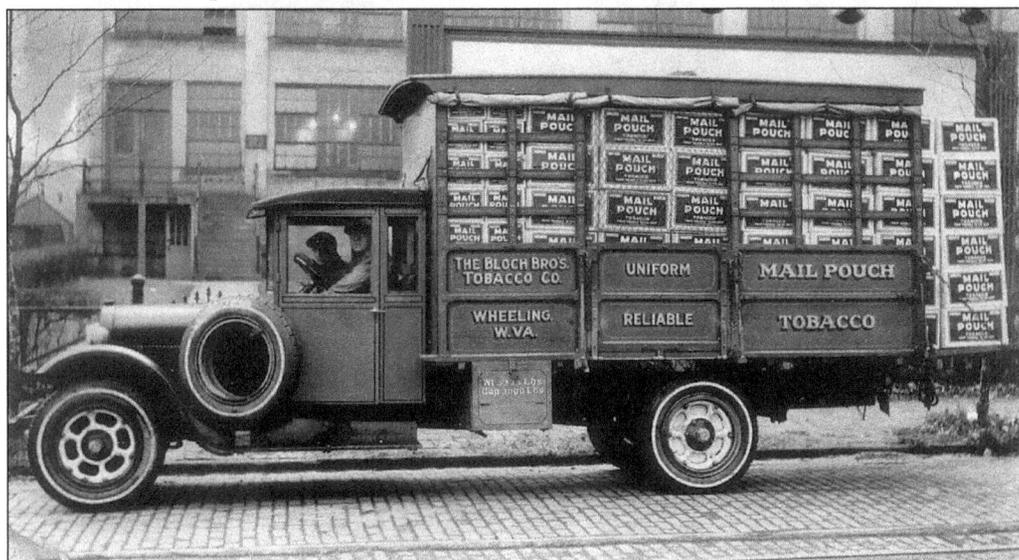

MAIL POUCH TRUCK. Numerous trucks filled with Bloch Brothers tobacco and advertising on the sides of barns helped make Samuel Bloch a very rich man. Samuel Bloch was elected president of Mail Pouch in January, 1902. In the 1940s and 1950s, Bloch's company began manufacturing other tobacco products including chewing tobacco, stogies, and high-grade pipe mixtures. (Courtesy of Fort Henry Club.)

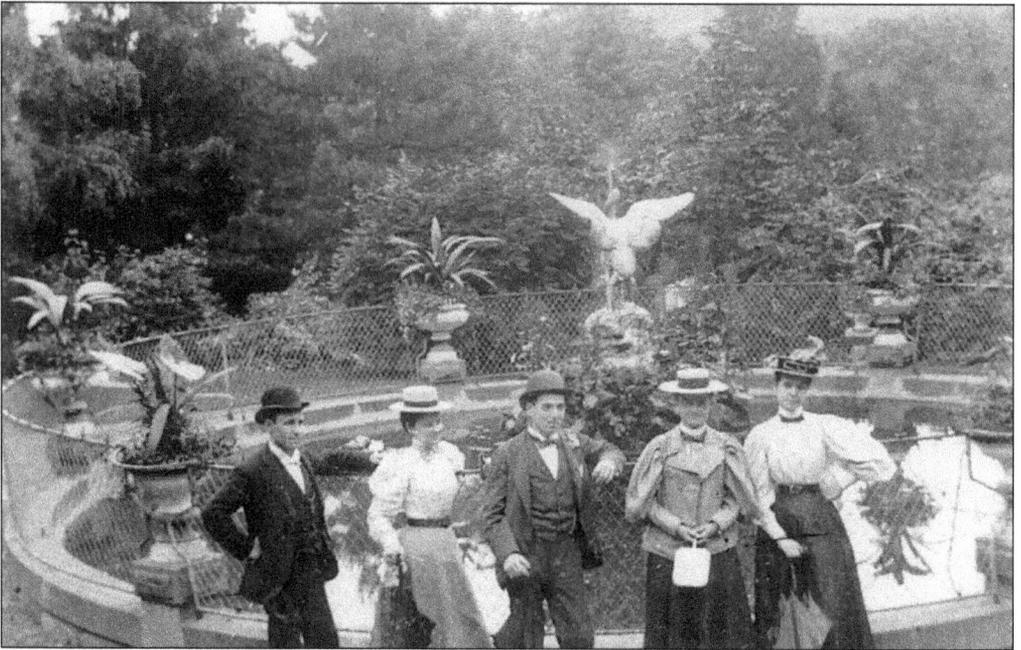

SOCIALITES AT THE FOUNTAIN, C. 1900. Many of Wheeling's citizens enjoyed going to the park where they could see and be seen by the rest of society. These people are dressed to impress. (Courtesy of Oglebay Institute Mansion Museum.)

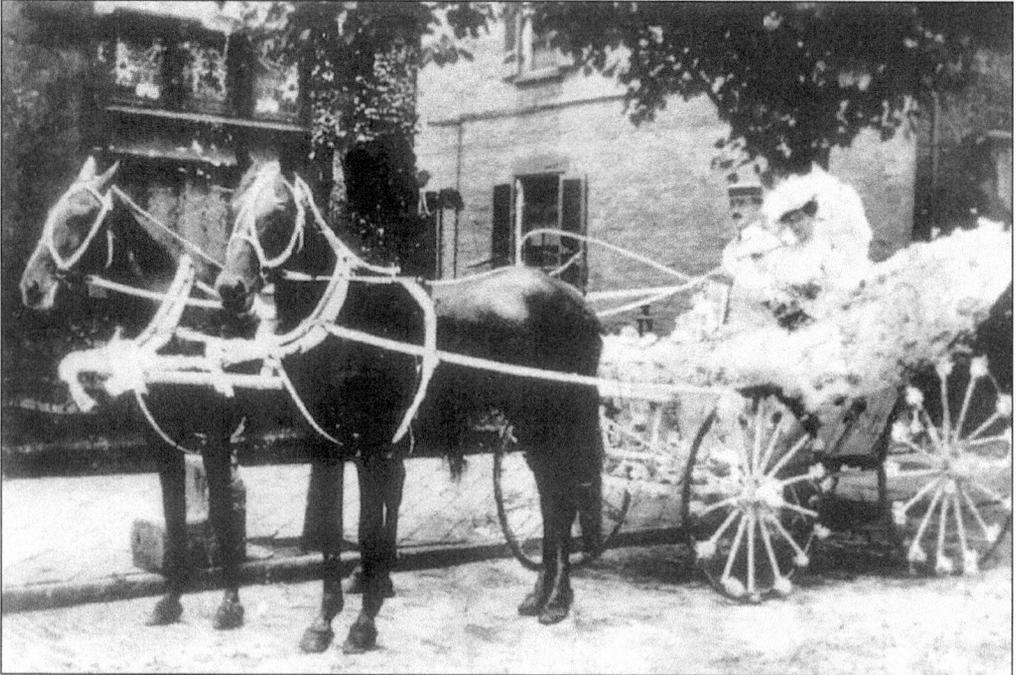

HUBBARD WEDDING, APRIL 30, 1901. Arthur Greer Hubbard is shown with his new bride, Mae Irwin Paul Hubbard. These two prominent Wheeling citizens were just married and are riding through town in the high style of the day. Notice the flowers on the spokes of the wheels and the brick street. (Courtesy of Fort Henry Club.)

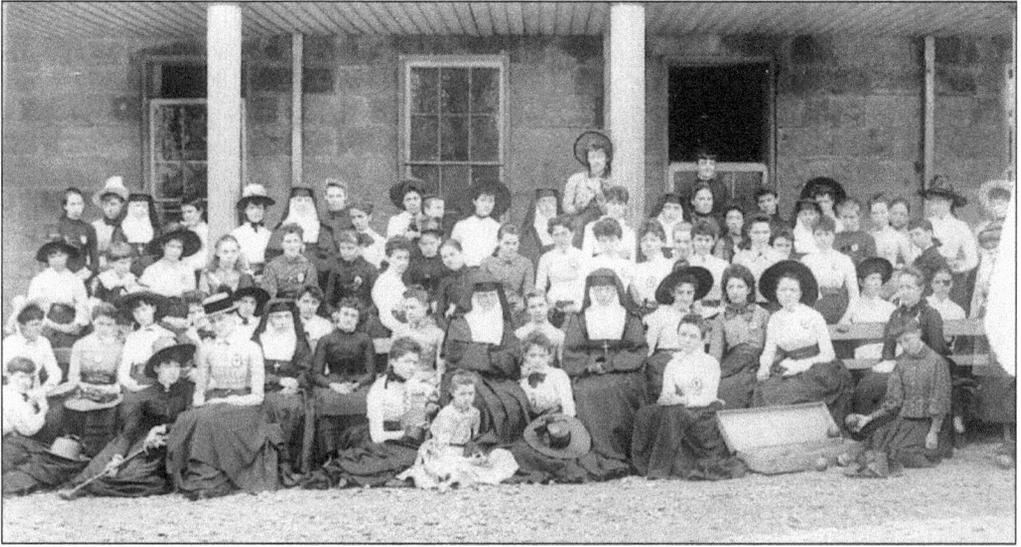

MOUNT DE CHANTAL, 1887. This photograph of the entire school was taken in front of the old wooden porch. The sister's names are written on the photo. Those in the photograph, from left to right, are as follows: (front row) Sister Benedicta Schuck, Sister Mary Clare Houston, and Sister Aimee Robertson; (back row) Sister Angela McHenry, Sister Mary de Sales O'Brien, Sister Xavier Slater, Sister Gertrude Reilly, and unidentified. Many of Wheeling's wealthiest families sent their daughters to Mount de Chantal. Did you notice the different bonnets, the crocket set, or the girl on the right with a patch on her eye? (Courtesy of Mount de Chantal Visitation Academy.)

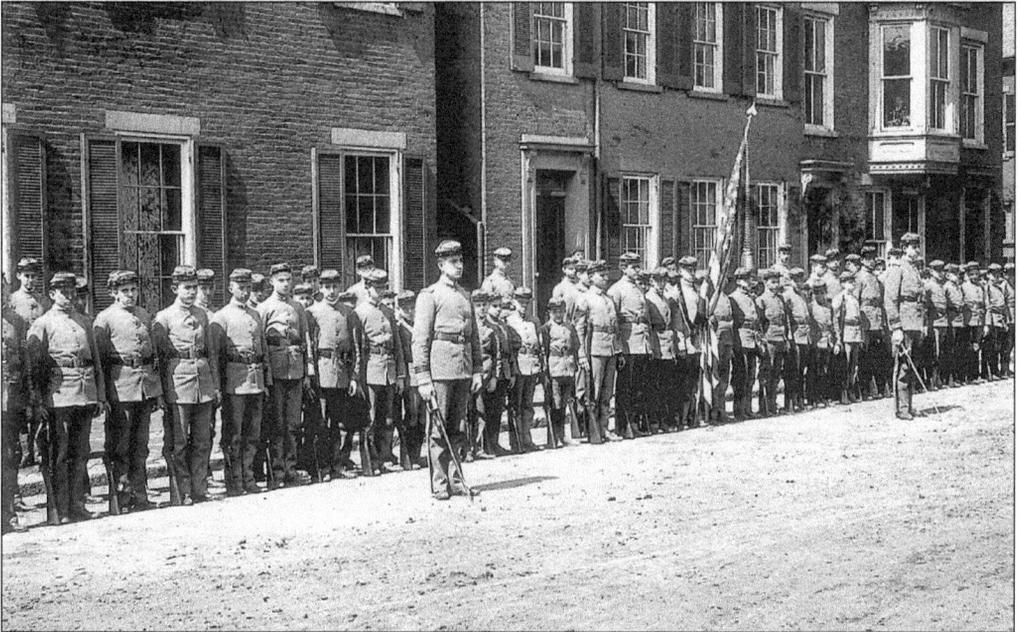

LINSLY BATTALION, 1891. These cadets are probably on Eoff Street near Linsly's second building at the corner of 15th and Eoff. Linsly's first building was at the corner of 13th and Chapline Streets. Linsly has been in four different locations in the city of Wheeling. Many of Wheeling's wealthiest families sent their boys to Linsly. (Courtesy of Robert W. Schramm.)

MICHAEL OWENS, INDUSTRIALIST. Michael Owens was the son of Irish immigrants and moved to Wheeling in 1869. He could easily be placed in this book's Blue Collar Chapter as he was active in the labor movement, especially Wheeling's Local 9 of the American Plant Glass Workers. He created many jobs with his inventions. (Courtesy of the Glass Packaging Institute.)

MICHAEL OWEN'S AUTOMATIC BOTTLE-BLOWING MACHINE. Owen's invention helped to revolutionize the glass industry and helped eliminate child labor from glass-bottle factories. In 1983, the American Society of Mechanical Engineers designated this machine as an International Historic Engineering Landmark. In 2003, Michael Owens was inducted into the Wheeling Hall of Fame. The United States Patent Office lists 1065 patents registered in Wheeling from 1790 to the present. These include a hanging ornament, an above ground pool cover, an illuminated golf ball, a drum dolly, and a cheese-like dairy gel. (Courtesy of the Glass Packaging Institute.)

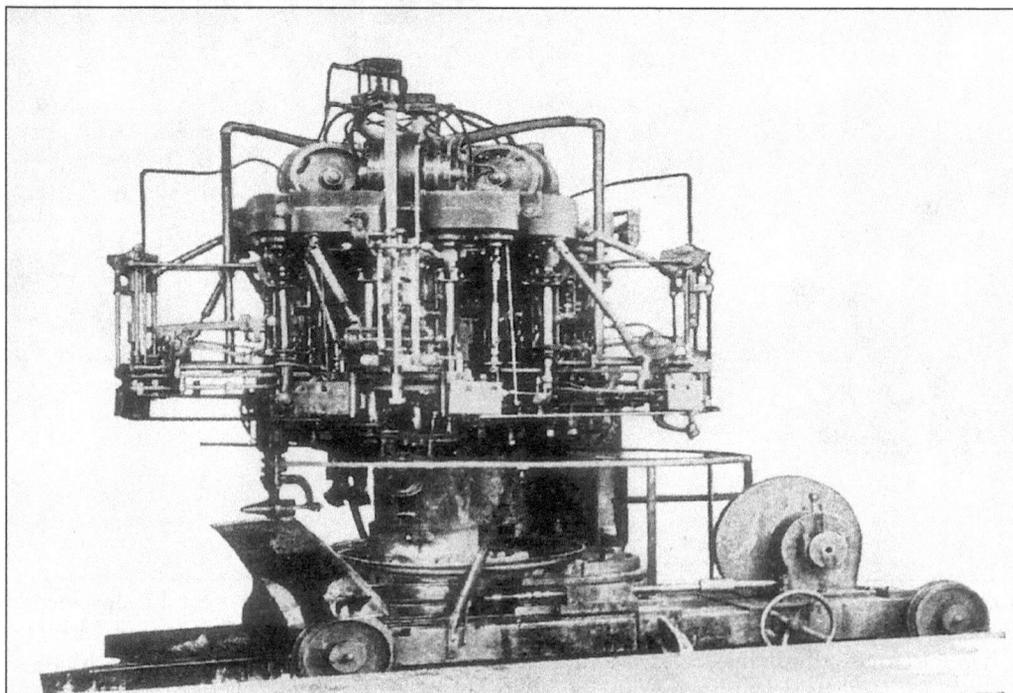

STIFEL BOOT. George E. Stifel (1849 to 1931) is admiring the flower arrangement inside a Stifel Boot, which was their trademark. The word Stifel in German means boot. George Stifel's family ran the calico works at Main and Fourth Streets. He built the Edemar Mansion on National Road, which was named for his children, Edward, Emily and Mary. This mansion today is the home of Oglebay Institute's Stifel Fine Arts Center. (Courtesy of Oglebay Institute's Fine Arts Center.)

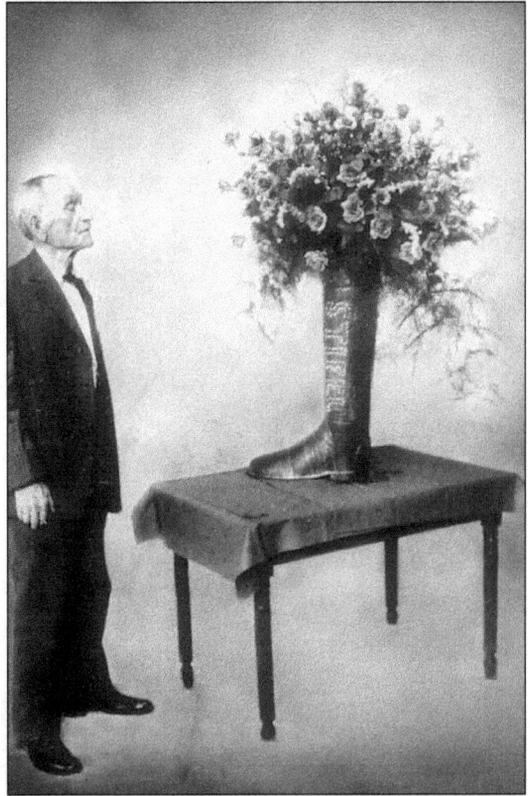

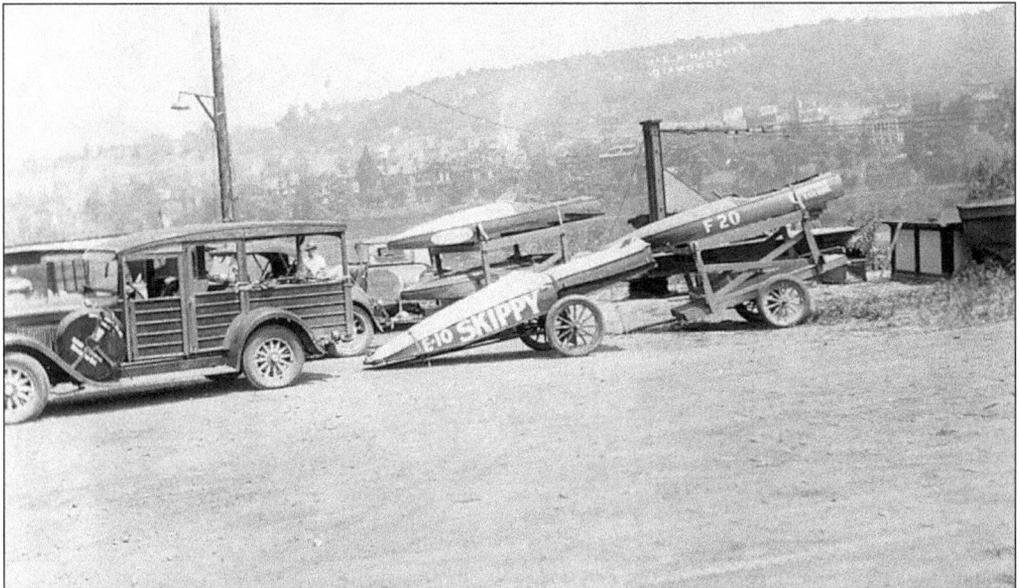

STIFEL'S FIRST OUTBOARD, C. 1910. Wheeling's affluent citizens enjoyed pleasure cruising, out boarding and yachting along the Ohio River. Postcards from this era show many boat races under the Steel Bridge.

ALEXANDER GLASS, (1858-1941). Alexander Glass was a giant in the steel industry as well as in the banking world. In 1890, he began the manufacturing of galvanized roofs and corrugated sheets. He was inducted into the Wheeling Hall of Fame in 1980.

WHEELING CORRUGATING COMPANY, 1890. Alexander Glass' company started in 1890 as a small cluster of wooden buildings near the Whitaker Iron Company. It soon grew to be leader in the field of finished steel products. This company made metal ceilings, ingots, tin templates, and a host of other materials.

Eight

HEROES

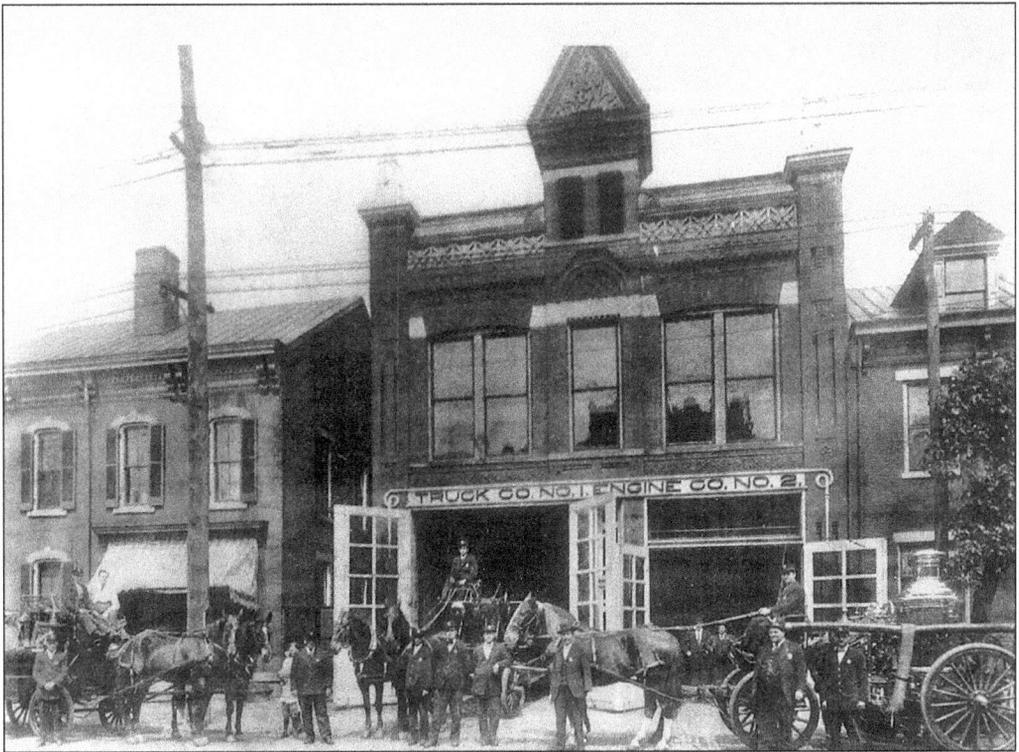

VIGILANT ENGINE HOUSE. This is the second fire house built on this site. The first was destroyed by fire on April 30, 1891. All of the firemen got out safely. This building was constructed in 1891 to replace the original structure. The Vigilant Fire House is topped-off with a bell tower. The bell tower has the 1891 construction date inscribed in its edifice. It is located at 648 to 650 Main Street and is still standing. (Courtesy of the Wheeling Fire Department.)

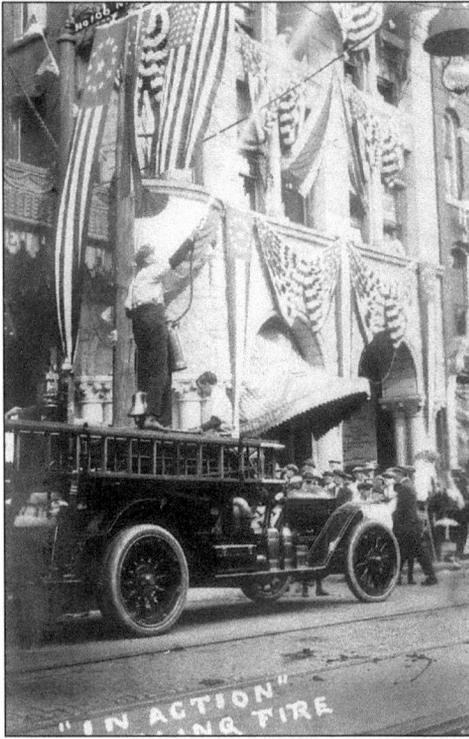

WHEELING FIRE DEPARTMENT "IN ACTION", JUNE 18, 1913. This photo shows one of our brave firemen squirting either a tall building or a street light which has caught fire. Twenty six Wheeling firemen have died in the line of duty and all are heroes. A partial list of those who have fallen in the line of duty include the following: Samuel Eggers, Thomas McCue, Bartholomew Link, Charles Carroll, Richard Donahue Jr., Engineer William McGee, Engineer Jacob Nagle, Captain Charles Ferguson, Captain Richard Turner, Captain Charles Moore, Engineer Clark Stamm, Firefighter Alexander Bowman, Engineer Wilbert Nolan, Firefighter Charles Simmons, Assistant Chief John Donovan, Captain Harold Lash, Captain Vincent Green and Assistant Chief Robert Foster. (Courtesy of Kirk's Photo.)

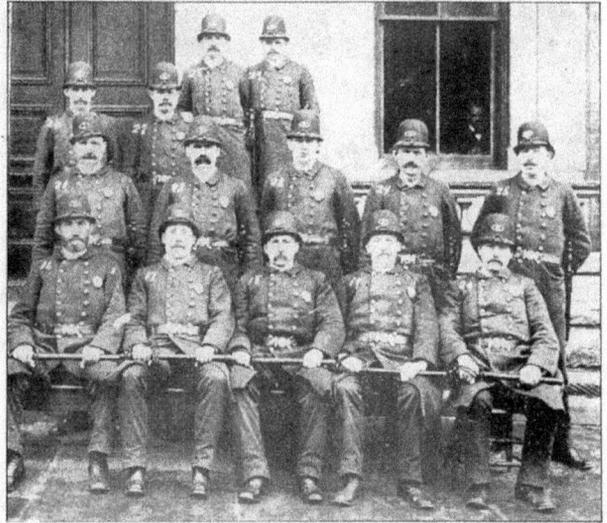

Wheeling Police Department 47 Years Ago

The above view gives a glimpse of the Wheeling crack police department of 47 years ago, and some of the faces will no doubt still be familiar to the older residents.

First row, left to right, Wally Lukens, John Donnally, Nick Herbert, Jacob Dekue, Robert McNichol.

Second row, left to right, John Deamond, Billy Carney, Joseph Conrad, Thomas Shanley, and Patrick Scally.

Rear row, left to right, Walter Terrill, Thomas Trushel, Joseph Daum, and Lee Buch.

WHEELING POLICE DEPARTMENT, 1887. Notice the Bobby-style caps and the moustaches. Wheeling's Police Department has been serving our town with high standards and low pay. (Courtesy of Wheeling News Register.)

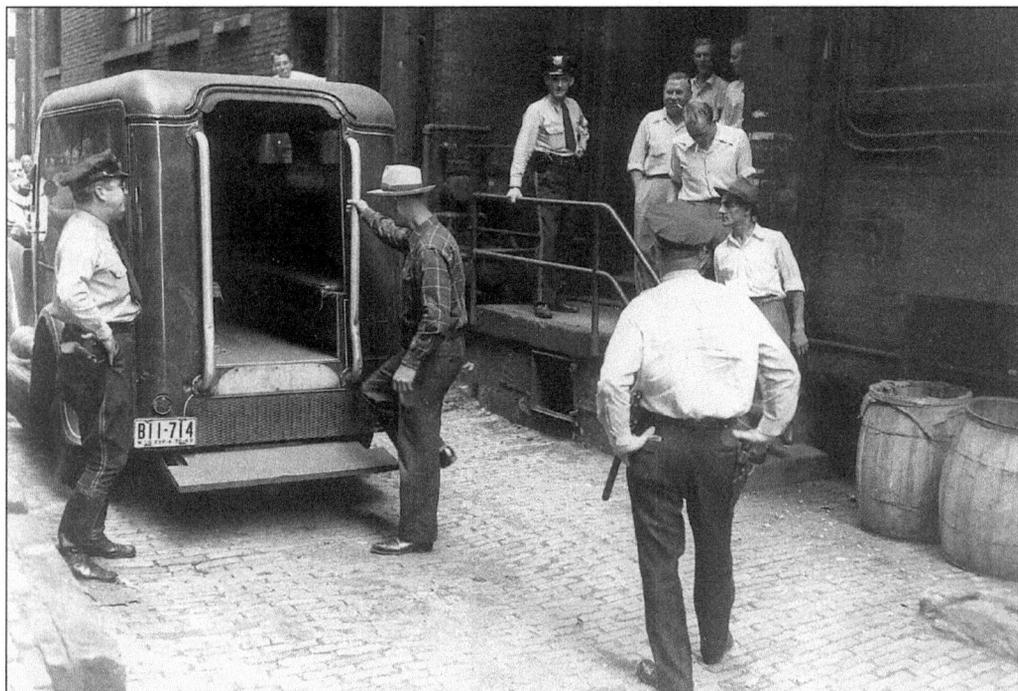

RAID AT "HARD HEAD" REUTHER'S ROYAL BAR. Seventeen men were arrested by Wheeling's finest at this bookie parlor in July 1948. The officer in the sunglasses is Jimmy Frame and the officer holding the rail is Harry Parshall. This was one of several joints raided on that day. A total of 34 gamblers were under arrest by nightfall. (Courtesy of Gary Zearott, Zee Photo.)

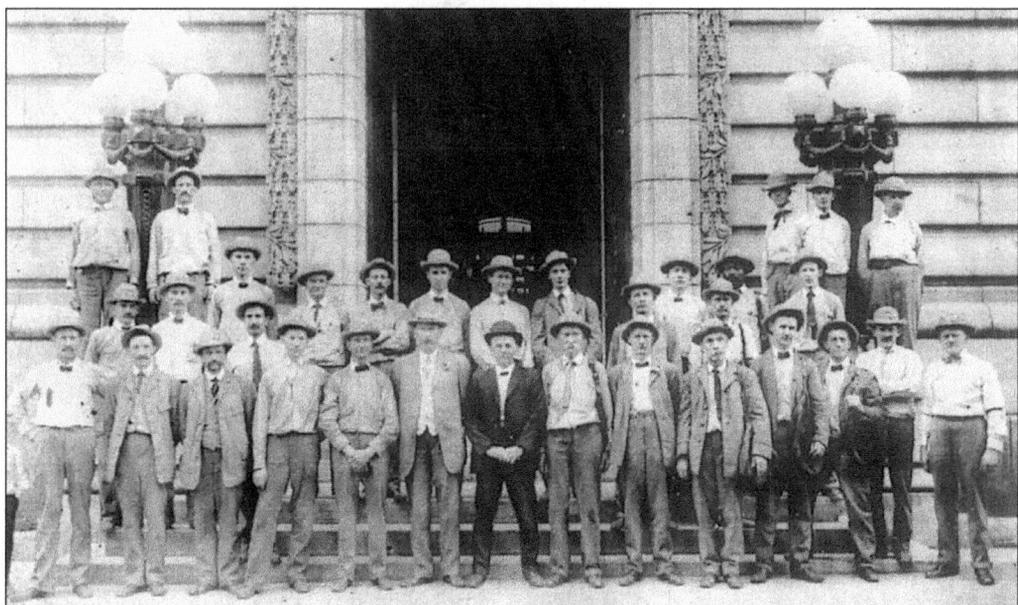

WHEELING POSTAL WORKERS, 1912. With all the hills and floods in Wheeling, our postmen had to be part mountaineer and part waterman. The African-American postman in the third row is William Turner. (Courtesy of Darryl Clausell.)

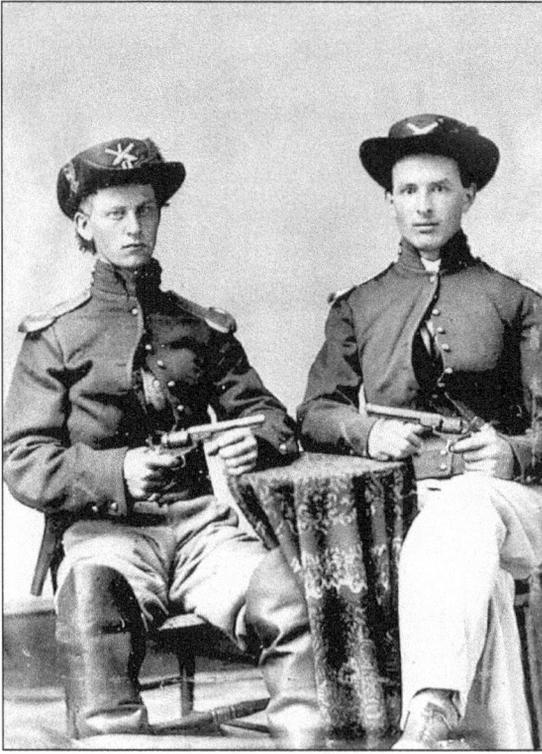

JOSEPH HERVEY, CIVIL WAR SOLDIER. Joseph P. Hervey is the soldier on the right. He was a member of the famed Carlin's Battery "D" 1st West Virginia Light Artillery. The other soldier's name is not known but he was also in Carlin's Battery. The group was named after Captain John Carlin and was mustered into service in Wheeling on August 20, 1862. They fought battles in Piedmont, Virginia, Winchester, Virginia and at New Market, Virginia. Joseph P. Hervey died of disease in Wheeling Hospital. (Courtesy of Linda Cunningham Fluharty.)

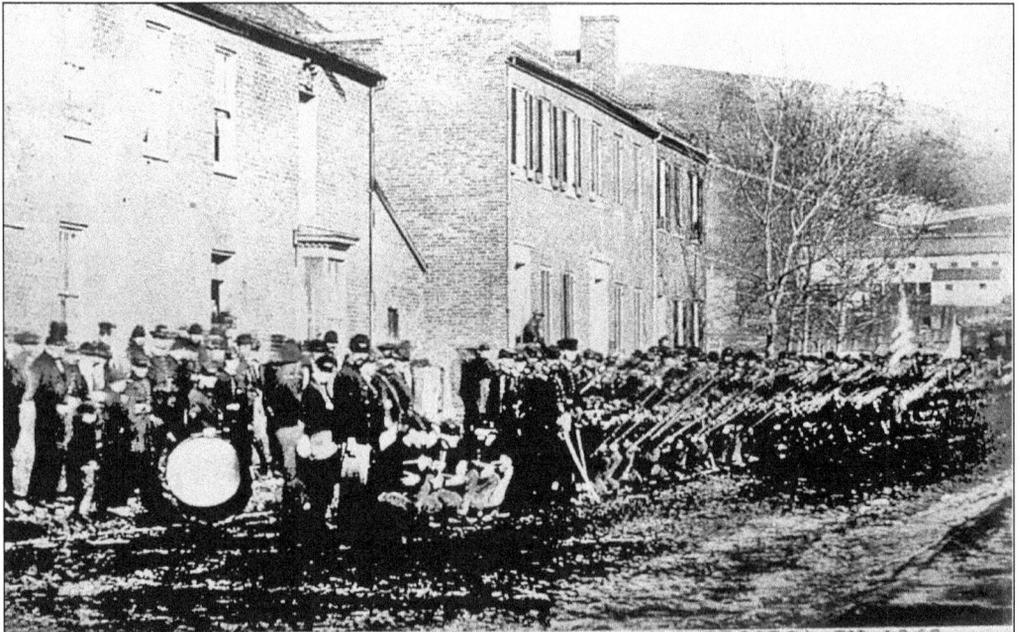

CIVIL WAR CAMP WILEY, 1862. This camp on Wheeling Island was first named Camp Carlisle, probably after John S. Carlisle. It was later changed to Camp Wiley, probably after Waitman T. Wiley. These two men disagreed how West Virginia would be divided. Both men were U.S. senators and, according to historian Linda Cunningham Fluharty, John Carlisle was viewed as somewhat of a traitor. (Courtesy of Herb Bierkortte.)

MAJ. SAMUEL MCCOLLOCH'S SMOKEHOUSE. Major McColloch is one of Wheeling's pioneer folk heroes. In 1777, he narrowly escaped being captured by Indians via leaping with his horse off a 300 foot cliff. There is a monument to "McCulloch's Leap" at the top of Big Wheeling Hill. Kirk's Photo Studio came across this photo decades ago but the exact location of the smokehouse is still a mystery. (Courtesy of Kirk's Photo.)

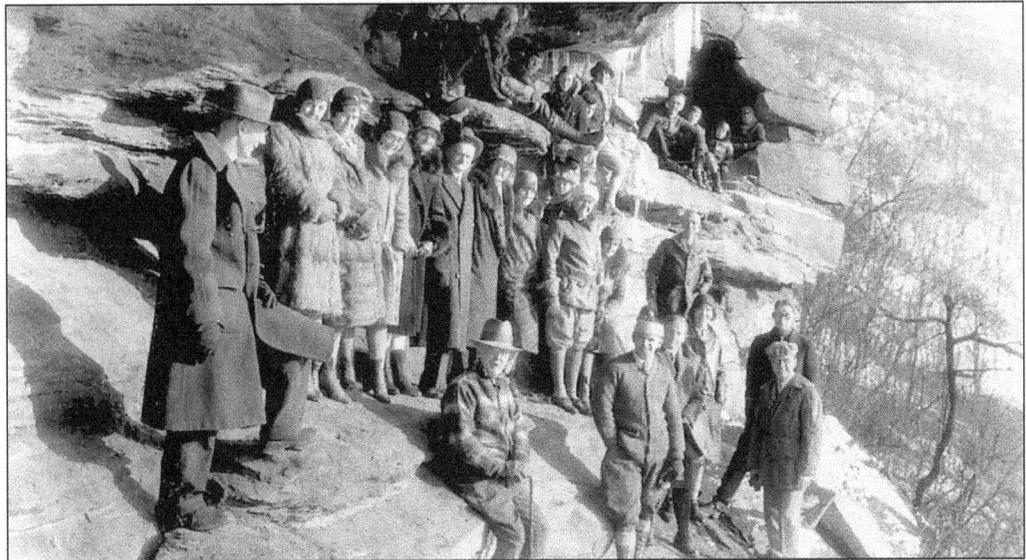

TURKEY GOBBLER'S CAVE. This photo shows two very different types of heroes. The naturalist, A.B. Brooks, leads one of his nature excursion groups to Turkey Gobbler's Cave. In 1911, the book *Forestry and Wood Industries* stated that "A.B. Brooks was among the greatest of West Virginia's naturalists." Lewis Wetzel represents the dark side of Wheeling's frontier lore as he hunted Native Americans from this cave out of revenge for the killing of his father and brother. Amazon.com lists seven books about Lewis Wetzel but many more exist, including a newsletter concerning the latest research on this interesting figure. (Courtesy of Oglebay Institute Mansion Museum.)

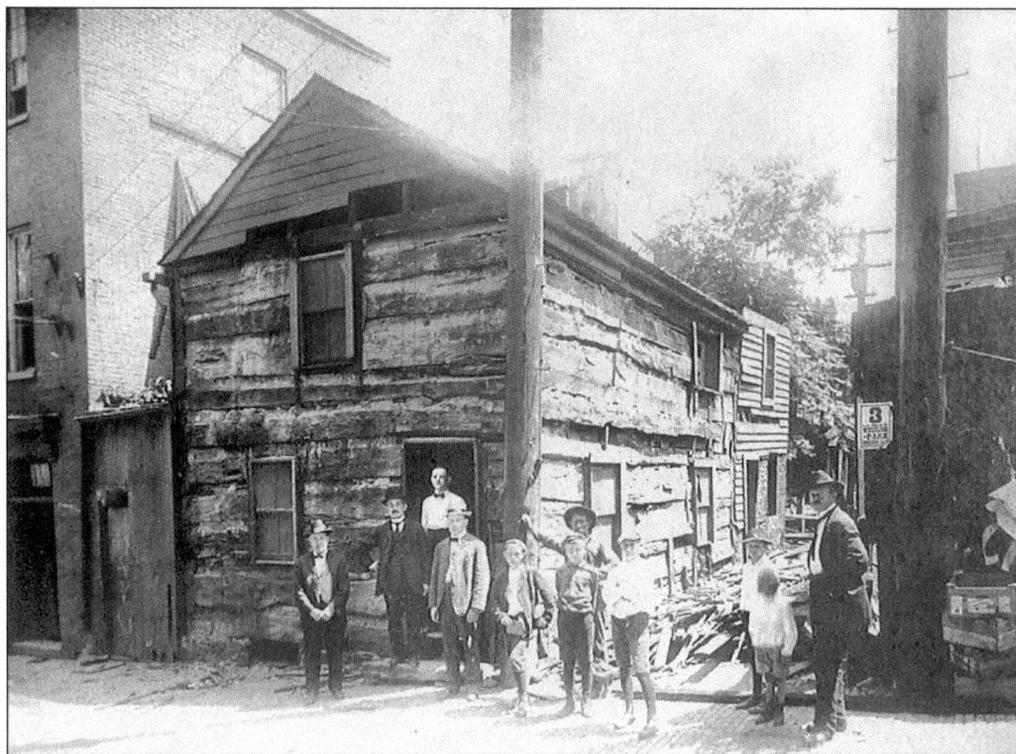

BETTY ZANE'S CABIN, C. 1910. In September, 1777, the British led 300 Indians against the settlement of Wheeling. During a particularly nasty siege against Fort Henry, Betty Zane saved the fort by running for gunpowder, which she carried back to the troops in her apron. This cabin is believed to be one of the Zane family dwellings. (Courtesy of Betty June Weimer.)

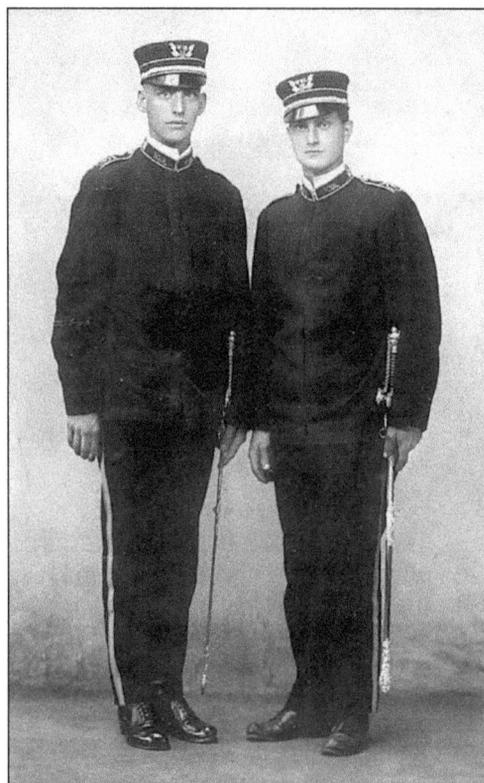

WHEELING MILITIAMEN, C. 1907-1910. This photo postcard shows two members of the old West Virginia militia in their dress uniforms complete with swords. "W. VA." appears on their collars and hats. This photograph was taken by Brink Miers Art Lobby, which was located on Market Street.

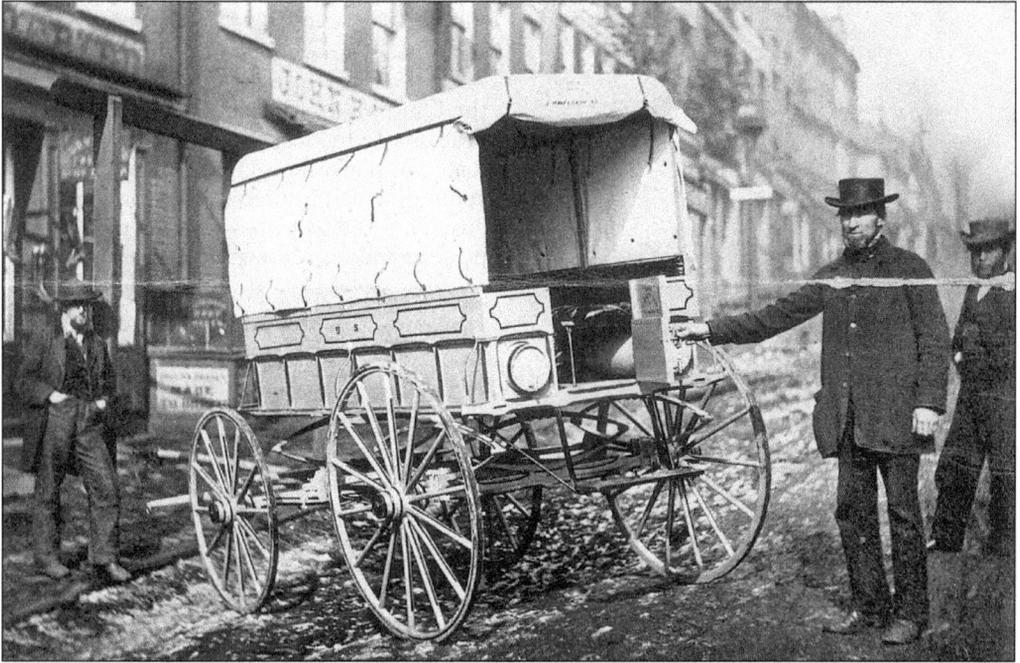

WHEELING CIVIL WAR AMBULANCE. The Wheeling or Rosecrans ambulance was designed by General W.S. Rosecrans and Dr. Jonathan K. Letterman. It was manufactured by the Wheeling Wagon and Carriage Company and transported the sick and wounded to Wheeling Hospital. At the time, Wheeling Hospital was located on Market Street. The wagon was drawn by two horses and could carry 11 or 12 people. (Courtesy of Margaret Brennan.)

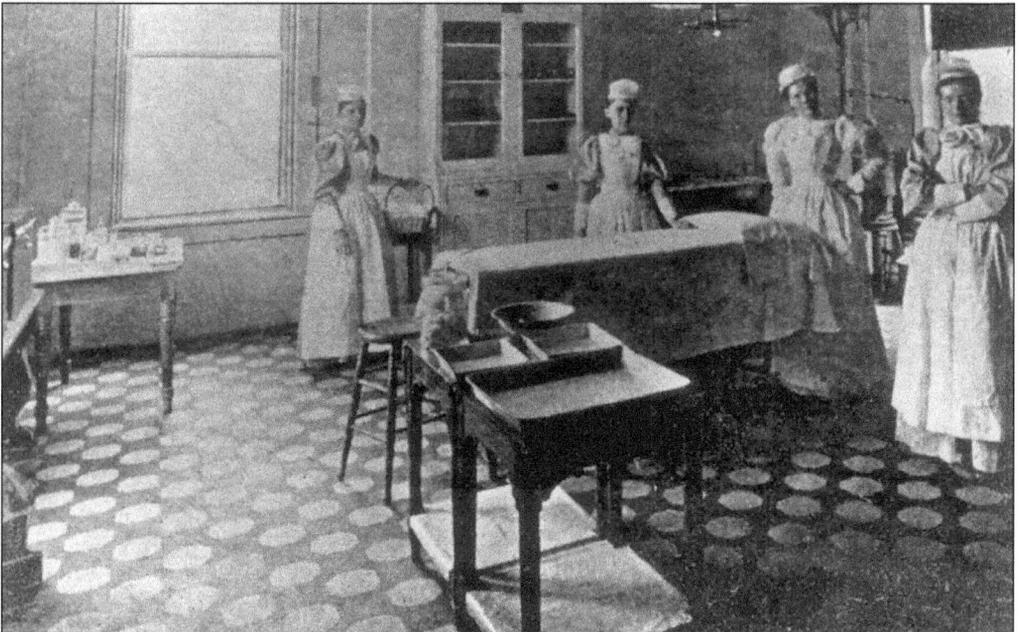

OPERATING ROOM NURSES, WHEELING CITY HOSPITAL, 1895. The City Hospital was the predecessor to the Ohio Valley General Hospital. The work that these ladies did was difficult considering the medical technology of the day. (Courtesy of Ohio Valley Medical Center.)

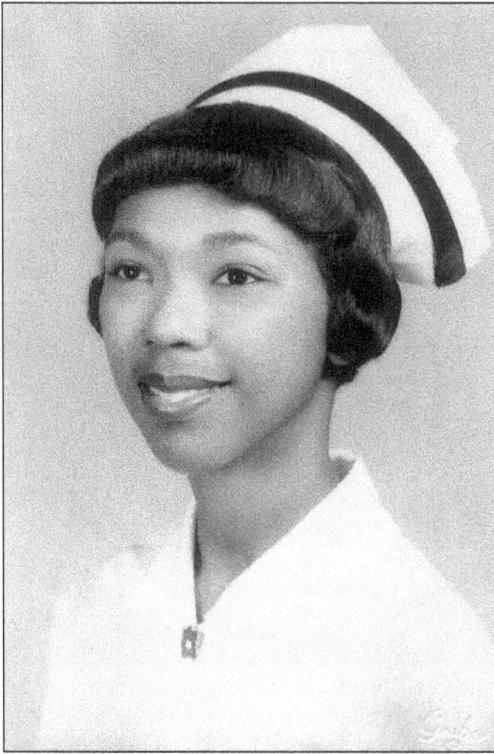

FIRST AFRICAN-AMERICAN NURSE, 1959. In 1959, Anne Thomas became the first African-American woman to graduate from the Ohio Valley General Hospital Nursing program. Individual people like Anne were forced to punch holes through the racial ceilings, which inhibited real growth in our city. They did so with a lot of dignity and perseverance. (Courtesy of Anne Thomas.)

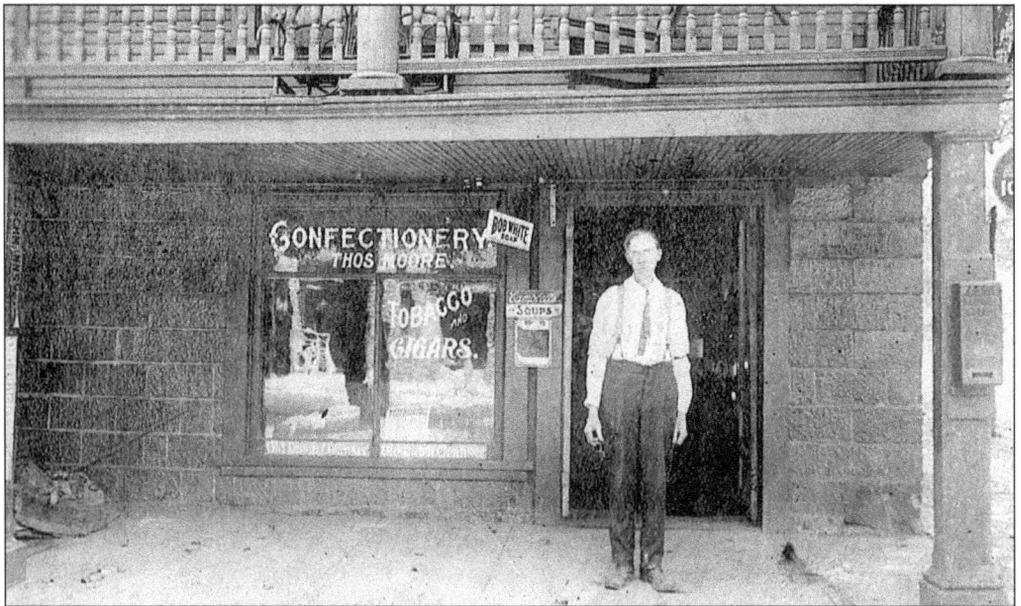

SULTANA SURVIVOR, 1912. Thomas Dunn Moore is standing in front of his store at the corner of Virginia Street and South York Street. Today this is a vacant lot. During the Civil War, Mr. Moore was captured and sent to Cahaba Prison. He was "rescued" and put aboard the Sultana Steamboat. This boat should have carried a maximum of 376 people but was carrying closer to 2,300. The boiler exploded and the ship caught fire. More than 1,700 returning Union veterans died in the river during that April of 1865. (Courtesy of Tom Gompers.)

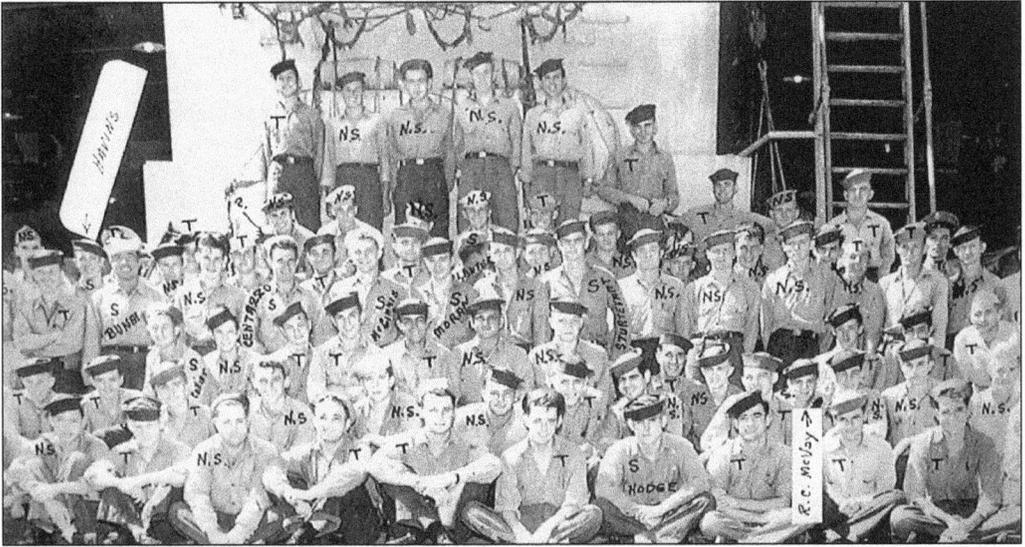

USS INDIANAPOLIS SURVIVOR, OCTOBER 12, 1944. Wheeling native Paul W. McGinnis, SM 3/C, was aboard the USS Indianapolis as it delivered the first atomic bomb to the island of Tinian. On July 30, 1945 the USS Indianapolis was hit by two Japanese torpedoes and sank in 12 minutes. Out of the 1,197 men aboard, only 900 survived the initial attack on the ship. The remaining brave sailors faced repeated shark attacks, an unforgiving sea, hunger, dehydration, cannibalism, hypothermia, and exhaustion. Mr. McGinnis remembers hallucinating about Arabs on camels circling his position. Mr. McGinnis was finally spotted and remembers waking up on the wing of a PBY plane. Only 317 members of the USS Indianapolis survived. Mr. McGinnis is the fourth row with an S written on his chest. He hand wrote an S for those who survived, an NS for non-survivors and a T for those who were transferred before the torpedoes hit. (Photograph courtesy Paul W. McGinnis.)

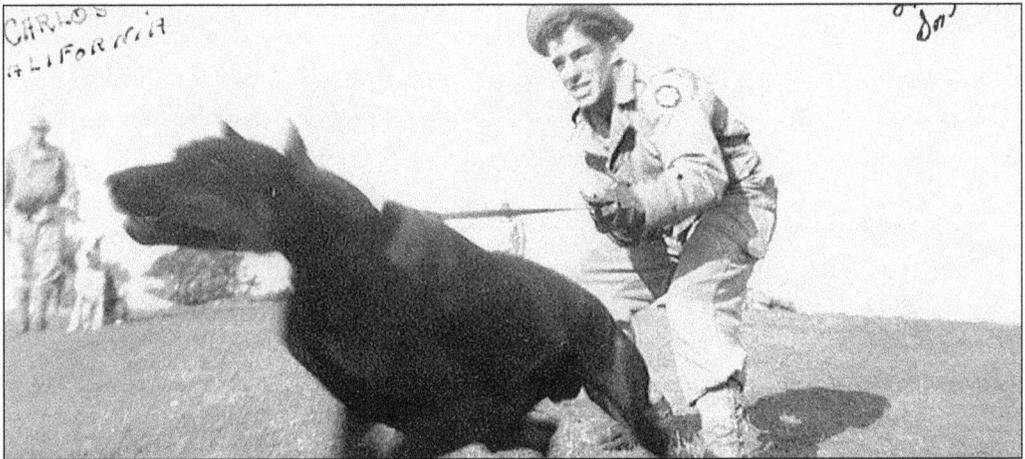

GENE LONG AND "BLITZ" THE ATTACK DOG, 1942. Gene Long won the Soldier's Medal in 1942 for rescuing all the Army attack dogs in the kennels at San Carlos, California. He continually entered a burning building until he almost gave in to the fire. They found him unconscious the next day inside a sewer pipe. He later trained dogs for James Cagney and Greer Garson. He appeared on WWVA where he sang with his brother. They cut records together and he also had a vaudeville act. Mr. Long is listed in a book entitled *Uncrowned Heroes.* (Courtesy of Gene Long.)

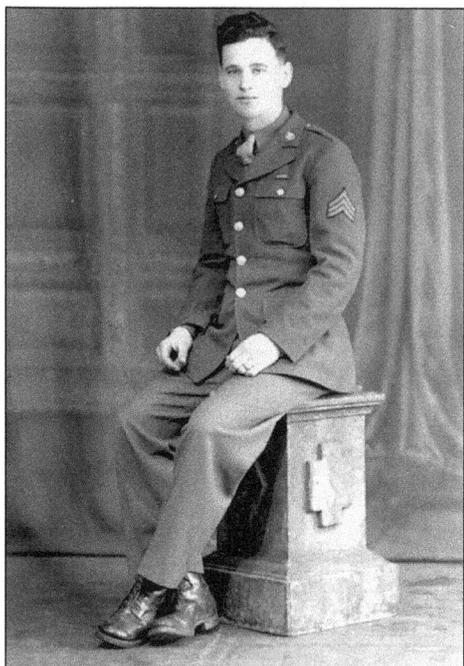

BOB IMHOFF, D DAY SURVIVOR, 1944. On June 6, 1944, Bob Imhoff and his friends from the Army's 5th Engineer Special Brigade landed on Omaha Beach. Many of Bob's cohorts did not make it through Rouen to Paris. Bob returned home to Wheeling to work for Boury Inc. for 43 years. When called a hero, he quickly disagreed, saying, "The friends I left in the wet sand at Normandy are heroes, I'm just lucky." Such humble statements make Bob all the more heroic.

MARINES IN CHIRAN, JAPAN, SEPTEMBER 1945. Harry Parshall and his fellow Marines were in Chiran to blow up the remaining kamikaze planes. Because Harry was a printer he taught the local Japanese printer how to write store signs in English. He gave Mr. Toshio Naka a bag of sugar, which was necessary in those days to keep the rollers sticky. He returned the next week to see what had been printed. The Japanese printer bowed his head and stated that he couldn't in good conscience use the sugar when his fellow villagers were hungry. Instead of getting mad, Harry would "find" sugar from the mess hall and give it to the villagers. In 2001, Japanese MBC/TV did a documentary about Harry's kind acts. He is the tall Marine in the middle with the dark shirt and cap tilted to the right. This photograph hangs in a museum in Chiran, Japan.

Nine

VISITORS

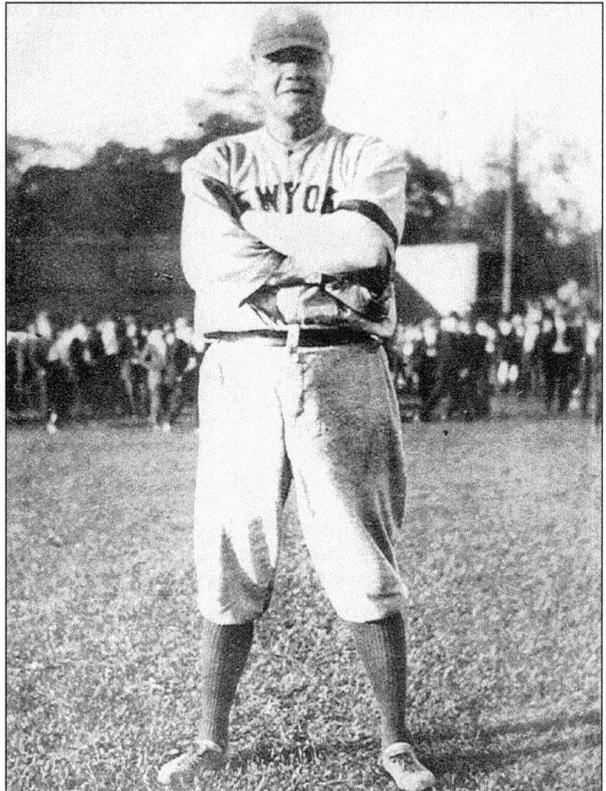

BABE RUTH, FULTON FIELD, 1930. Babe Ruth came to Wheeling on a barnstorming tour with his team, the Babe Ruth All-Stars. These tours promoted baseball and were big money makers. In 1930, Babe Ruth signed a contract for $80,000 which was $5,000 more than President Herbert Hoover made in that year. When asked about the difference, Ruth said "I had a better year than he did." (Courtesy of Betty June Weimer.)

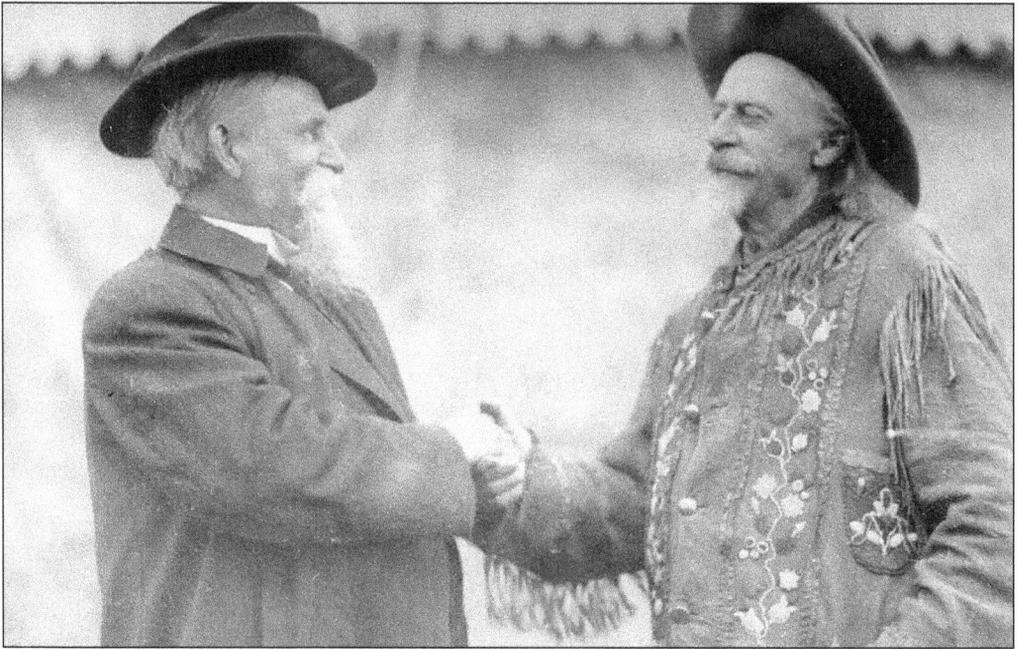

BUFFALO BILL'S WILD WEST SHOW, AUGUST 31, 1895. Buffalo Bill's Show came to town with many characters including Annie Oakley and the Deadwood Stagecoach Riders. The Wild West Show would reenact the Custer Battle, featured Pony Express riding exhibitions, and stage mock Indian attacks on stagecoaches. (Courtesy of Gary Zearott, Zee Photo.)

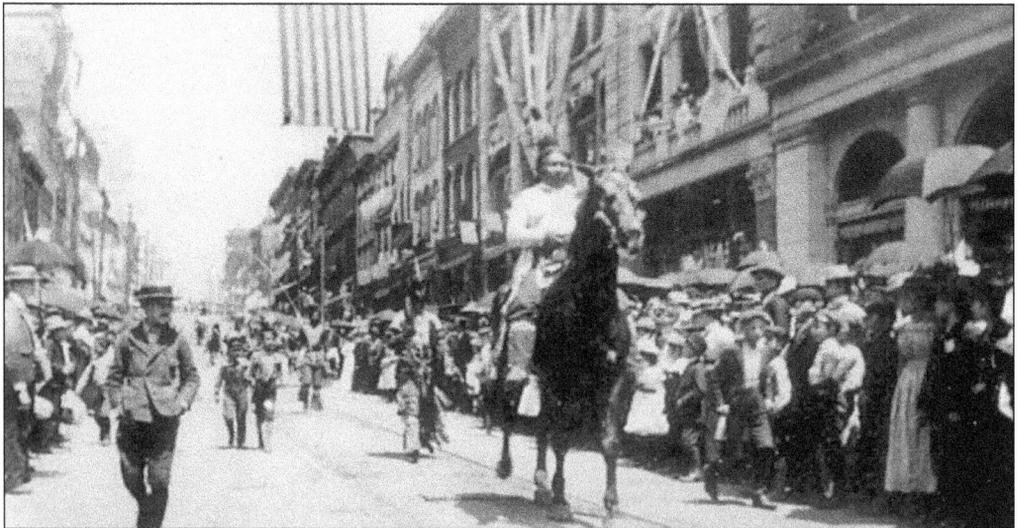

BUFFALO BILL'S TROOPS RIDE DOWN A STREET IN WHEELING. The following is taken from Edward Marsden's report for the *Indian Helper* magazine on January 24, 1896. "I left Pittsburgh and came to Wheeling, early on the 31st. On my arrival, I found the city in commotion. I did not know whether it was on my account or somebody else's. However, I went up to Main Street, and I found out that I was only about three minutes ahead of time to see the Wild West Show parade!....Brethren, I was quite relieved when the Wild West Show and myself finally parted at Wheeling. The time will come when there will be no more Wild West Shows in the United States." (Courtesy of Tom Daily.)

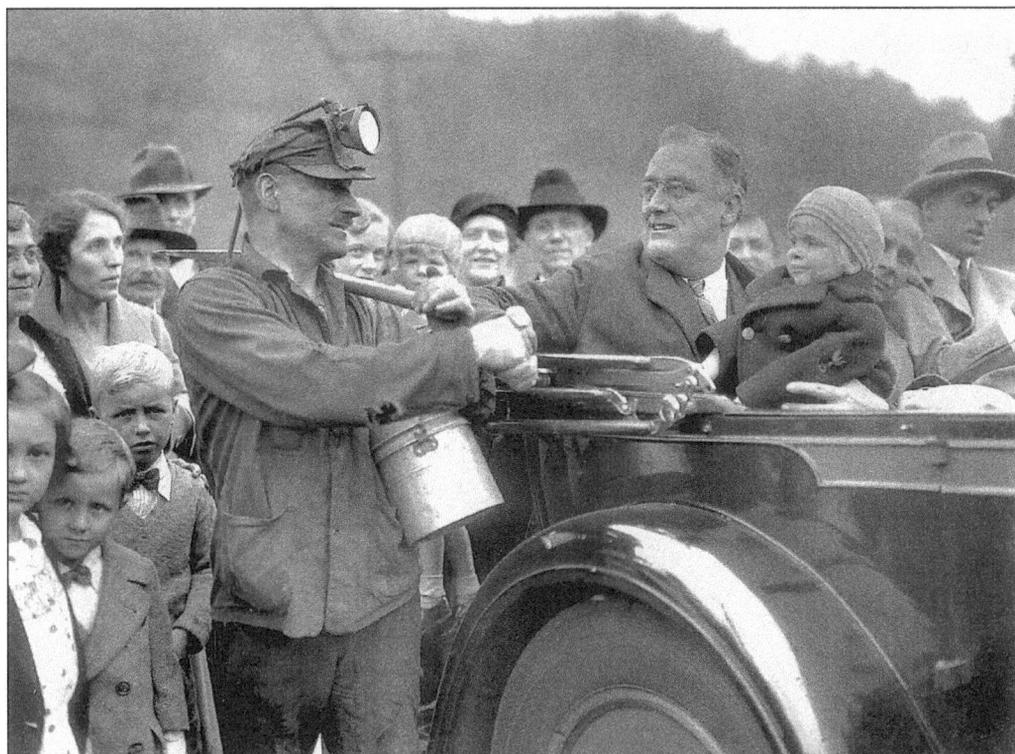

FDR AND AN ELM GROVE COAL MINER, OCTOBER 19, 1932.
Presidential candidate Franklin Delano Roosevelt drove along Route 40 on his was to Pittsburgh. He stopped in Elm Grove to shake the hand of coal miner Tony Fiorino. Tony's face and hands were black from 12 hours of shoveling coal. The image of candidate Roosevelt shaking the dusty hand of a hard working, Depression era miner became famous during that time. (Courtesy of Corbis International.)

ELEANOR ROOSEVELT AT MOUNT DE CHANTAL, FRIDAY, MAY 25, 1940. Mrs. Roosevelt gave a speech at Mount de Chantal before enjoying an elaborate tea later at the Windsor Hotel. She would also speak at the Market Auditorium under the auspices of the Wheeling Community Forum. Sister Frances Joseph Thompson stands to her left and Mary Anne Hess is standing in front. (Courtesy of Mount de Chantal Visitation Academy.)

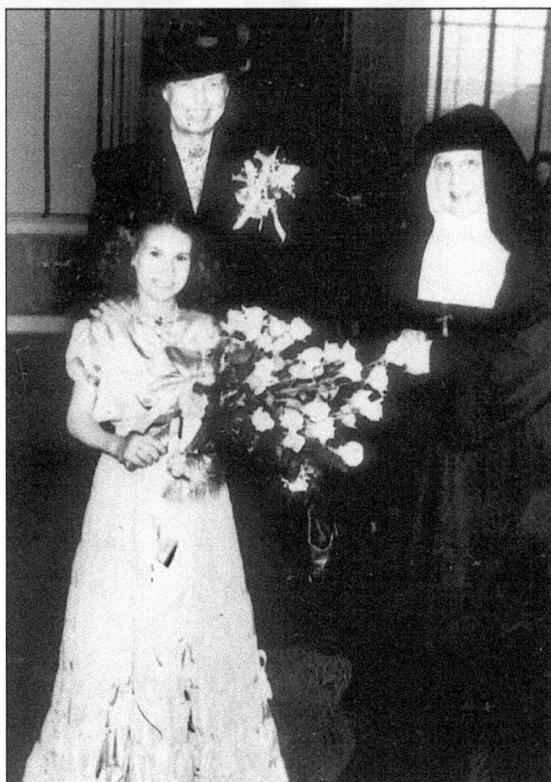

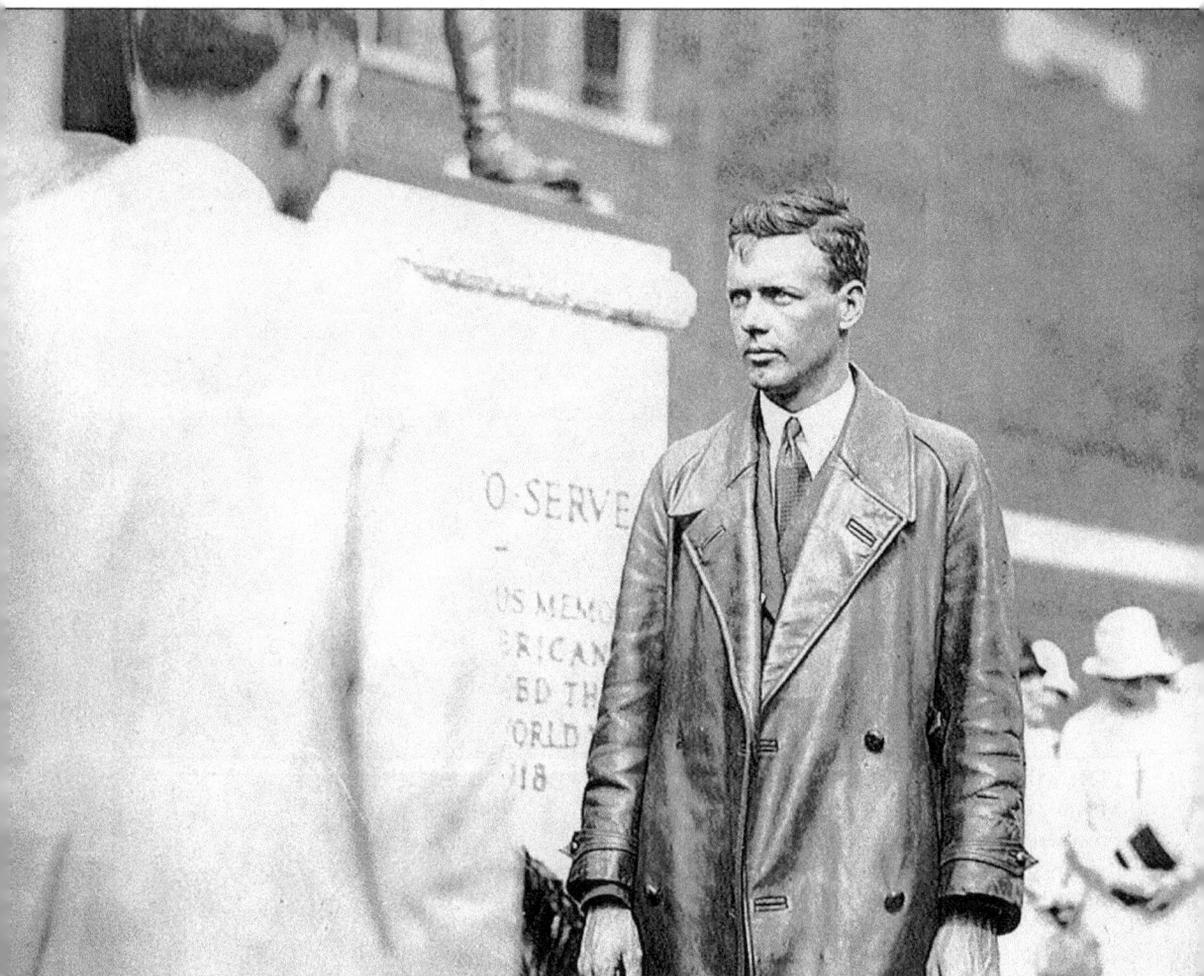

LINDBERGH AT THE AVIATOR STATUE, AUGUST 4, 1927. Col. Charles A. Lindbergh put a wreath at the foot of the Lewis Bennett Memorial at Linsly Institute. Lindbergh also spoke to 25, 000 people that gathered on Wheeling Island to hear him. He was introduced by Mr. Schenk. During this visit he also posed for a photograph with "Miss Wheeling" Mildred Bright. (Courtesy of Betty June Weimer.)

ALL AMERICAN GIRL, OCTOBER 1927. Pioneer aviatrix, Ruth Elder is posing next to Capt. George Haldeman. They came to Wheeling to promote her attempted trans-Atlantic flight to Paris. She took off from Roosevelt Field for Paris in October, 1927. Due to trouble with the airplane, she had to land in the ocean after 2,623 miles. She was rescued by a Dutch oil tanker. (Courtesy of Tom Tominack.)

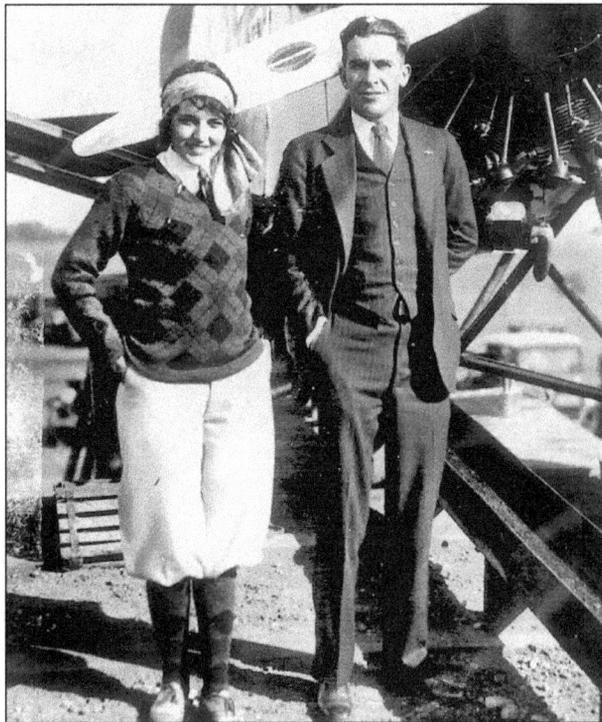

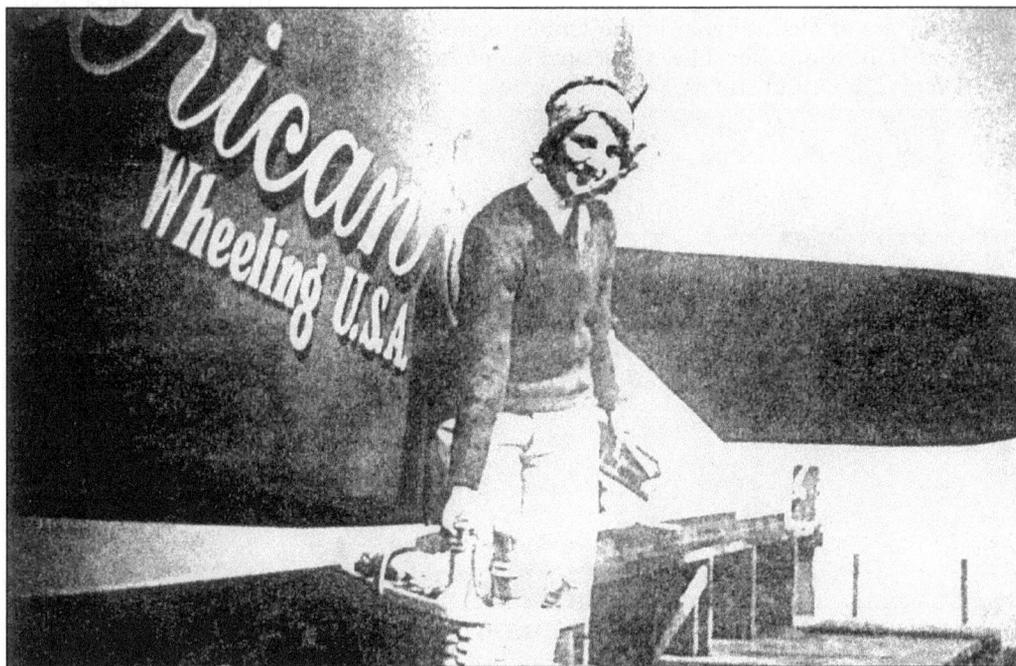

RUTH ELDER, "ALL AMERICAN GIRL," WHEELING USA. Ruth Elder is seen here with a picnic basket in front of her Stinson-Detroiter monoplane. The fact that Ruth Elder failed in her trans-Atlantic flight does not diminish the fact that she was a courageous pioneer in the field of aviation. (Courtesy of Tom Tominack.)

JOSEPH MCCARTHY, FEBRUARY 9, 1950. Senator McCarthy gave one of the most important speeches of the Cold War to the 275 members of the Ohio County Republican Women's Club at the McLure Hotel. In this speech, he stated that "I have here in my hand a list of 205 that were known to the Secretary of State as being members of the Communist Party and who, nevertheless, are still working and shaping policy in the State Department." These words started the era of McCarthyism in the United States. McCarthy is seen shaking hands with Walter S. Hallaman, a Republican National Committee member. (Courtesy of West Virginia Division of Culture and History.)

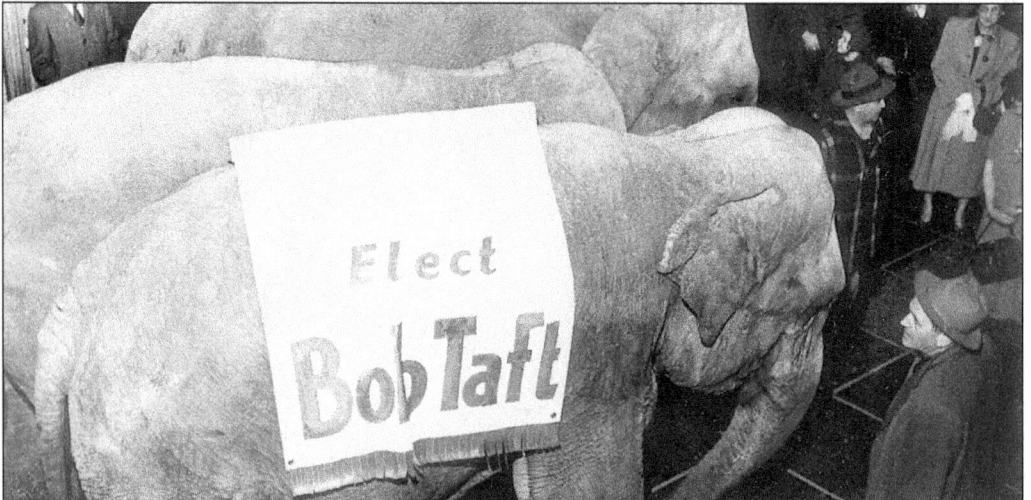

ELEPHANTS IN MCLURE HOTEL FOR MCCARTHY SPEECH. Senator McCarthy later claimed that he had not said 205 Communists, but rather, 57 Communists. Republican pundit Ann Coulter tries to make the case in her new book *Treason* that Joseph McCarthy's Wheeling speech has been wrongly maligned and that there were Communists in the State Department. Whether or not you agree with Ms. Coulter, one thing is for sure, it started in Wheeling. (Courtesy of West Virginia Division of Culture and History.)

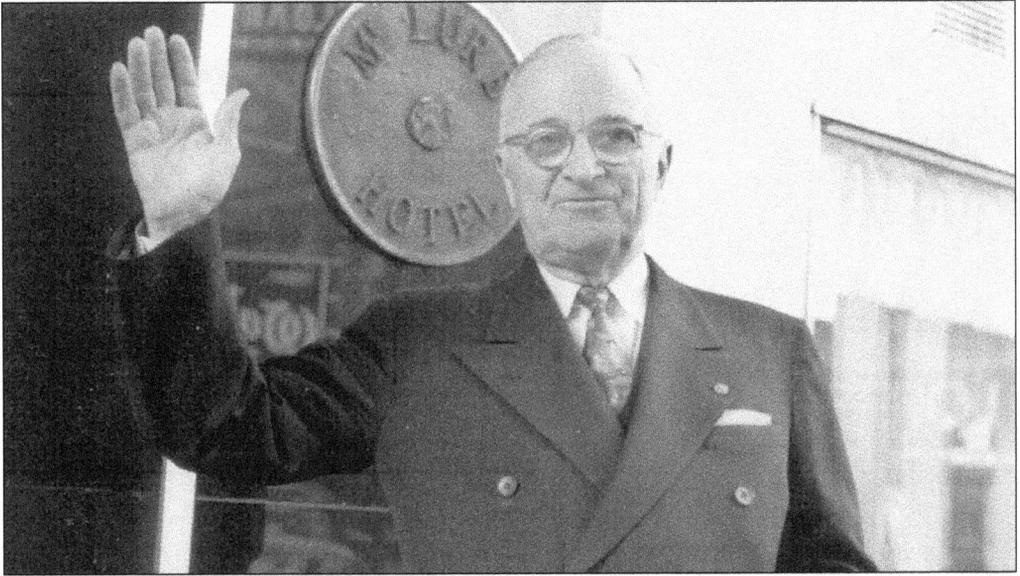

PRESIDENT TRUMAN WAVES FROM THE MCLURE HOTEL, OCTOBER 24, 1952. President Truman gave a 15 minute whistle-stop speech at 17th and Eoff Streets to a crowd of 3,500 people. He was stumping for Governor Adlai Stevenson. He stated that "I've been riding through Wheeling for 20 years but this is the first time I've been given a way of coming and going without getting caught." (Courtesy of Margaret Brennan.)

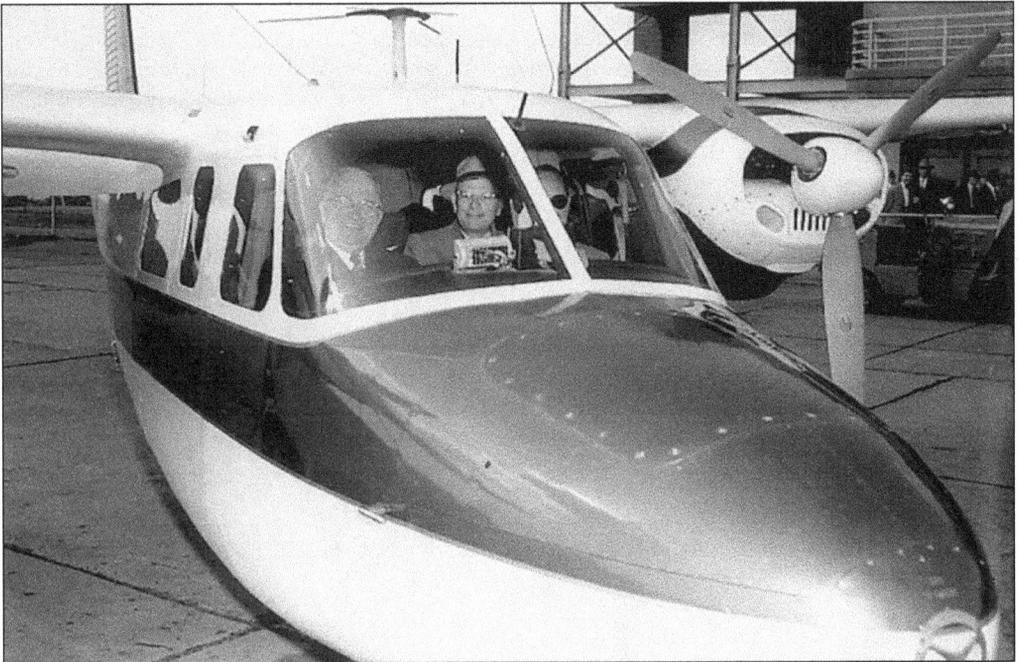

HARRY TRUMAN AT WHEELING OHIO COUNTY AIRPORT, OCTOBER 10, 1956. Former President Truman is seen sitting in Gov. William C. Marland's Rockwell Aero Commander plane. Truman urged Wheelingites to elect Robert H. Mollohan to the Governor's office, Governor William C. Marland to the U.S. Senate and candidate C. Lee Spillers to Congress. (Courtesy of Margaret Brennan.)

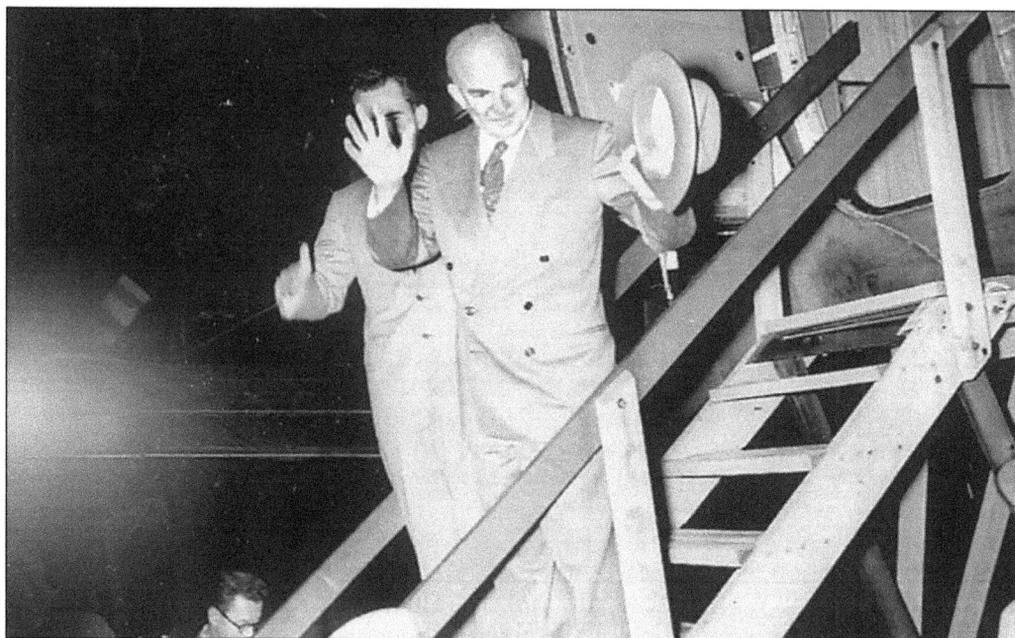

IKE GREETS NIXON AT WHEELING OHIO COUNTY AIRPORT, SEPTEMBER 24, 1952. Years later President Nixon remembered this exact moment by saying "I was so surprised when we landed at Wheeling to hear that the President was here at the airport that frankly I was putting on my coat when I began to move toward the door and then all of a sudden, somebody said the President is on the plane. And when he walked up with me and shook hands, I don't really recall what was said. Reporters who were with me reported that I said, which I imagine is probably true, that I said that, 'Mr. President, you didn't have to do that.' And the President said something to the effect, 'Well Dick, you're my man, or something of that sort, or 'You're my boy." (Courtesy of Margaret Brennan.)

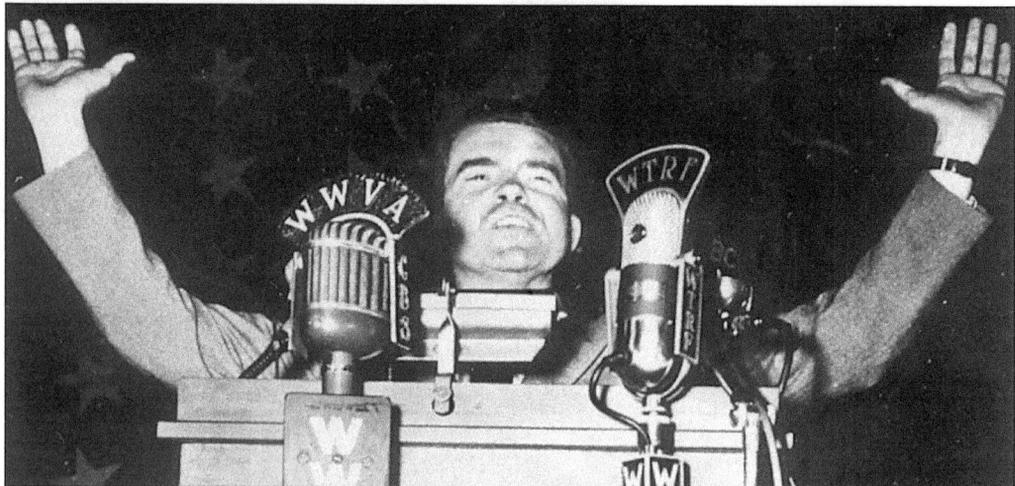

NIXON IN WHEELING, SEPTEMBER 1952. An elated Sen. Richard M. Nixon soaks up the cheers from Wheeling's citizens. Adding to his joy was Dwight D. Eisenhower's speech to 9,000 people in Wheeling Island Stadium where he announced that he had decided to keep Senator Nixon on the ticket. Prior to their visit, Nixon had given his famous "Checkers" speech and his political future was uncertain. (Courtesy of Margaret Brennan.)

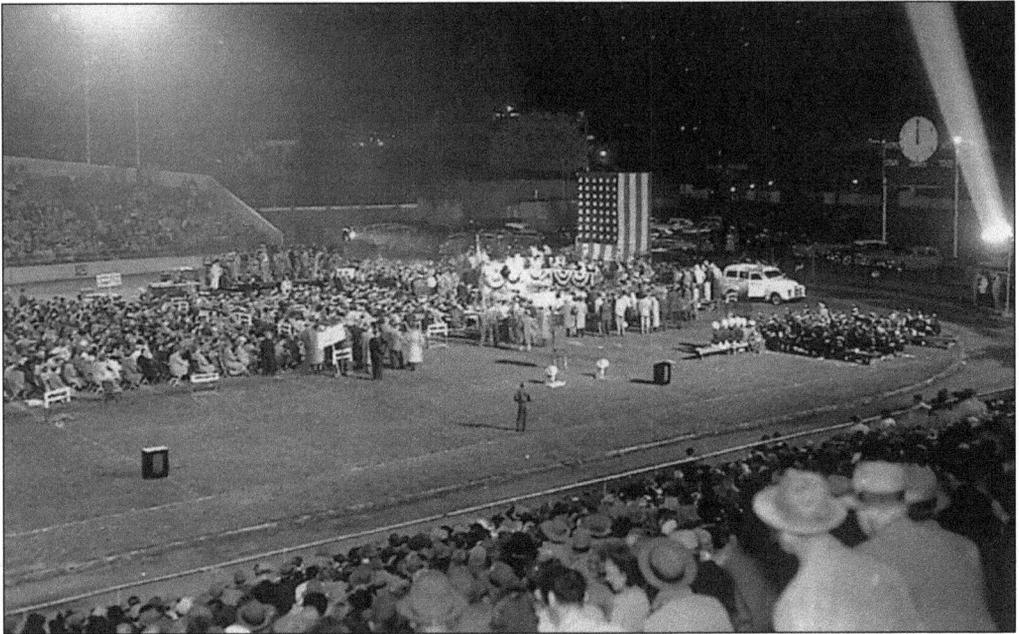

ANOTHER VIEW OF IKE AND NIXON AT WHEELING ISLAND STADIUM, SEPTEMBER 24, 1952.
A shivering crowd of 500 people listened to Eisenhower vindicate Senator Nixon. Keeping
Nixon on the ticket changed the face of the Republican Party. For that reason alone, this
speech was important. (Courtesy of Margaret Brennan.)

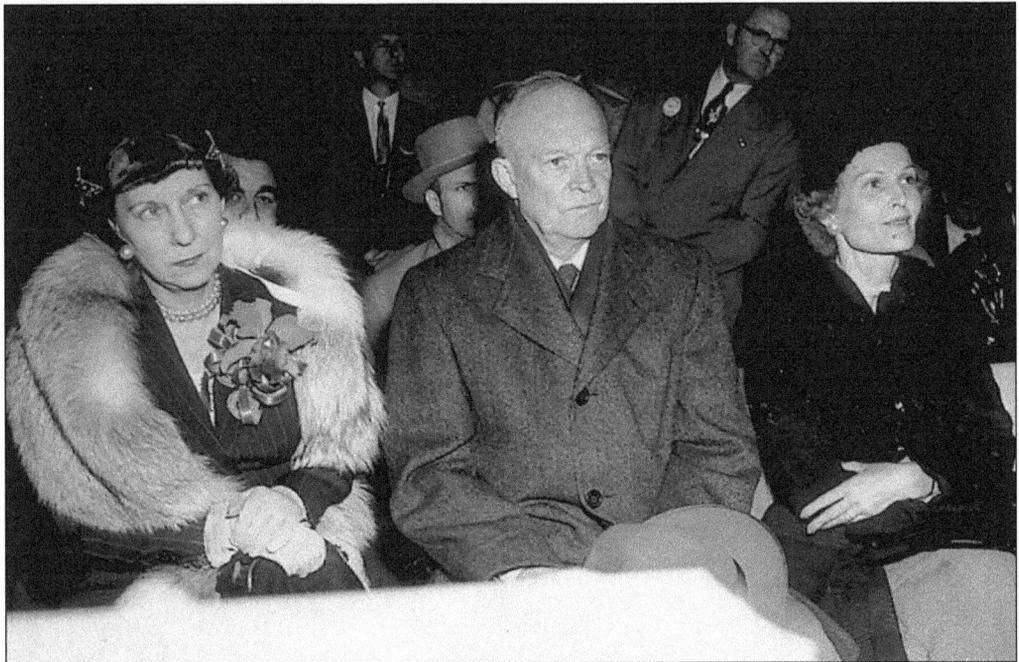

MAMIE EISENHOWER, DWIGHT EISENHOWER, PAT NIXON, 1952. The three of them
look extremely bored as Nixon gives a speech in Wheeling. Perhaps Mr. Eisenhower is
questioning whether he has made the right decision keeping Nixon on the ticket. (Courtesy of
Margaret Brennan.)

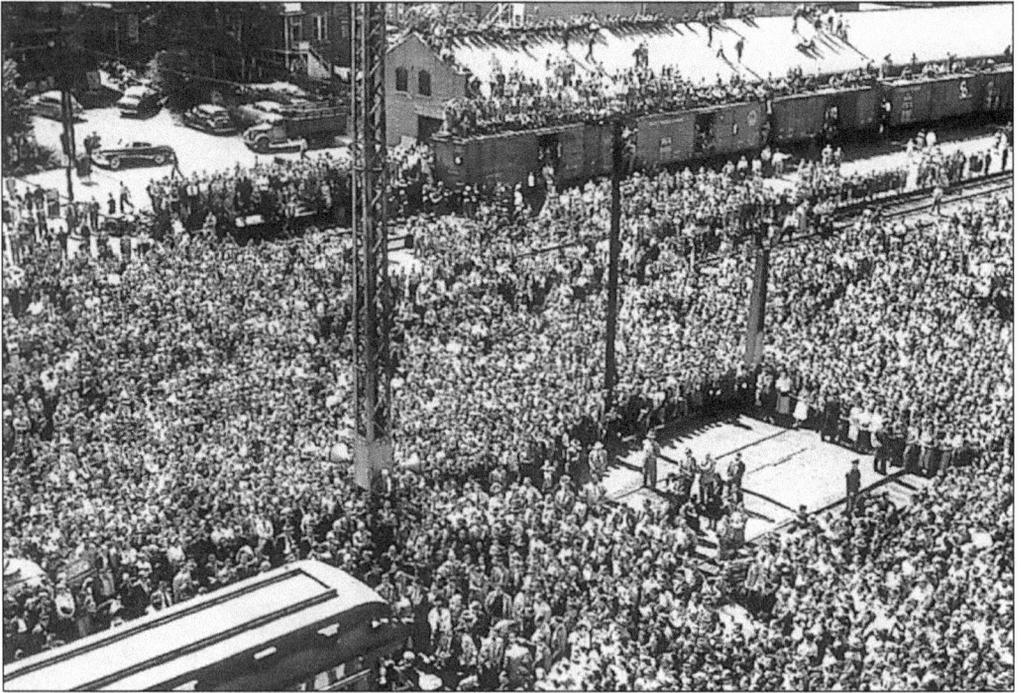

EISENHOWER GIVES WHISTLE-STOP SPEECH IN WHEELING. Notice all the people on top of the trains and even on the roof to listen to Mr. Eisenhower. This remarkable photograph shows that citizens of Wheeling were very interested in politics. (Courtesy of Margaret Brennan.)

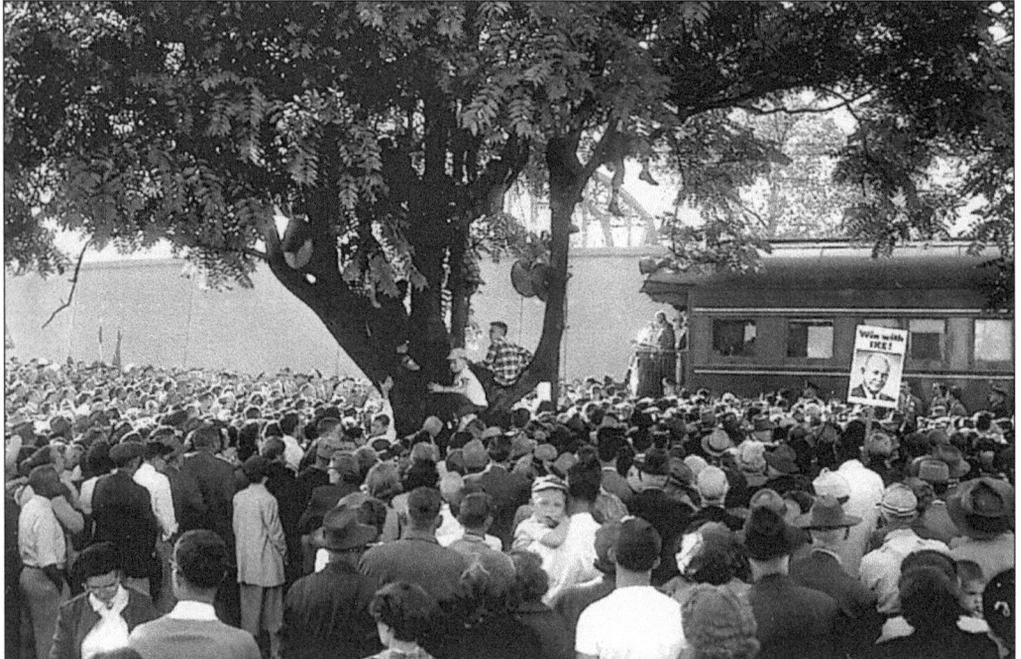

JUST ONE MORE IKE PHOTOGRAPH. This photograph captures a time when presidents gave speeches from the backs of trains. There are at least eight boys sitting in that tree to catch a glimpse of Ike. (Courtesy of Margaret Brennan.)

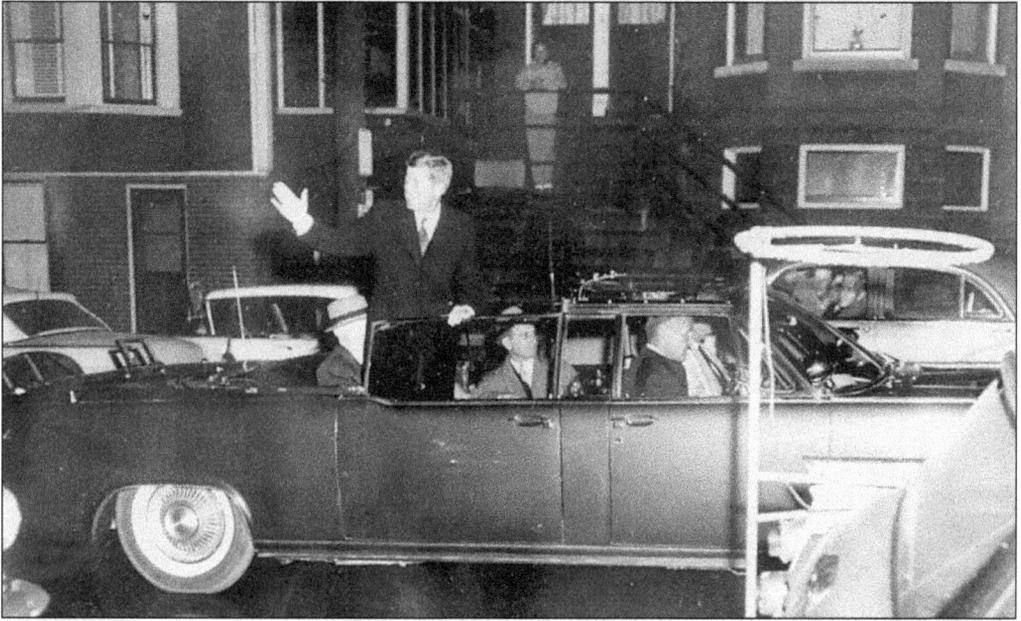

JFK Waves to Nurses in North Wheeling, 1960. Mary Staley, vice-president of the Wheeling Genealogical Society, remembers wrapping her asthmatic son in a blanket outside Wheeling Hospital so that he could see JFK as he drove by. Kennedy stayed with Judge Jack Pryor and his wife Nancy Pryor. To this day she still remembers him as "A fantastic guest and a wonderful guy." (Courtesy of Herb Bierkortte.)

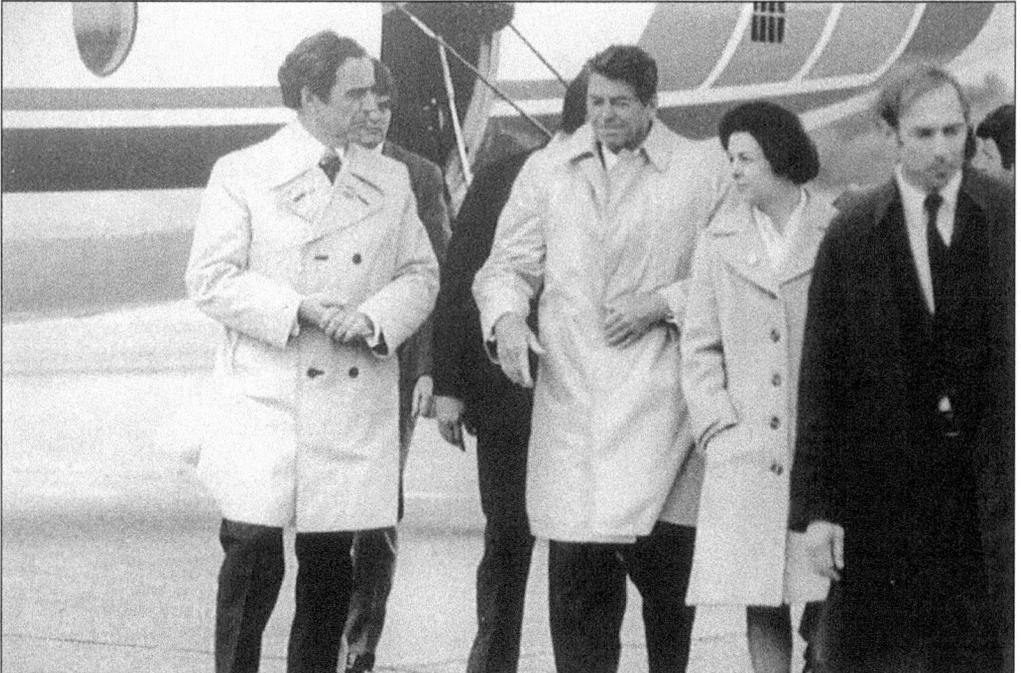

Ronald Reagan at Wheeling Ohio County Airport, May 1976. At the time, Ronald Reagan was running for the Republican nomination and was in town to give a speech at Wheeling Jesuit College Field House. (Courtesy of Mount de Chantal Visitation Academy.)

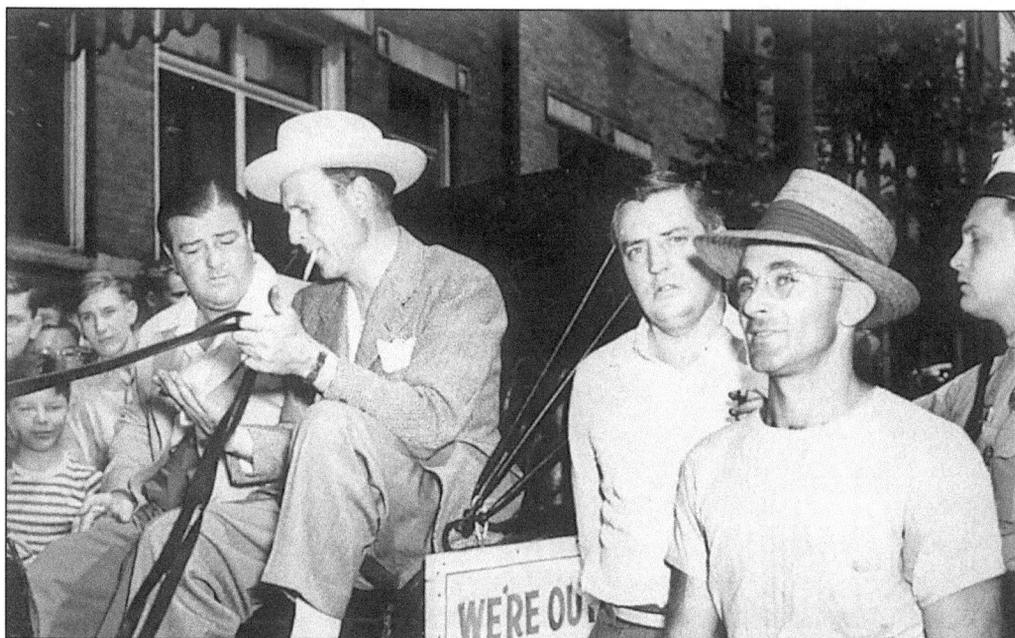

BUD ABBOTT AND LOU COSTELLO, OCTOBER 8, 1942. The comic duo came to town for the Ohio Valley War Bond Rally. They performed their famous "Who's On First" for a riverfront crowd at the Wheeling Wharf site. This picture shows them on their way from the Fort Henry Club to the riverfront. (Courtesy of Gary Zearott, Zee Photo.)

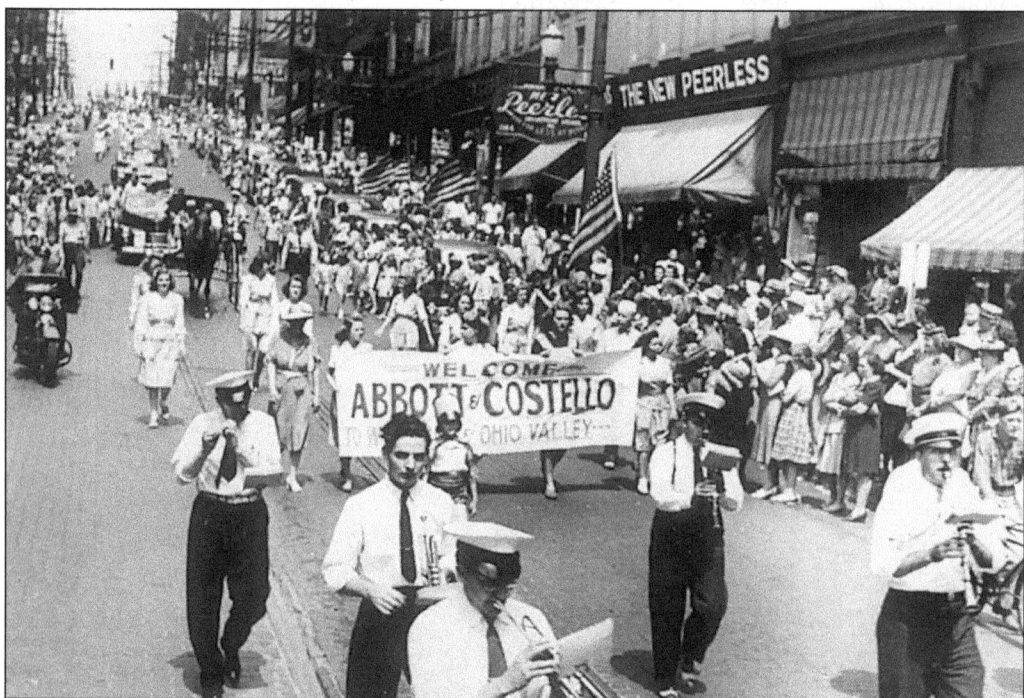

PARADE FOR ABBOTT AND COSTELLO, 1941. Bud and Lou ate pork chops that cost $18.75 a piece, at the Kiwanis luncheon. The Kiwanis Club members pledged $15,000 in War Bonds. (Photograph courtesy Gary Zearott, Zee Photo.)

JACK DEMPSEY, YACHT CLUB, SEPTEMBER 8, 1947. Jack Dempsey was in town as a guest referee for the Joey Maxim fight and decided to have a beer or two with local bar owner Bill "Hard Head" Reuther. He signed this photo "To Bill, a real pal, from Jack." Jack Dempsey has another connection to Wheeling as he was once married to actress Lina Basquette, who lived her later years in our town. (Courtesy of Kirk's Photo.)

GENE AUTRY, JANUARY 31, 1952. The famed singing cowboy played two engagements at the Capitol Music Hall. Gene Autry made at least three trips to Wheeling and was genuinely more interested in what he could do to help Wheeling's recent flood victims than telling stories about himself in Hollywood. Mr. Autry also did not mind that the two young kids, Richard Hussey and Jimmy Hussey, were wearing Roy Rodgers shirts and Hop-along Cassidy bandanas.

TARZAN COMES TO WHEELING, JULY 1963. That was the local headline when former actor and five-time Olympic gold medalist Johnny Weissmuller came to town. He is seen here at the Woodsdale Elbys where he was mobbed by over 500 children. Johnny held 67 world swimming records, 52 national championships, and made 19 movies.

Ten

MISCELLANEOUS
MEMORIES

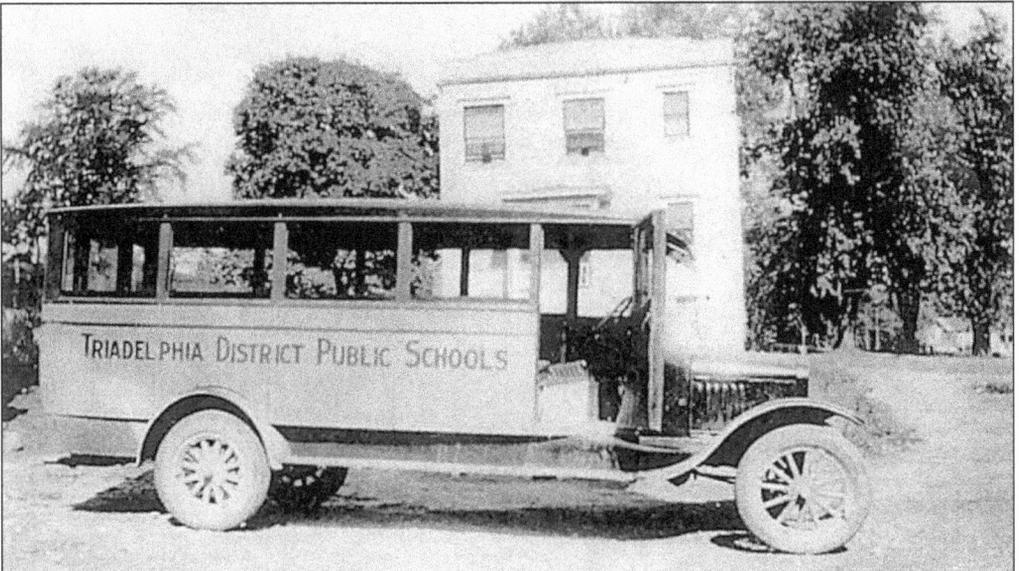

TRIADELPHIA DISTRICT PUBLIC SCHOOL BUS. The photo reads the following: Bus No. 3, No. Miles Traveled Per. Mo—436, No. Children Hauled Per. Mo—874, No. Gallons Gas Used Per. Mo—36. (Courtesy of Margaret Brennan.)

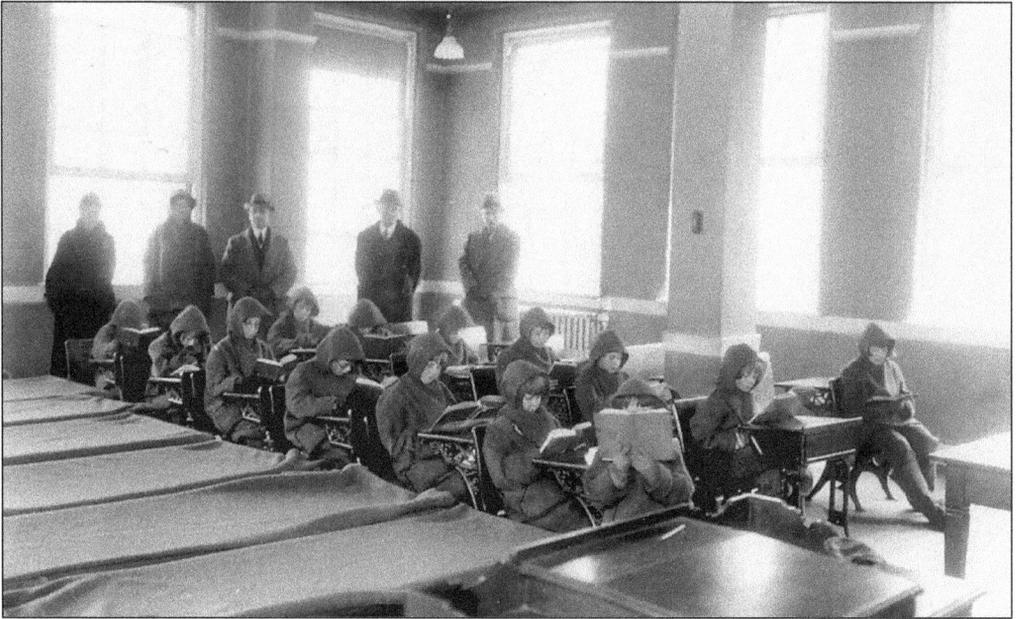

CHILDREN WITH TUBERCULOSIS. Little medication existed for the treatment of TB, so patients were treated with fresh air. The windows were flung open 365 days a year, allowing fresh air into their ailing lungs. These young students and their instructors are dressed warmly for class. The Anti-Tuberculosis League of Ohio County was organized on May 20, 1909. Dr. Harriet Jones was elected the first president. This photo was taken at Madison Grade school, c. 1910–1920.

ST. ALPHONSUS SCHOOL ROOM 6, GRADE 5, 1906. The St. Alphonsus Church was born in 1856 to meet the needs of the German-speaking public. On January 1, 1884, the Capuchin Fathers of the Pennsylvania Province took over the parish. The first grade school opened in the church basement in 1859. The present school was erected in 1874. In 1994, the Capuchins left after 111 years service. (Courtesy of John Weishar.)

KIDS ON THE STEPS AT EOFF STREET TEMPLE, C. 1900. In 1849, the Eoff Street Temple was organized. In 1873, it was one of the charter members of the Union on American Hebrew Congregations. The cornerstone was laid and in 1891 the Temple was dedicated in 1892. (Courtesy of Temple Shalom.)

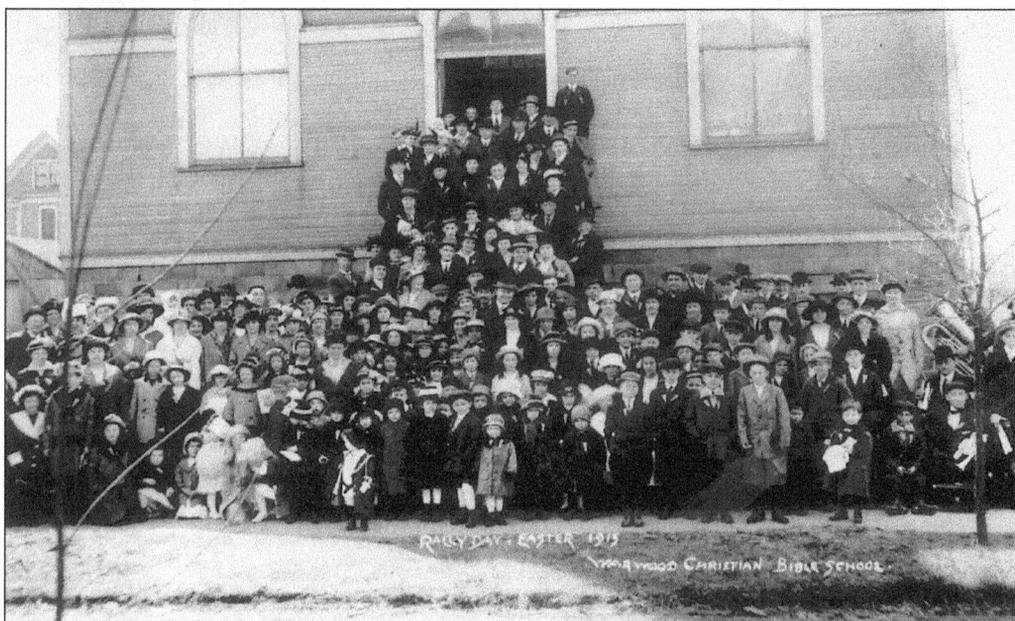

WARWOOD CHRISTIAN BIBLE SCHOOL, EASTER, 1915. In 1909, the First Christian Church of Wheeling gave two lots on Eight Street for a Christian church. They were later exchanged for the North 17th Street lot. On May 30, 1911, the entire church was erected. The men built the church and the women fed them continuously. (Courtesy of Minister Roger A. Murfin.)

113

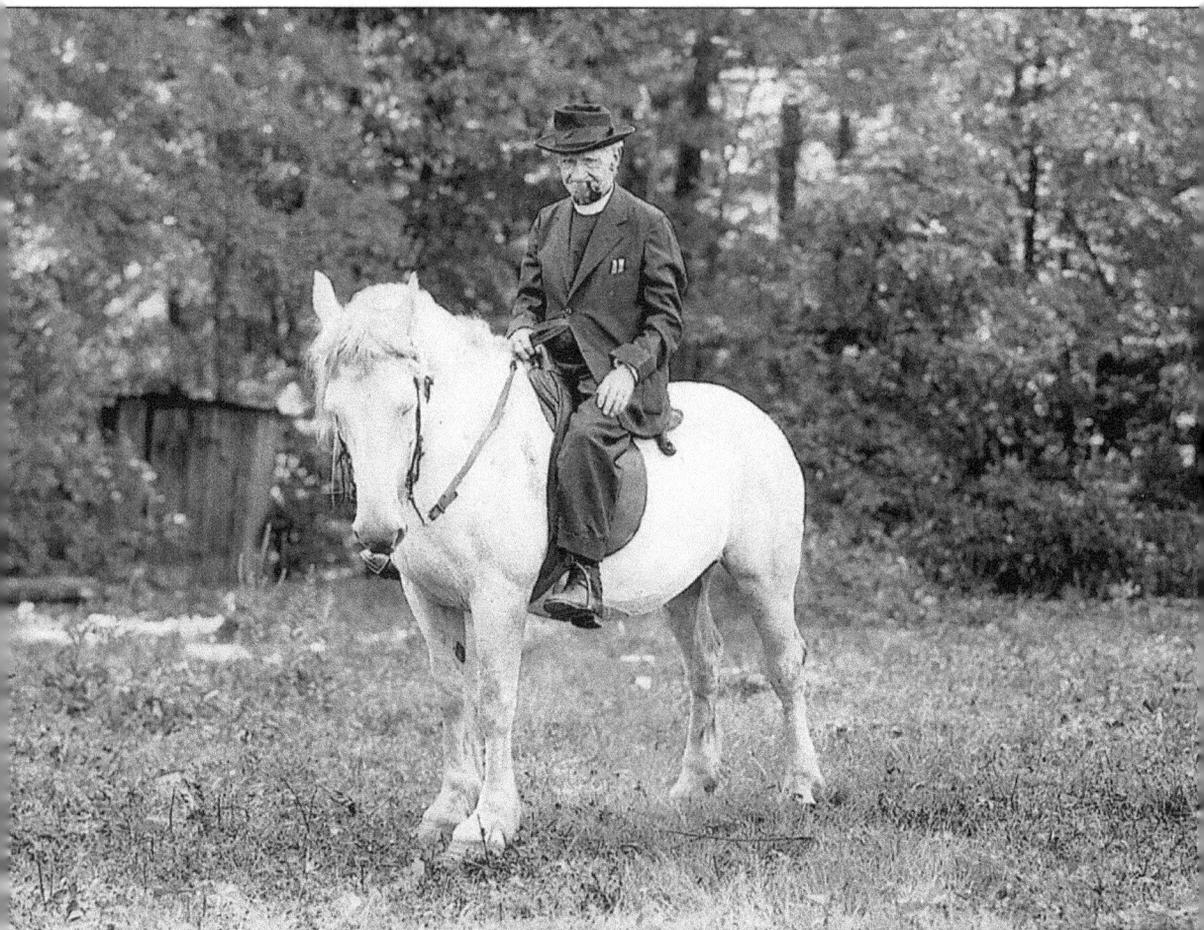

MONSIGNOR THOMAS A. QUIRK, (1845–1937). He was born in Clonmel, County Tipperay, Ireland. He assisted several Irish revolutionaries who escaped from jail. Mr. Quirk immigrated to the United States and enlisted in the Union Army. After the Civil War, he was recruited by Wheeling Bishop Richard V. Whelan to serve in the Wheeling Diocese. (Courtesy of the Archives of the Wheeling-Charleston Diocese.)

"BIG" BILL LIAS, C. 1955. William G. Lias (1900–1970) was born in Greece and at birth weighed 12 1/2 lbs. He was called "Butt Boy" in school (one can imagine not to his face). Lias controlled the illegal rackets in Wheeling. He had four convictions for illegal booze and a couple of prison terms. In this picture, he is standing in the doorway of the courthouse for one of his many trials. Most people say that he got away with much more than he was ever convicted of. He was questioned in the death of his first wife Gladys, the explosion at Nick Frank's Coffee Shop, the bombing of "Skinny" Thorton's home, the fire at Sam Grossield's, and the car bombing of Paul Hankish. He was also suspected to be behind the shooting of his cousin Mike days before he was to testify against him. Bill owned or had interests in the Wheeling Downs Race Track, Zeller's Steak House, Club Diamond, White Front, The Bachelor's Club, and the Roosevelt Restaurant. Mr. Lias mimicked Al Capone's technique to garner public support by giving away turkeys to the poor at Thanksgiving. (Courtesy of Gary Zearott, Zee Photo.)

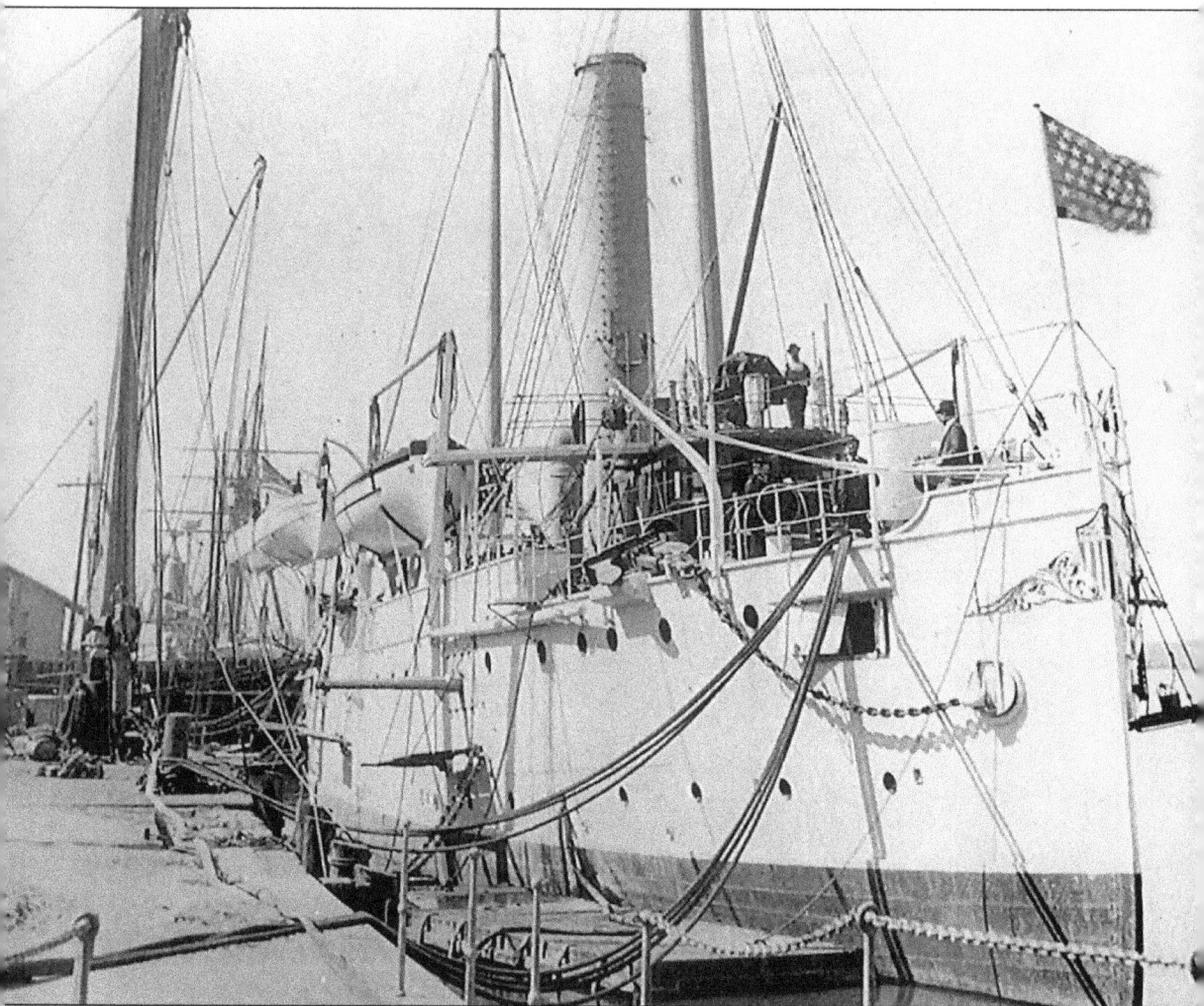

USS WHEELING, 1897. The USS *Wheeling* (1897–1946), is shown here at Mare Island Navy Yard, California. This 990 ton gunboat was built in San Francisco and commissioned in August 1897. It saw duty in the Eastern Pacific, Samoa, the Caribbean, the Azores, and around Gibraltar. It was decommissioned in October 1919 and became a Naval Reserve training ship. (Courtesy of Margaret Brennan.)

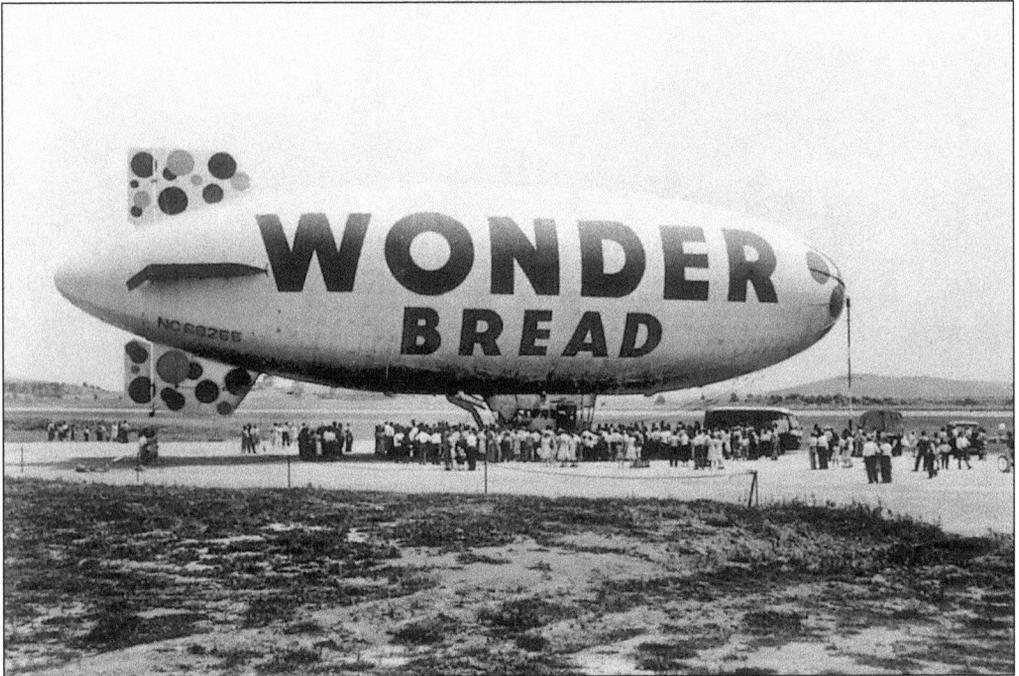

WONDER BREAD ADVERTISING BLIMP, C. 1955. This blimp floated into the Wheeling Ohio County Airport to the cheers of the anxious public that gathered on the airstrip. Vendors sold balloons and a fleet of Wonder Bread trucks lined the road to the airport. To the horror of the Wonder Bread Marketing Department, the blimp unexpectedly deflated and slouched to the ground. (Courtesy of Tom Tominack.)

IRON COFFINS, 1913. These iron coffins resembling Egyptian mummy cases were found inside the vaults in the old Catholic Cemetery on Rock Point Road near the old Reymann Brewery. (Courtesy of Kirk's Photo.)

IRON COFFIN VAULTS, SUNDAY, MARCH 3, 1912. Wheeling was an iron producing city and her wealthy citizens probably saw these elaborate coffins as status symbols. (Courtesy of Kirk's Photo.)

OSIRIS SHRINE CIRCUS. The circus frequently came to town and usually operated from Wheeling Island Stadium. In 1972, the "Flying Wallendas" performed at the stadium in front of a crowd of 7,500 people. Karl Wallanda's son-in-law, Chico Guzman, leaned back and hit a high power wire and fell 70 feet. He died from electrocution and severe head injuries. The incident blacked out the entire stadium. The ring master, Bill Kay, worked to calm the audience down. (Courtesy of Milt Gutman.)

SCHMULBACH BREW ADVERTISEMENT, 1896.
This ad promises health to nursing mothers and invalids. One rarely sees the words "Epicures, Brainworkers, Mingled Souls, and Invalids" in modern beer advertisements. (Courtesy of the Wheeling Fire Department.)

THE MINGLED SOULS OF MALT AND HOPS,

GOLDEN BREW

The most delicious and invigorating EXPORT BEER on the market.

A boon to nursing mothers and invalids, A Fountain of Life to Brainworkers and Epicures.

The Schmulbach Brewing Co.'s famous Brands
'Golden Brew,'' Culmbacher,'
'Wiener,' and 'Lager' Beer

Have recorded in the public's estimation.

"The One Hundred Points of Perfection," an altitude of merit supreme and unequalled.

"THEY'RE PURE—THAT'S SURE"

And are especially adapted for table use and family consumption. Call for them and take no other.

"JUST FOUND HIS MAIL POUCH"

ANTI NERVOUS DYSPEPTIC TOBACCO
A COOL SWEET SMOKE AND LASTING CHEW

ANTI-NERVOUS, DYSPEPTIC, TOBACCO ADVERTISEMENT. Aaron and Samuel Bloch formed Bloch Brothers Tobacco Co. in Wheeling in 1879. They started to roll stogies but observed that their own employees enjoyed chewing the left-over tobacco from the stogie-making processing. The brothers started packaging the clippings and began selling them as "West Virginia Mail Pouch." Later it would lovingly be referred to as "West Virginia Coleslaw."

119

MARSH'S TOBIE LABEL. M. Marsh and Sons, a local stogie company was founded in 1840 and produced tobacco products in Wheeling for 162 years. Mark Twain once stated "Then once more, changed off, so that I might acquire the subtler flavor of the Wheeling Toby . . . I discovered that the worst cigars, so called, are the best for me, after all."

BIZARRE BEAUTY FLOAT, NOVEMBER 28, 1947. This parade is moving up Market Street in front of the Diamond Music Lounge. The woman on the float, Miss Joan Estep, was Miss Wheeling 1947. She was judged "One of the 15 most beautiful girls in America." This float appears to be made with aluminum foil and mannequin heads.

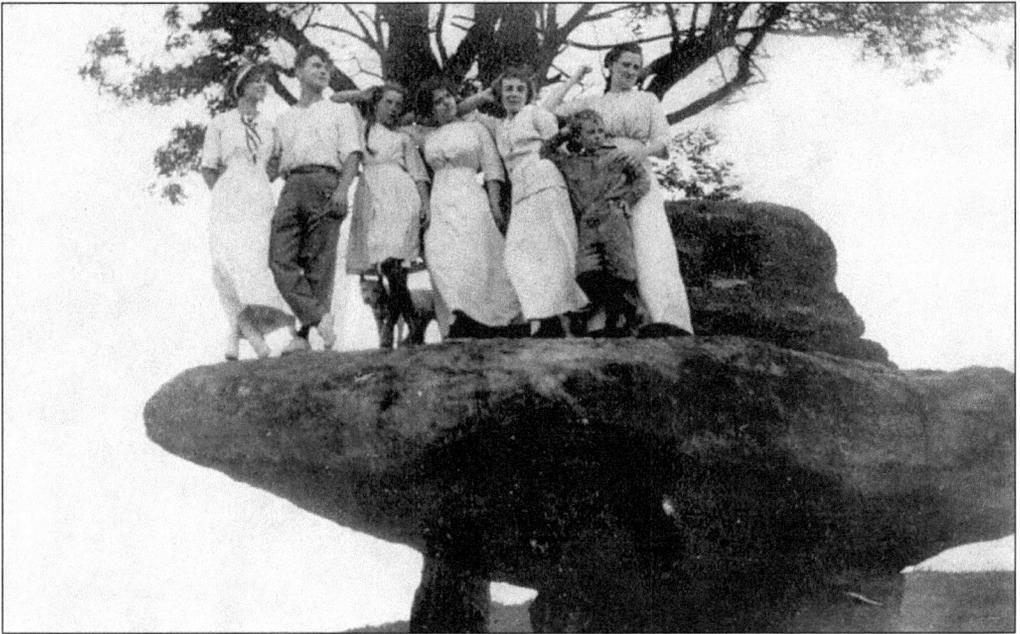

POSING ON TABLE ROCK, C. 1905. This popular picnic and make-out spot has been the site of thousands of Wheeling photographs. While collecting pictures for this book, almost everyone asked if I needed a picture of Table Rock. Notice the lack of trees on the hill behind the rock. Today it is heavily wooded. (Courtesy of Oglebay Institute Mansion Museum.)

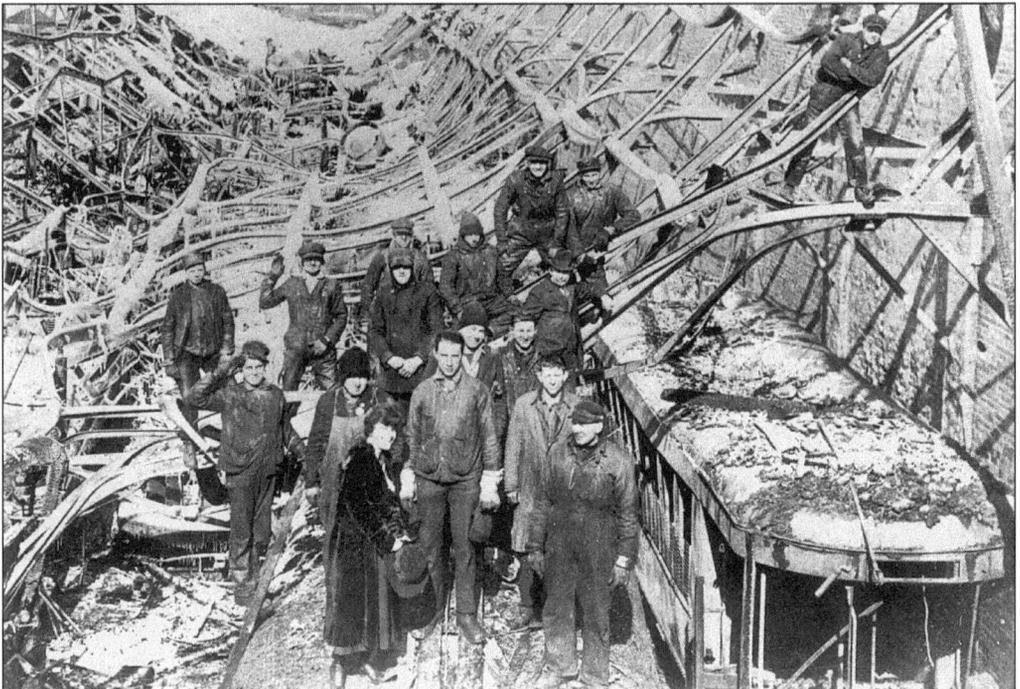

FIRE AT STREET CAR BARN, FEBRUARY 1918. The people in this photograph seem remarkably happy considering that their business had just burned down. The boy on the left who is saluting the camera seems positively pleased.

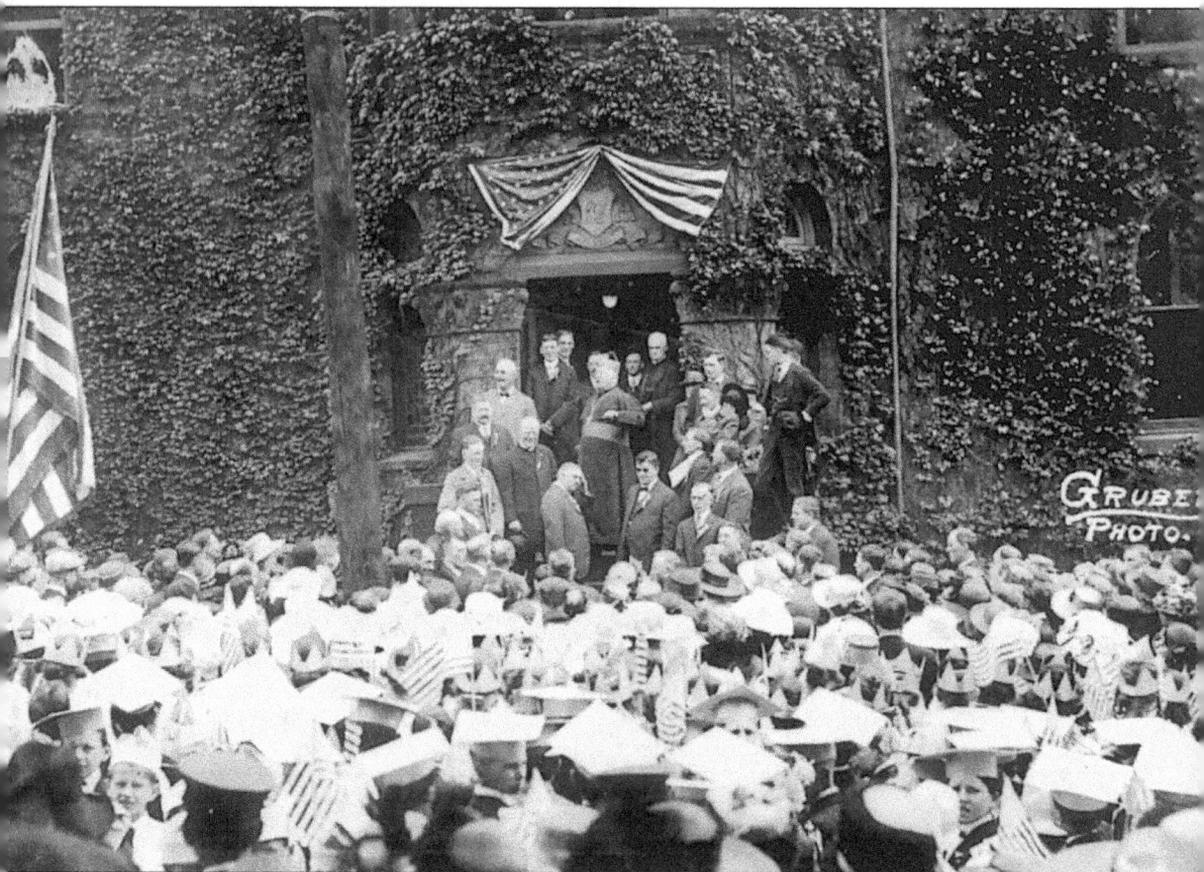

PARISHIONERS AT ST. JOSEPH'S CATHEDRAL, C. 1920. The congregation has gathered in front of the Catholic rectory following a procession. Bishop Donahue is believed to be the man giving the speech on the steps. (Courtesy of the Archives of Wheeling-Charleston Diocese.)

MAYOR'S SPEECH, JUNE 20, 1913. Mayor H.L. Kirk is giving a speech on the opening day of the Semi-Centennial celebration. This patriotic day was filled with speeches, parades, and flags. (Courtesy of Kirk's Photo.)

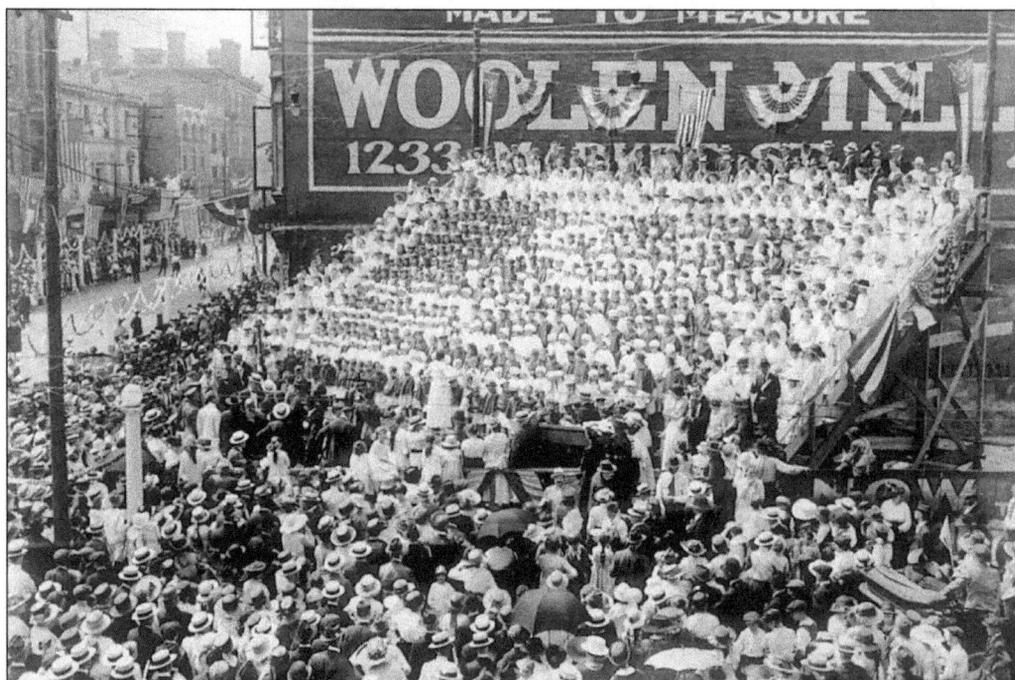

INDEPENDENCE DAY FLAG CHORUS. These young women made the shape of a flag at Woolen Mills on 1233 Market Street. It is believed that this was an Independence Day celebration but that is hard to verify. (Courtesy of Oglebay Institute Mansion Museum.)

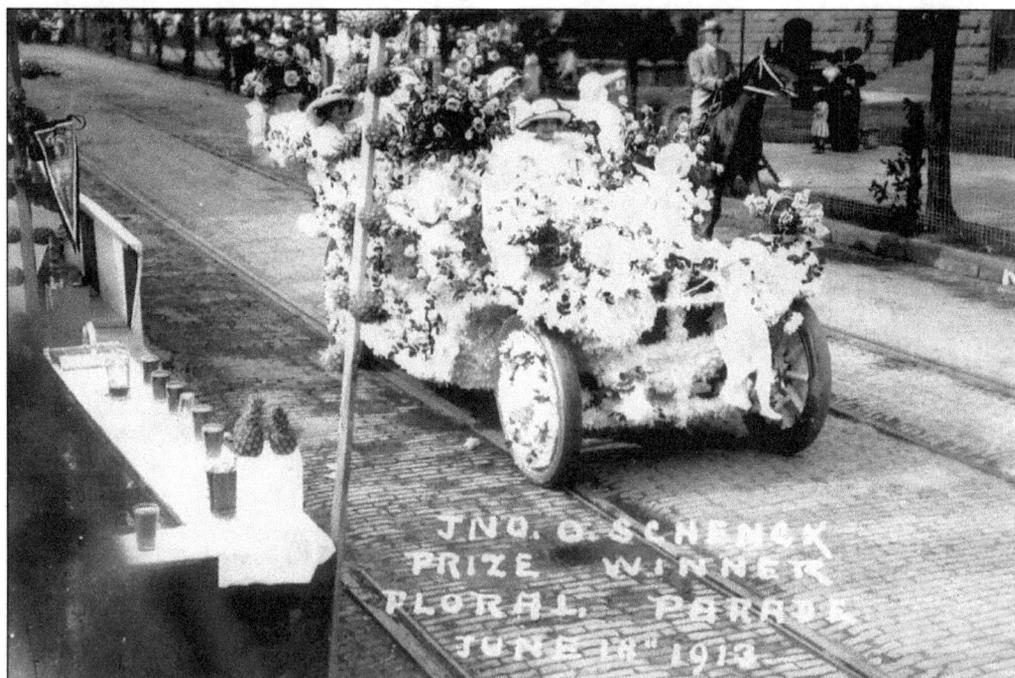

FLORAL PARADE, JUNE 18, 1913. Mrs. Schenck appears to be the prize winner of the floral parade. Notice the man riding the beautiful horse behind the flower car and beer and pineapple stand to the left or the streetcar tracks. (Courtesy of Kirk's Photo.)

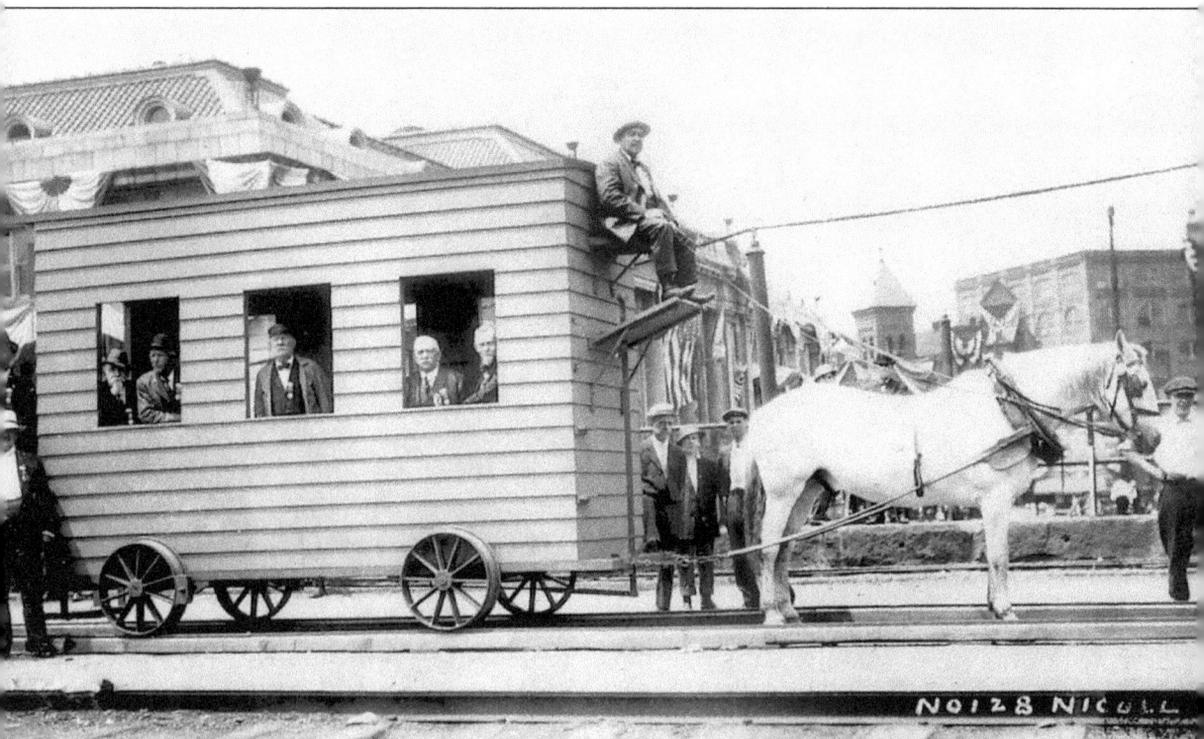

Horse Pulling a House, 1913. This early vehicle could be considered an early mobile home. The B&O Railroad Station is in the background. (Courtesy of Kirk's Photo.)

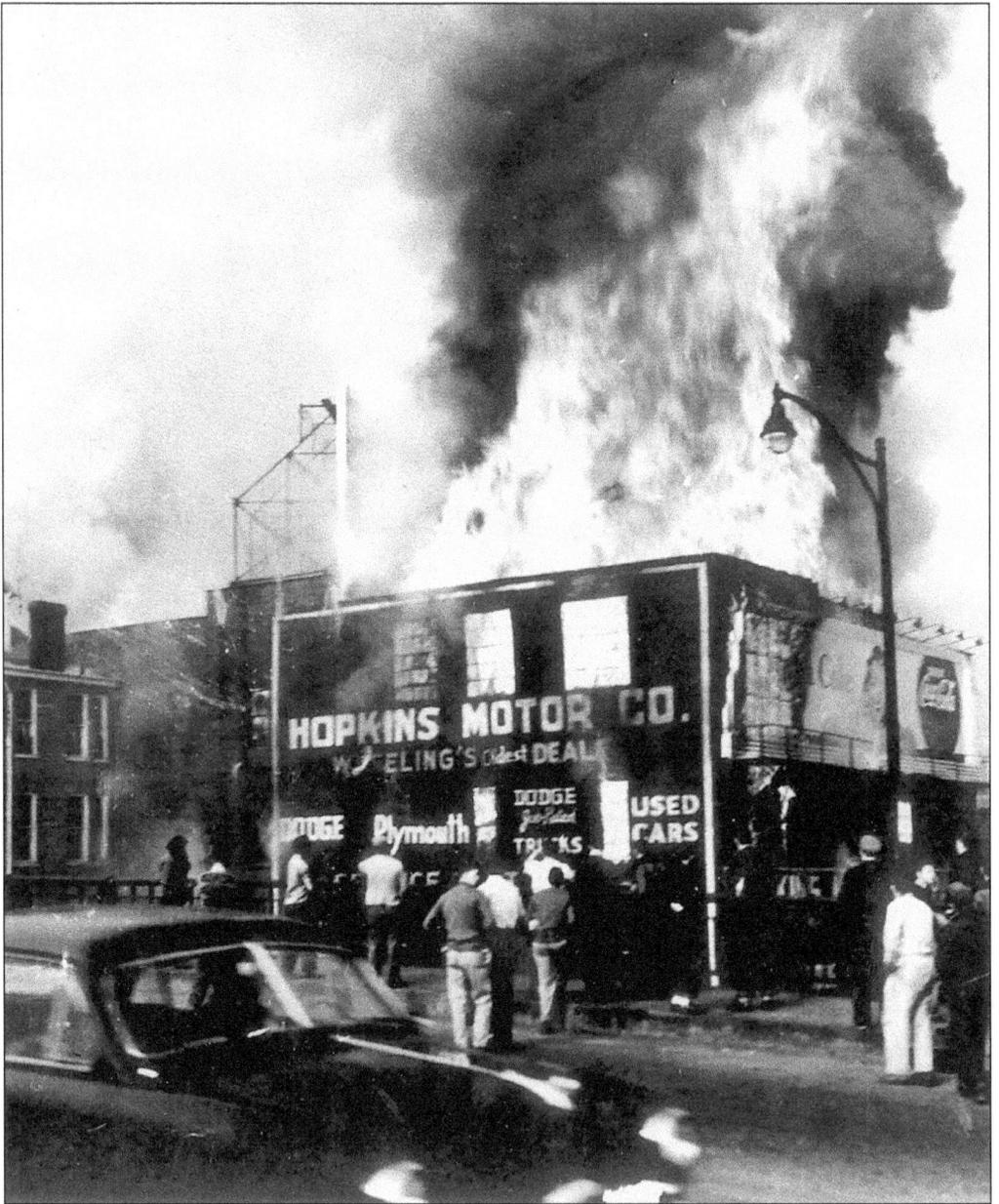

HOPKINS MOTOR CO. FIRE, OCTOBER 20, 1949. An early morning fire destroyed this building on 20th Street. The blaze was attributed to the explosion of a coal-gas furnace. It was owned by Walker Dick and was assessed to be $250,000. Also lost in the fire were 15 new cars, 30 used cars, and 5 cars in the garage for repair. Chief McFadden stated that "if it hadn't been for the quick response of Wheeling's finest, the entire block could have gone up in flames." (Courtesy of Betty June Weimer.)

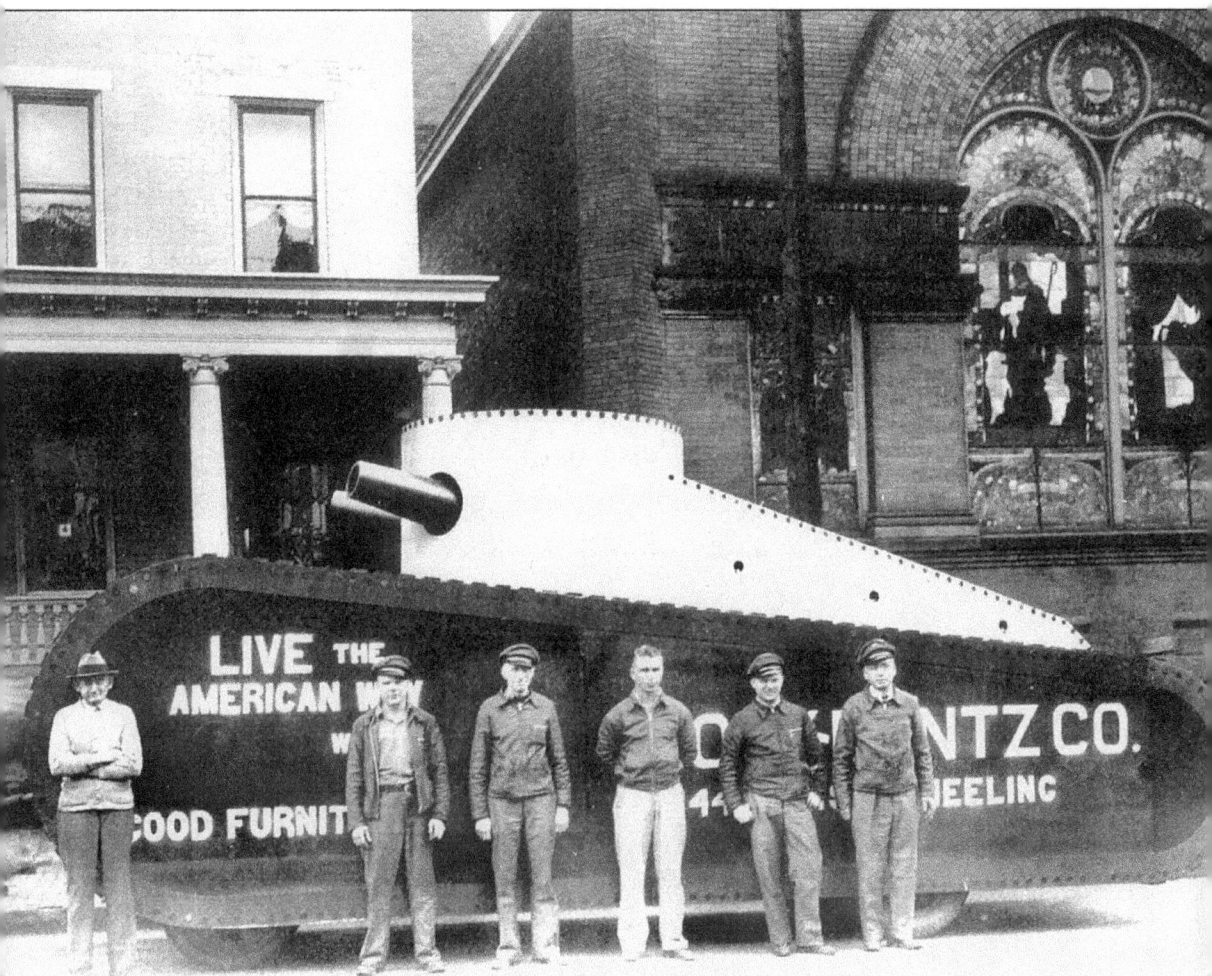

LIVE THE AMERICAN WAY WITH GOOD FURNITURE. This Cooey-Bentz float probably used veterans to walk along beside. The Cooey-Bentz Company was a home furnishings business at 3601–3603 Jacob Street. (Courtesy of Margaret Brennan.)

Visit us at
arcadiapublishing.com

www.ingramcontent.com/pod-product-compliance
Lightning Source LLC
Chambersburg PA
CBHW050612110426

42813CB00008B/2528